VANCOUVER
NOIR
1930 – 1960

DIANE **PURVEY** JOHN **BELSHAW**

VANCOUVER
NOIR
1930 – 1960

Anvil Press | Vancouver | 2011

Anvil Press Publishers Inc.
P.O. Box 3008, Main Post Office
Vancouver, B.C. V6B 3X5 Canada
www.anvilpress.com

3rd Printing: November 2012

Library and Archives Canada Cataloguing in Publication

Purvey, Diane
 Vancouver noir / Diane Purvey and John Belshaw.

Includes bibliographical references and index.
ISBN 978-1-897535-83-7

 1. Vancouver (B.C.)--Social conditions--20th century. 2. Vancouver
(B.C.)--Social life and customs--20th century. 3. Vancouver (B.C.)--
History--20th century. I. Belshaw, John Douglas II. Title.

FC3847.4.P87 2011 971.1'3304 C2011-906157-0

Book design: Derek von Essen

Represented in Canada by the Literary Press Group

Distributed in Canada by the University of Toronto Press and in the U.S. by Small
Press Distribution (SPD).

The publisher gratefully acknowledges the financial assistance of the Canada Council
for the Arts, the Canada Book Fund, and the Province of British Columbia through the
B.C. Arts Council and the Book Publishing Tax Credit.

Printed and bound in Canada.

DEDICATION

To our parents, who made their homes (and ours)
in Vancouver during the Age of *Noir*.

RALPH & BARBARA PURVEY
ROBERT & MARJORIE BELSHAW

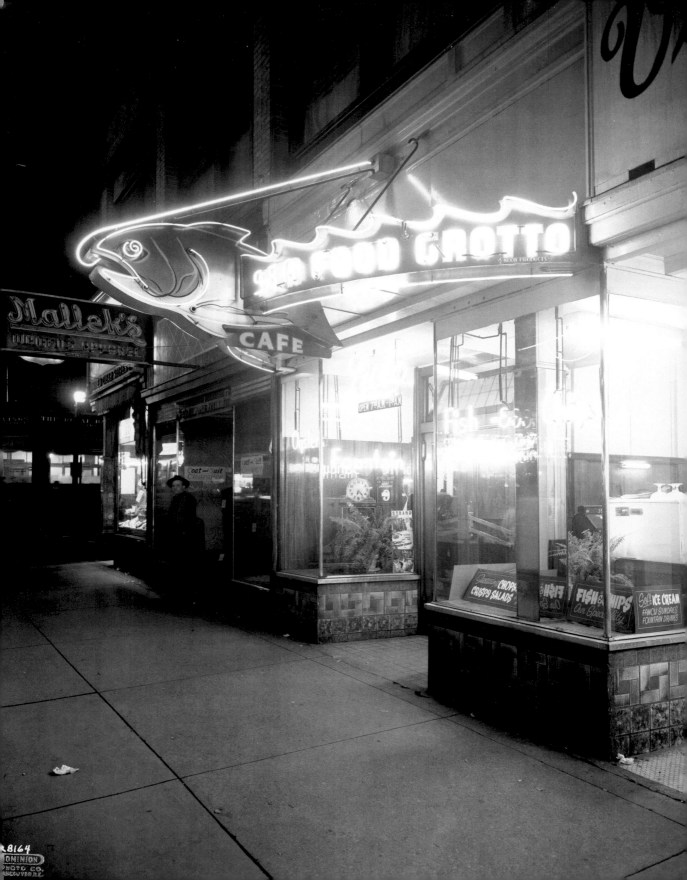

Contents

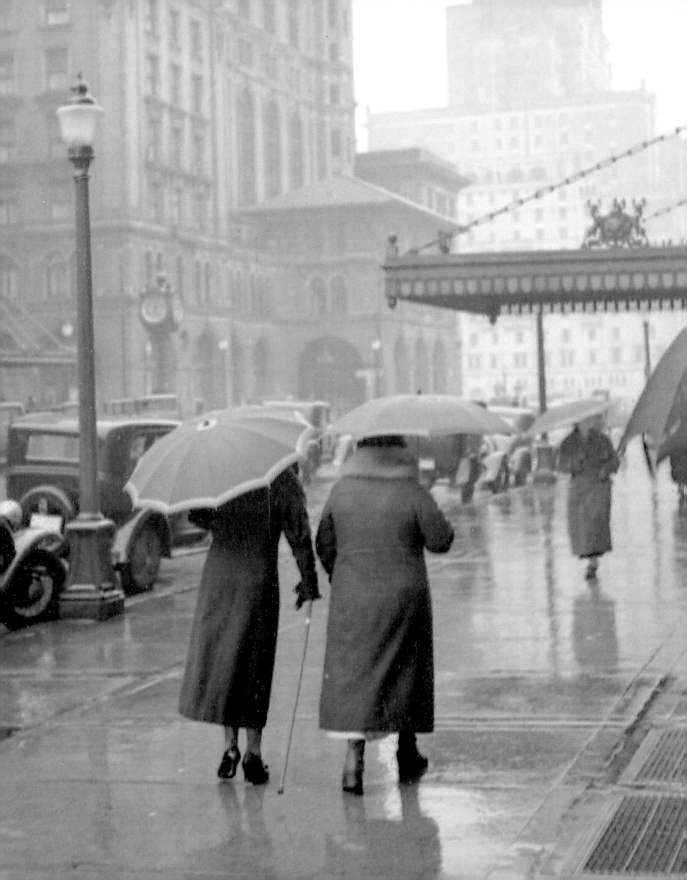

PREFACE

WE WERE GALVANIZED to undertake this study after a visit to the Museum of Modern Art in San Francisco in 2002. An exhibition of black and white crime scene photographs got us asking questions about the intersection between image and reality, between *"film noir"* style and the lived lives of San Franciscans and Los Angelenos in the years between the Wall Street Crash and the Cuban Missile Crisis. Were these photographs a by-product of *film noir* or was it the other way around? Did the coincidence of imagery arise entirely because of the film technology of the day?

As Vancouverites, we couldn't help but ask whether similar cameras used under similar circumstances produced similar images of the Terminal City. Our previous research had included, serendipitously, two studies on Canada's westcoast metropolis, both of which dealt with crisis, crime, and corruption. The first was a Master's thesis on Depression-era Vancouver, a decade in which corruption in City Hall was a given and when questions about human rights were often answered with a truncheon. The second was a recently minted Ph.D. dissertation in which Cold War-era domestic violence, murder, and courtroom drama were explored in depth. This latter project led to a study of capital case files in Ottawa, some of which contained evocative, often graphic, photographs that would send a shiver down the spine of Sam Spade.

The principal challenge before us through the life of this project has been to forcefully challenge Vancouver's prevalently cheerful if damp reputation while treating the subject matter—specifically some of the tragedies we trace—with the respect they deserve. There are ethical issues involved in the reproduction of images of the deceased; we have some experience in the field of historic and contemporary thanatology so we were careful to make measured choices. The balance to strike between the individual's story and that of the community is, however, not always an easy one.

Looking west on Georgia from Granville on rainy day, ca. 1930.

CITY OF VANCOUVER ARCHIVES 260-251,
PHOTO BY JAMES CROOKALL

One photograph that did not make the cut deserves special mention. In 1947 Viola Woolridge was murdered in cold blood. Her husband, Malcolm Woolridge, confessed immediately to the homicide but he was allowed to go free by a court that, astonishingly, believed Viola failed to pass the litmus test of what society viewed as appropriate feminine/ wifely/motherly behaviour and that she got what was coming to her. Viola's story illustrates the point we wish to make about the *Noir* era: that ascendant middle-class values could have severe—sometimes lethal— consequences, as you will see in the chapter on murders. But what you won't find here is a police photograph we tracked down of Viola, her body sprawled on the floral-patterned carpet of the Woolridges' bedroom, a heavy brown bureau behind her, on top of which a picture of her infant son is propped up behind a small hairbrush. On the walls a few cheaply reproduced works of art have been pinned to the wallpaper above the small bed with its cast-iron bedstead. Viola's head is turned toward the camera, a dried streambed of blood sprouting from a hole in her right temple. Her dark hair is swept up in permanent wave, her eyes are open. It's a classic murder scene: shocking, banal, gruesome, and all too ordinary. Vancouver was, in the year Viola died, a city where a man could pull a loaded gun from a paperbag and put not one, not two, but three bullets into his wife because she didn't meet his, nor society's, ideal of womanhood. We regret that, in fairness to Viola's descendants, this picture cannot be reproduced here. Because in her cold dead eyes one sees reflected the sort of hard, *Noir* city Vancouver once was.

We are happy to acknowledge the significant contributions made by others to this project. First, our thanks go to our undergraduate research assistants: Marcy D'Aquino, Lindsay Goodridge, and Pam Cairns at Thompson Rivers University, and Jacqueline Gordon and Allan Bishop at Langara College. Friends and colleagues at Thompson Rivers University, North Island College, and Langara College indulged us when we described the project and some of its elements. Vince Kreiser helped out with information about Vancouver's older sport venues, John Mackie came through with details about the Marine Building, and James Johnstone proofed, critiqued, and improved the manuscript. Tina Block invited us into her Historical Methods class and her students didn't chase us out. The Courtenay & District Museum hosted a public lecture. And the audience and commentators at an early presentation of preliminary findings at the Canadian Historical Association's annual conference in

2006 at York University provided useful feedback when most needed. Jean Barman—not for the first time—has to be singled out for her helpful observations. We want to acknowledge, too, the support we received in the form of Scholarly Activity Funds at Thompson Rivers University. None of this would have mattered had we not enjoyed the enthusiastic and professional engagement of curators and staff at the City of Vancouver Archives, the Vancouver Police Museum, the downtown branch of the Vancouver Public Library (Northwest Room), the British Columbia Museum and Archives, and the New Westminster Museum and Archives. Nor would we have got very far without the shelf-loads of local histories, tirelessly produced by independent writers and small publishers.

As was the case with *Private Grief, Public Mourning*, Anvil Press was a joy to work with. Brian Kaufman, Karen Green, and designer Derek von Essen provided talent, resources, and encouragement. And, of course, we want to acknowledge Ross Nelson's superbly effective service as a cartographer.

No task of any value that we have ever undertaken has got very far without the support of our family: Natalie, Ian, Gabriel, Ralph, and Barb. We are utterly grateful.

This book is framed by photographs, so it is to the city's professional and amateur photographers of the mid-twentieth century that we owe the greatest debt. Art Jones and Ray Munro (together known as ArtRay), Jack Lindsay, James Crookall, Gord Sedawie, Stuart Thomson, and Bob Olson were among the most prolific Vancouver photographers of their day. Many more remain anonymous. All were opportunists who took pictures for newspapers and for the police; or they set up their own commercial studios; or they were freewheeling freelancers who had a particular eye for the city. The fact that thousands of their photographs reside safely at the City of Vancouver Archives, in the Vancouver Public Library, and elsewhere is testament to the foresight and vision of a handful of politicians and civic officials to whom we also doff our fedoras.

Because Vancouver is a city of newcomers constantly replenished with arrivals from far afield, its history is often badly misunderstood and undervalued. *Vancouver Noir* is a modest attempt to shift the view of the Big Smoke. This is our city, we were both born and raised here. To paraphrase Burt Lancaster from the *noir* classic, *Sweet Smell of Success*, we love this dinky town.

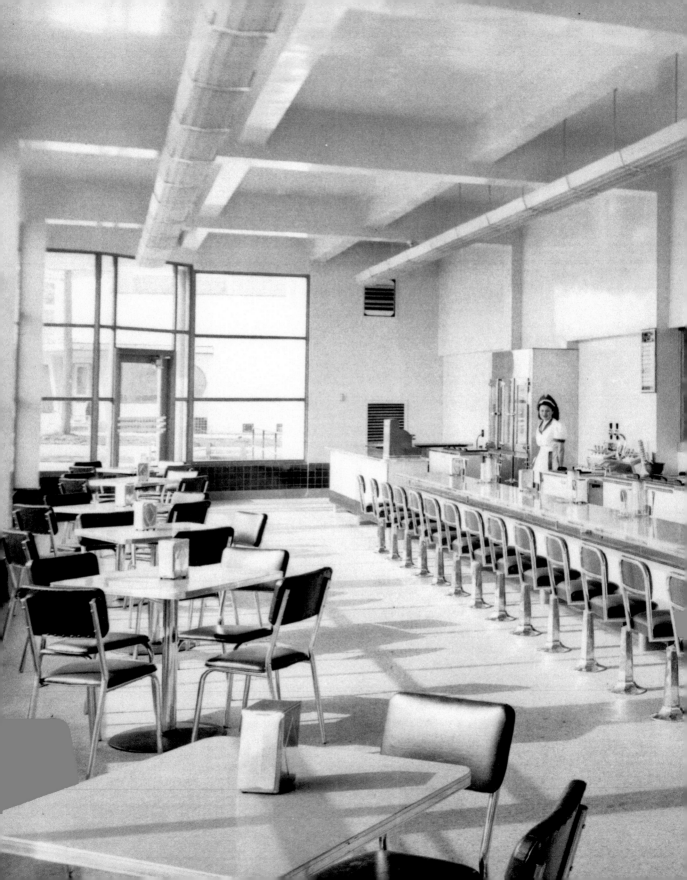

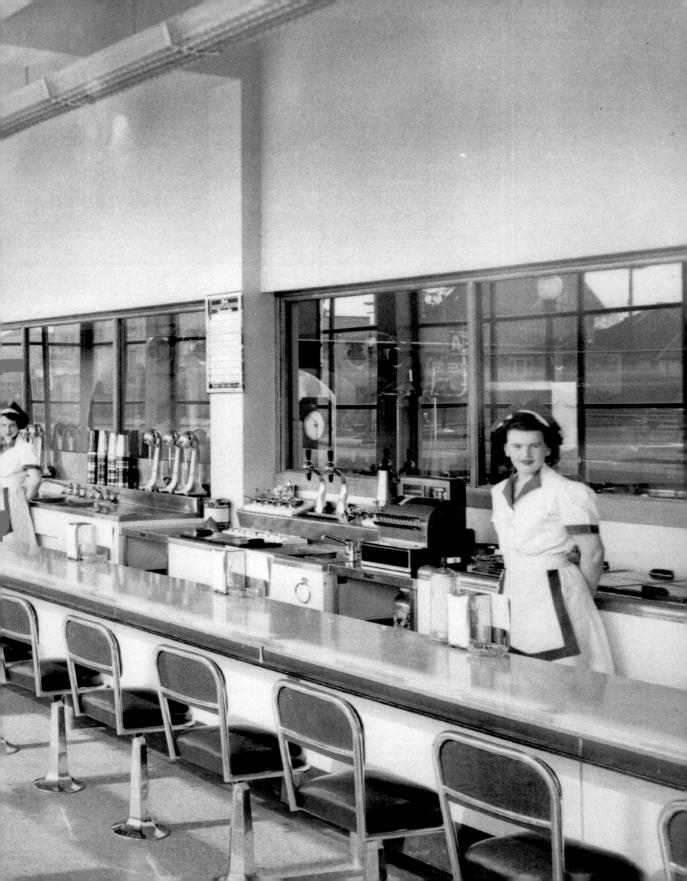

INTRODUCTION

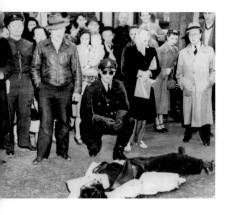

above: A corpse in the street in 1957 produces a curious crowd, but not shock or horror. A motorcycle cop poses while a mother holds up an infant for a better view.
VANCOUVER POLICE MUSEUM, 1957.

left: The Marine Building at street level, ca.1933.
CITY OF VANCOUVER ARCHIVES 260-1433, PHOTO BY JAMES CROOKALL

previous page: A downtown diner, 1942.
CITY OF VANCOUVER ARCHIVES 1184-1407, JACK LINDSAY.

In Vancouver, in the 1920s, planning was in the air. The City Beautiful Movement—an international campaign to visually and morally improve industrial-era cities—was at its peak and Canada's Pacific coast port was outgrowing its frontier past and its limited boundaries. The city was simultaneously expanding and refining itself. As it stretched out to the south and west and rubbed up against the Fraser River and neighbouring municipalities, there was talk of refashioning much of the old downtown with stately public buildings, a new bridge over False Creek, and a grand boulevard to Stanley Park. There were also the usual calls for reforming the way the city did its business so that property values didn't pitch and toss, boom and bust quite so spectacularly as they had in the recent past.[1] The ideal of tree-lined prosperity painted across a larger canvas emboldened city authorities.

In 1925 Vancouver introduced Canada's first urban zoning plan. Four years later, on the eve of the Great Depression, the city absorbed the municipalities of Point Grey and South Vancouver. Also in the fateful year of 1929, a blueprint for Vancouver's future was in the hands of City Council. Rather than propel Vancouver into a shining, new era, however, these two initiatives polarized life in the city, brightening some streets while darkening others. Together, they paved the way for the *Noir* era in Canada's west coast metropolis.

Noir

This period, from the Great Depression to the '60s, is associated in popular culture—but in movies and literature in particular—with the concept of "*Noir*". It is a nebulous idea, but *Noir* is most often associated with crime, corruption, cynicism, and moral ambiguity, with a nether-world of gangsters, hustlers, junkies, *femmes fatales*, drifters, political fixers, private eyes, city officials on the take, and charismatic cult leaders as its stock characters. *Noir* also features larger than life crime-busters,

urban missionaries, and crusading politicians who wage war against a multitude of sins, some of which occur against a sexualized background. As a port city evolving from a provincial to a regional metropolis, Vancouver presented openings for opportunists on either side of this black-and-white divide, and it provided fertile ground for imagining that (a) things were much worse than they really were, and (b) things might actually get better.

But there's more to *Noir*. In one respect, it can be seen as a transitional phase in a twentieth century city's development. It occurs (in the case of Vancouver) when middle-class reformers redefine the boundaries of acceptability and, in the process, add a layer of mystique to the very thing or things they are trying to eliminate. Faced with their own economic insecurity in the 1930s and global insecurity in the two decades that followed, the middle classes of the western world as a whole reacted with rules, police, sanctions, and language that conflated taboo with temptation. To cite just one example, the city's white elite described and promoted a vision of Vancouver's Chinatown neighbourhood and its denizens as "exotic, exciting but also criminal, dangerous, and unhealthy…."[2] Surely these are the elements of all good *Noir* images?

Much has been written of Los Angeles and San Francisco during these years, leaving the impression that the era of tough guys and two-timing dolls, slouch hats, and vicious killers were a monopoly of American cities. This was not the case in fact. As one Canadian commentator points out, North American urban society as a whole was "torn between a biologistic reading of the city during this period, which would cast it … as a rotting social body," or one in which "a people anxious to reclaim their city are set against invading and occupying forces (Italian gangsters and soldiers on furlough)." The common markers of the language of *Noir*, Will Straw argues, are "hygienic metaphors," such as "cleaning up."[3] This was as true of Vancouver as it was of Montréal, Canada's biggest city at the time and, self-consciously, its most exotic.[4] It was, of course, true of the whole archipelago of west coast port cities. This was a linked network of rapid urbanization, crime waves, and changing social values. The chain stretched from San Diego through Portland and Seattle, north to Prince Rupert and Anchorage. The same ships carried contraband and sailors from harbour to harbour, looking for dealers and trouble. The border was no barrier: Vancouver's criminal element and its scandal victims cooled their heels south of the line—where they risked being rounded up by

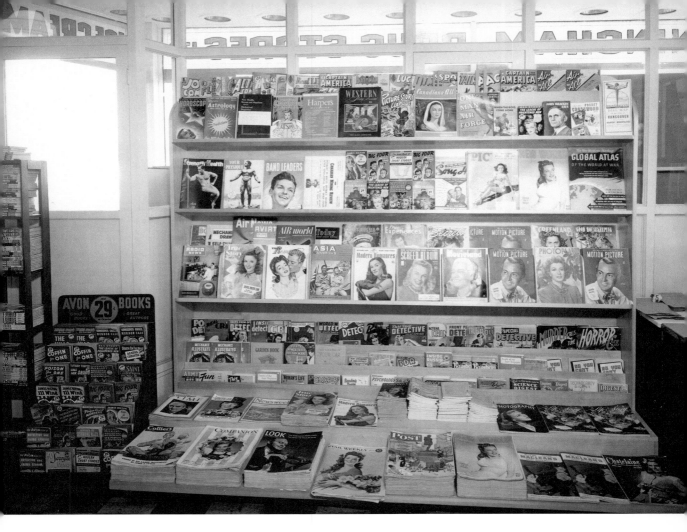

The magazines and comic books of the day strike a distinctly *Noir* tone, 1945.

the LAPD and other new-model police forces. At the same time, the language of urban reform, the glorious growth of automobile culture, political zoning, and planning as an instrument of physical and social change moved as freely across the border as Harland Bartholomew, the city's St. Louis-based planning consultant.

The images of the era were also shared. Vaudeville, circuses, and touring musicians linked these cities (and others). Pulp magazines and novels were also part of the common cultural currency. As two Canadian historians observed, the point of the "true crime" genre was to show how dissatisfaction with one's lot in life led to trouble: "Canadian magazine publishers favoured stories that recounted how ordinary folk—car mechanics and lunch counter waitresses—who aspired to lives of luxury inevitably ended up behind bars or strung up on a scaffold. These were the kinds of people who refused to accept their station in life, to line up for an honest job or to stick it out with a boring husband."[5] A platoon of comic-

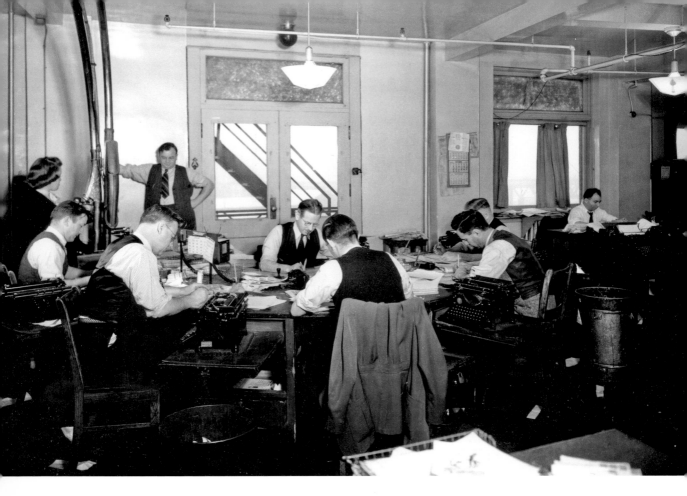

At one time, the "City Desk" at the newspaper was, in fact, a desk. Reporters competing for the front page, ca. 1946.

strip crime-fighters created another accessible, visual language of trouble along the waterfront and in the cheap gin joints of the western world. The CBC (established in 1936) was an ineffectual barrier to American radio imperialism: *The Shadow*, *The Whistler*, *The Green Hornet*, and *The Naked City* slipped into Canadian households, bringing with them the common currency of gunplay, fistfights, wealthy masked vigilantes, and hard-boiled detectives. Even the burlesque circuit along the coast was a vehicle for disseminating a particular style and vocabulary, one that drew the ire of respectable folks and newspaper publishers on both sides of the border. Toward the end of our period, in the 1950s television appears on the scene and perpetuated storylines familiar since the 1930s. One has only to think of the TV series *Dragnet* to recall that particular way of presenting crime and respectability.

Arching over all of these other media, of course, were moving pictures from Hollywood. *Film noir* presented, reflected, and cemented something strangely familiar to urban dwellers. As of 1930, the cinema had only recently left the silent era. In the decade that followed

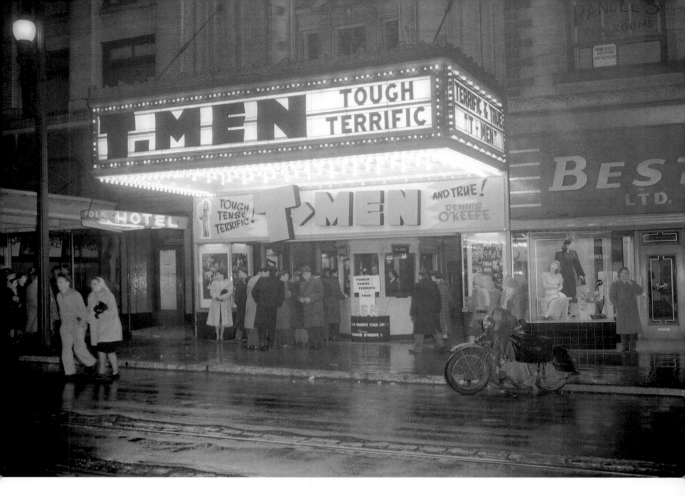

Hollywood produced optimistic and cheerful romps but it also started to experiment with darker subject matter, films that "presented a world of fear, paranoia, and infinite corruption."[6] Shot in black and white, the crime films of the day include detective series like those featuring Charlie Chan, Mr. Moto, The Thin Man, and Bulldog Drummond, which were followed by the classic *films noir*, like *You Only Live Once* (1937), *Stranger on the Third Floor* (1940), *The Maltese Falcon* (1941), *Double Indemnity* (1944), *The Killers* (1946), *Kiss Me Deadly* (1955), and *Touch of Evil* (1958). The themes were consistently the same: *film noir's* "formalistic darkness" was able to "spin out the moral tales of an underground city where the productions of honest toil always lose out to the quick fixes of curruption and speculative vice, where the déclassé rich and the gangster predator rule an economy of easy money and its purchase on the good life."[7] Screen stars of the black-and-white age became the reference points of popular culture: a local Vancouver attorney, for example, was described as a dead ringer for Spencer Tracy.[8] And the silver screen was itself a source of some fear: "The craving for excitement and amuse-

Film noir, by 1948, was a powerful source of images, style, and language.
CITY OF VANCOUVER ARCHIVES 1184-2284, JACK LINDSAY

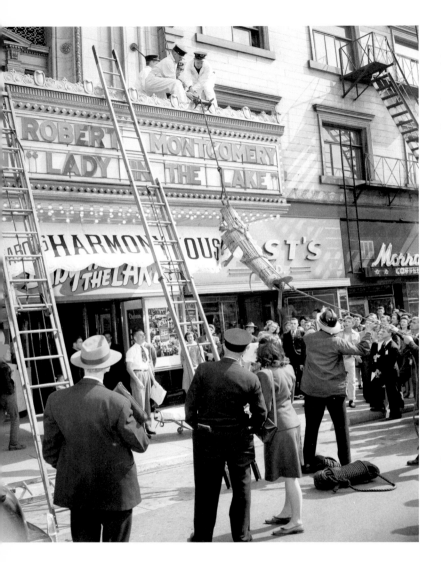

Accidents of all kinds were fair game
for photographers and for the front page.
A painter falls to death onto the Orpheum
Theatre marquee, 1947.

ment by present-day youth, and the glorification of crime as exemplified by the modern 'Movies'" was thought by some law-enforcers to "have a bearing" on the rise of juvenile crime.[9] *Film noir* was influential in that it spilled out of cinema, and into one medium after another. It even spilled into real life.

In this respect, American historians of the *Noir* era have proven too parochial. Assuming that the style and feel of the era was a peculiarity and a monopoly of American cities, they have missed a much larger story of morality, social class struggle, and image. In the manufacturing of that visual record and the *Noir* sensibility, one technological development, more than all others, literally frames this period and both captures and defines *Noir*.

"Speed Graphic" photography enjoys its glory years between the Wall Street Crash and the start of the 1960s. A new generation of more portable (relatively speaking) and more easily deployed cameras took black and white photography into situations where a tripod and a portrait camera simply could not go. These cameras recorded the *Noir* era but they also defined its elements. Larry Millett, author of *Strange Days, Dangerous Nights* and *Murder Has A Public Face*—two studies of the visual history of crime in the U.S.A.—argues convincingly that the era of *Noir is* the "speed graphic" era. The speed graphic camera was both a technology and a technique, a camera that was made for the urban jungle. It captured rain-slicked streets, the spontaneity of crowds, the darkened corners, speeding cars, and neon lights. As well, it could—and would—

become the original candid camera. Speed graphic photographers could get in close when they chose to, and they often did so. Shocking photos of crime scenes, the unfaithful spouse, the surprise witness, the busted head, the angry cop, the body lying across an intersection disjointed like a Sunday turkey … these were the possibilities and the language of the speed graphic newspaper photographer in Minneapolis, San Francisco, Toronto, Vancouver, New York, and across the Atlantic.

The photos begat a visual language of a streetlife that had gone undocumented in earlier generations, and the very newness of these images contributed to moralistic outrage and panic, even when the things they recorded were not especially new. More than a little sleazy at the edges, a city like Vancouver was a stage set for confrontations between decency and its foes in a photogenic age. As photographer Fred Herzog puts it, Canadian downtowns in this period offered "a bare existence" to their citizens, one "that upgrades life to grade B movie drama full of photo ops."[10] Herzog came to the city too late to be numbered among the many photographers of the *Noir* era, including Gord Sedawie, Jack Lindsay, Stuart Thomson, Bob Olsen, James Crookall, Art Jones and his partner, Ray Munro, and dozens of other professional and amateur cameramen and women who plied their trade for the newspapers, the police, the courts, and even for art. Put to use as an eye on crime and incivility, the speed graphic technology was, perhaps ironically, also pressed into service as a means of recording various crusades against deviance in the modern city. Thus we have the crime scene but also the forensic lab, the unsavoury loiterer but also the sturdy cop on the beat. The bright flash of an exploding bulb at the scene of a murder or in a crowded courtroom itself became a familiar element in the landscape of *Noir*.[11]

The speed graphic era relates to the Age of *Noir* in that it could describe a bullet hole, a riot, vice, beauty, deformity, and powerful emotions in ways that words could not. It could show newspaper readers the face of the problem and urge them to believe that the weed of crime did, in fact, bear bitter fruit, that certain practices were unacceptable and that measures to exact justice and order were justified. Read in this manner, the black and whites produced by speed graphic cameras defined *Noir* to such an extent that *film noir* had to adhere to those styles in order to be convincing. After a while it becomes impossible to distinguish the tail from the dog.

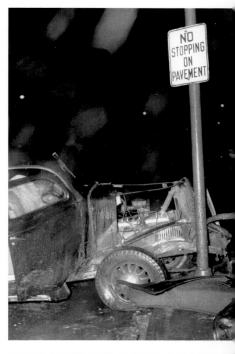

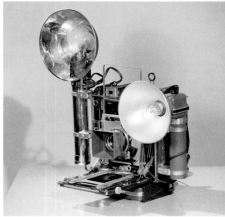

top: No Stopping, 1944.
ARTRAY PHOTO, VANCOUVER PUBLIC LIBRARY VPL 84847

above: Artray Photographers Ltd. Speed Graphic camera, Mity-Lite strobe unit, 1944.
VANCOUVER PUBLIC LIBRARY VPL 82804

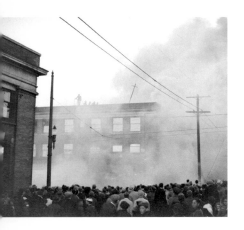

Flames engulf the Ilchester Apartments at
1497 West 7th in the spring of 1935.
A crowd quickly gathers.

CITY OF VANCOUVER ARCHIVES 99-2858,
STUART THOMSON

A shared Anglo-North American media culture and a common kind of visual literacy thus produced a *Noir* era in Vancouver that bears interesting similarities to what might be found in Dashiell Hammett's San Francisco. But the Vancouver version was more than this, more than a condensed Canadian edition. With its peculiar racial divisions (a gulf that was arguably deeper than in San Francisco), its industrial city core (much more immediate than in Los Angeles), its gaudy neon (brighter and more extravagant than anywhere else in North America), the First Nations presence (more integral to the fabric of the community than in Seattle), and the local elite's self-conscious Britishness (something that was not conceivable in the USA), Vancouver's dark interlude was played in a different key.

What most distinguishes Vancouver in the *Noir* era from L.A. and 'Frisco was the ability of the Canadian city's powerbrokers to blame American sources of corruption. Rampant materialism and illicit drugs both came from south of the border; Hollywood films and New York crime comics wrought a terrible influence on Canadian youth; international unions based in the U.S. fostered treasonous radicalism along Burrard Inlet; and lax Yankee attitudes toward divorce undermined the foundation of Canuck family values. American reformers and crusaders might also invoke foreign troublemakers, but pointing an accusing finger at the Kremlin, for example, is to shift the threat to a different continent. Being able to ascribe moral turpitude, urban decay, and crime to the pernicious influence of the next-door neighbour gave a different shape to the practices of fighting *Noir* in Vancouver through the mid-century. Corruption and violence became understood as essentially foreign and territorially illegitimate. South of the border, crime might tear at the fabric of the American Way, but in Vancouver it was the American Way itself—with its stylized popularization of crime, sexuality, and culture—that stood to undermine the bourgeois vision of Canadian society.

Needless to say, this was unfair. North American media were able to exert an increasingly homogenizing influence, yes, but there were more than enough homegrown taste-makers who could shape a vision of urban life. Take motion pictures, for example. Long before Vancouver became "Hollywood North," there was a flurry of filmmaking in the Terminal City. The 1930s in particular witnessed the greatest output of movies before the 1970s. The titles of some are supremely evocative of *Noir*

obsessions, even before the term "*film noir*" had been coined: *Secrets of Chinatown* (1935), *Secret Patrol* (1936), *Lucky Corrigan* (1936), *Death Goes North* (1937), and *Johnny Stool Pigeon* (1949).[12] More to the point, Vancouver was crafting an independent history of criminality and style. A port town, its boundaries were always porous: contraband came in and went out, despite the efforts of lawmakers and police. Pioneer feminist, jurist, and social critic, Emily Murphy, contributed to Vancouver's growing reputation as something like an open city in her 1922 book *The Black Candle*. An anti-drug screed, Murphy's tome fed for another generation the myth of the "Yellow Peril," the fear felt by many whites that Asian immigration would result in widespread economic and moral decline. American visitors subsequently enjoyed the free flowing liquor in Vancouver bars during their country's experiment with prohibition, a fact that made the city a favourite for vaudeville performers.[13] Vancouver also gained notoriety for its cabarets and bars, for its home-grown swing music, for its strippers, and its gambling.

In the *Noir* era huge crowds often assembled on Vancouver streets, 1940s.
CITY OF VANCOUVER ARCHIVES 1184-800, JACK LINDSAY

The "*Noir*" era and the "*Noir*" phenomenon furnish appealing, perversely colourful (in glorious black and white), and sometimes puzzling material for the historian. But they are not trivial. What they illustrate is the extent to which old behaviours, which had once been acceptable, were becoming acceptable no longer. And they show, increasingly, how the social and economic elites of Vancouver were gaining control and imposing their values and visions on others. The fate of Ward 2 is one of the earliest and most stark examples.

This is the Modern World

The zoning plan of 1925 was presented by the City's own Planning Commission, a blue chip, blue-blood cabal of west-side gents and two society doyennes. The new order proposed in the plan was less a prudent

zoning proposal than a scorched earth policy. It would permanently change the face of the downtown peninsula. More than that, the plan signalled the beginning of an effort to erase from a City Beautiful what the middle classes viewed as a political and social blight. From 1930 to 1960 it plunged part of the city, part of the life of the city, into shadow.

The most densely populated working-class community at the city core was known in 1925 as "Central School," or "Ward Two;" these days it's mostly known as "Yaletown." It stretched six long blocks from the warehouse district on the north shore of False Creek across the lands now occupied by the Vancouver Public Library's main branch, the Queen Elizabeth Theatre and the Post Office on Georgia, and Vancouver Community College, which stands where the Central School itself once stood. The wood frame houses were packed in tight, the eaves of one house only inches from those of the next. There was hardly need for a tram system: most workers had jobs in the railyards and mills on False Creek or along the Burrard Inlet docks. People walked everywhere. Much of life, despite the incessant drizzle, was lived in public spaces

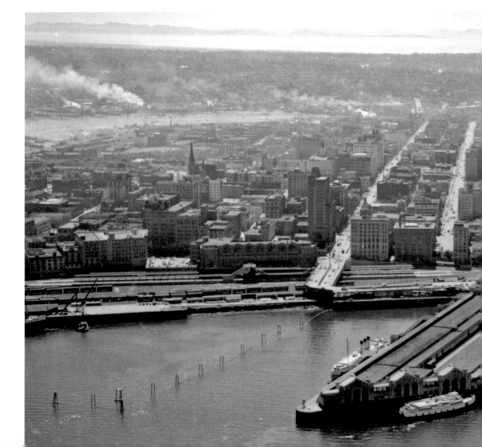

The broad avenues of the central business district Uptown contrast with the industrial bowl of False Creek, the source of the city's nickname, 'The Big Smoke', 1950.
ARTRAY PHOTO, VANCOUVER PUBLIC LIBRARY
VPL 81376A

and large gatherings were common enough. Near the centre of Ward Two was the Cambie Street Grounds, a football pitch and playing field that also functioned as the open-air meeting hall of the city's outspoken downtown working class (it was subsequently paved over for a bus depot and is currently a parking lot and proposed site for the new Vancouver Art Gallery). It was a sturdy blue-collar neighbourhood made up of seamstresses, millhands, dockworkers, boardinghouse-keepers, loggers, shopkeepers, and boathands. The Catholic Church loomed large here. Holy Rosary was opened on Dunsmuir Street in 1900 and gained cathedral status in 1916, but the Catholic Charities Building at the east end of Robson Street and other ancillary operations, many of which have long been abandoned, are evidence of what was once a densely populated working class neighbourhood that included large numbers of Italians, Irish, and French-Canadians.[14] There were other churches, to be sure, but Ward Two's most popular creed in the 1920s was socialism.

Vancouver—and British Columbia as a whole—has a long history on the Left. Nineteenth century industrial unionism produced local

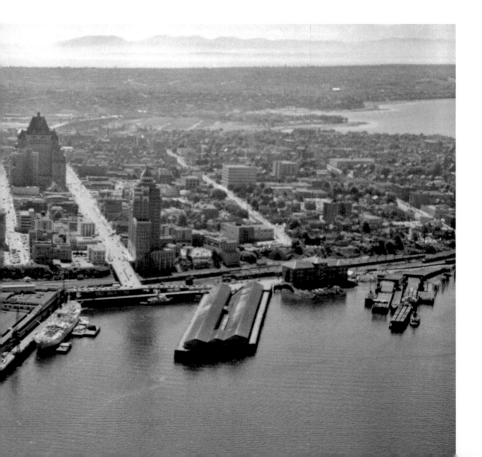

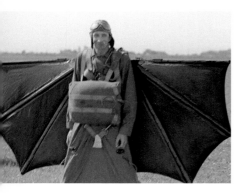

Photographer James Crookall haunted the local
airfields and came across this stuntman, whose
outfit anticipates that of the comic book Batman
by two years, 1937.

CITY OF VANCOUVER ARCHIVES 260-713,
PHOTO BY JAMES CROOKALL

support for the Industrial Workers of the World (colloquially referred to as "the Wobblies"), the One Big Union movement, a labour movement that reflected the low-skilled and highly physical work performed in the resource extraction sector and in transportation industries, and a political manifestation that included the Socialist Party of BC, the Cooperative Commonwealth Federation, and various incarnations of the Communist Party of Canada. On the docks, in the railyards, in the woods, on the water, and at the ballot box, organized labour and socialists of quite a few stripes posed a significant and resilient threat to the kind of unbridled frontier capitalism that had emerged in the mines and mills and canneries on the west coast. And, of course, they constituted a real and mobilized challenge to City Hall and the Provincial Government. Throughout the *Noir* era, popular protest—whether actually led by or just supported by definitive Lefties—would be regarded by the establishment as a menace to their authority. This was as true of demonstrations of support for the unemployed in the 1930s (regarded as a thinly veiled attempt on the part of the Soviet-controlled First International to foment global revolution in support of Moscow), or Communist Party picnics in the 1950s (seen as offering succour to the West's atomic-powered ideological foe in the midst of the Cold War). The Vancouver establishment tried many tactics to rein in their opponents, some of which were as brutish as a truncheon, some as subtle as civic planning.[15]

The 1925 Plan introduced "zoning." Ward Two was the first neighbourhood to be affected. It was designated a "commercial" zone, a lethal change. Commercial zoning effectively made it impossible for homeowners in the Central School area to borrow money to repair their homes. Financing for a new roof was now out of the question. In a neighbourhood where cedar shakes were being manufactured, this was a cruel irony. More to the point, the zoning effectively made it impossible for homeowners to sell their homes to anyone other than entrepreneurs who wished to operate a commercial business at the site, which was to prove highly unlikely in the Depression and the war years that followed.

The effect on the neighbourhood was devastating. The area framed by Seymour and Cambie, Davie and Pender Streets began a long, irrevocable downward spiral. Those who could, moved out of Central School; those who could not, stayed and suffered. Some homes were razed to make way for businesses but, more often, they were replaced with parking lots. There are only a handful of houses left now, but there

were hardly more standing even in 1960, by which time the once busy cluster of distinctive blocks and sub-neighbourhoods had been reduced to a checkerboard of gravel wastelands.

Was this outcome a matter of chance or design? Who stood to gain by the death of Ward Two? West-side wealth approved because, until 1935, Vancouver City Council was based on the ward system. Each of several distinct neighbourhoods elected their own representative. Gutting the radical vote from the downtown peninsula would have tipped the political scales to the right; moving to an at-large system was a little more risky but it delivered the same effect a few years later.[16] At the same time, the zoning process was an early salvo in the middle-class struggle for citywide respectability. Moving the local working class to airy and new east- and southside suburbs, it was hoped, would scrub clean the face of the city, free up room for more commerce and industry, and get the political troublemakers off the downtown streets.

The sanitizing of the city centre was part of a North America-wide movement to rationalize urban spaces. The so-called "Urban Reform Movement" of the late nineteenth and early twentieth century was not entirely spent before the Depression, and its mindset was to inform generations to follow. At the time, there were plenty of "progressives" keen to take a scalpel to the civic body.

One of the key figures in this efficiency drive was the American urban planner, Harland Bartholomew. In the late 1920s he was hired by Vancouver City Hall to develop a vision that would take Vancouver from its rough-and-ready-frontier-town adolescence into a more mature, modern stage of development. Although he was limited by Vancouver's waterfront geography and well-established land-use practices associated especially with the railyards and the docks, Bartholomew recommended in 1929 a pattern of zones that was essentially the same as what he would, over an influential career, recommend for hundreds of American cities.[17]

At the very heart of the Bartholomew plan was the notion of a "central business district." Like many other late nineteenth century cities in Europe and North America, Vancouver's centre was a moving target. For the first few decades of its history, the city hub was found at the lower reaches of Main Street, at the Burrard Inlet docks where the original lumber mills stood. The city advanced from there to the south, east and west, taking in residential spaces in Strathcona and Grandview-Woodland, warehouses and offices in Gastown, and commercial

avenues along Cordova and then Hastings. This layer cake at the old city core mostly worked, in that the newest strip stood on the shoulders of earlier generations. But there was always a tension in Vancouver between that old downtown and the one that the Canadian Pacific Railway and its allies in Ottawa, Montréal, and Toronto wanted to fashion to the west on an axis dominated by Granville Street. By Harland Bartholomew's day, the centre of gravity was being pulled from the eastside and from the CPR terminal at the foot of Granville to a newer West End fulcrum at Granville and Georgia. Bartholomew's proposals gave this usurping its legitimacy.

With that in mind, the stripping of Ward Two made practical sense. Zoning it for six-storey residential/industrial/commercial would provide additional lands for business centre growth.[18] It would implicitly, of course, require the demolition of the Central School neighbourhood. Opposition to this vision was, not surprisingly, regarded on the west side of town as deviant and seditious. Civic pride and a rationalized urban landscape demanded acquiescence.

Bartholomew's timing was awful. His plans were mostly stopped by the global depression of the 1930s. But his fundamental belief in a central business district survived and informed generations of City planners. What's more, his proposed Burrard Street Bridge came to fruition, designed in part to block out the visual pollution of industrial False Creek from the residences of the West End.[19] Otherwise, Bartholomew's legacy was a sensibility that defined some areas as ideal and others as problems.

Constructing Deviance

What happened to Central School (aka: Ward 2) is part of a larger story. Most of that tale took place between 1930 and 1960, although strands trail back into the Edwardian era while others poke their way into the twenty-first century. Vancouver artist and writer Stan Douglas has shown how the more recent but very evident decline of another, nearby neighbourhood—the Downtown Eastside—was tied to elite visions of the urban core as a last refuge for social, sexual, racial, and economic deviants.[20] Part of his analysis turns on the belief that the accelerated decay of Vancouver's oldest neighbourhood sprang out of a moral and health panic in the 1990s associated with HIV and AIDS. In point of fact, the story of the Downtown Eastside's decline is a much longer one, a saga of rolling scares dating back to the interwar period, but gathering

speed in the thirty-year interval bookended by the Wall Street Crash and the U-2 spy plane crisis of 1960. In those years urban life on the west coast was played out as a pitched battle between respectability and corruption. And that "corruption" could be found in the streets and in the halls of power.

The sanguine rationalism and cool efficiency of emerging bureaucratic agencies like the Planning Commission was sharply contrasted by other civic offices. Civic politics in Vancouver have always had a peculiar tenor. The province's largest city, it is not British Columbia's capital. It is separated from that seat of power by the Strait of Georgia, a not-insignificant body of water that

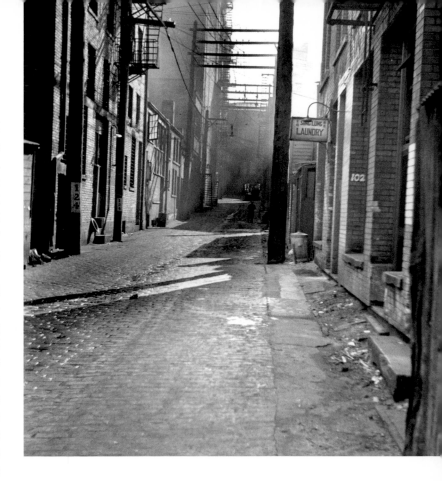

An East End alleyway, ca.1933.
CITY OF VANCOUVER ARCHIVES 260-1581,
JAMES CROOKALL

segregates the economic seat of power from the political seat of authority. And Vancouver is a long way from Ottawa. What's left? Civic politics. Politicians drawn from south- and eastside wards tended toward populism and local needs, but away from a larger civic vision. Election campaigns were boisterous and the candidates sometimes lacked decorum. Nowhere was this more visible than in the mayor's office. For years it was characterized by flamboyance, recklessness, and controversy. For that reason, the mayor's office offers a window into this period of conflict over social values and a vision for the city.

Louis "L.D." Taylor had been elected mayor seven times down to 1926. A journalist and newspaper publisher, Taylor was one of the city's great populists. He never met a crowd he couldn't pander to. Elections were held on an annual basis, so personalities like Taylor got plenty of chances to dazzle the voters. The first two-year mayoral mandate was introduced in 1926; in 1928 power slipped from Taylor's hands. W.H. Malkin, a wealthy businessman, successfully campaigned on a platform that included heavy law-and-order and civic morality planks. The contrast with Taylor, in this respect, is significant to the *Noir* phenomenon.

Taylor had for years adopted what might be called a laissez-faire attitude to crime in the city. If the crime wasn't serious—and Taylor considered gambling and the sex trade, for example, as largely unimportant—then Taylor was almost indifferent.[21] Also, Taylor became tarred with the brush of "ward-healing" politics: across North America local politicians were being caricatured as local bosses who spent civic budgets in ways geared to securing their position and benefitting their home ward first and foremost. The "ward-healer" was shorthand for City Hall corruption, a friend to local ethnic and criminal power brokers who could get the vote out when necessary but a foe to larger business interests. An increasingly monolithic, modernistic, and moralistic middle class in the 1920s found Taylor's style and substance increasingly intolerable; Malkin became their champion.

Gerry Gratton McGeer, an Irish-Canadian lawyer with strong ties to the Liberal Party, was to play a key role in the fall of Taylor in 1928 and thus helped set the stage for the *Noir* era. Allegations of corruption in City Hall and in the Vancouver City Police Commission produced an inquiry headed by lawyer L.S. Lennie. McGeer had garnered some populist credentials in a 1920s legal battle over discriminatory freight rates that punished British Columbia but he had been frustrated in two attempts to win election to federal office. He saw that there was hay to be made by using the Commission as a bully-pulpit, haranguing Lennie and Taylor alike. Mud was flung. Inevitably, some of it stuck to Taylor. The Vancouver that emerged from the Lennie Commission was ripe for a crackdown on crime and immorality. The pump had been primed for Malkin's crusade, but McGeer was to make a career on the backs of the twin spectres of crime on the streets and corruption in City Hall.

Before what we have called the *Noir* era was fully underway, then, its agenda had been set. Old dogs like Taylor were on the way out; new brooms like McGeer were on the way in. The sorts of things that Taylor had tolerated in a port city—brothels, Ma-and-Pa bootleg operations, and unorganized gambling dens—were now vilified. In order to improve his chances of winning back office in the 1930s, even Taylor bought into the panic over crime.[22] Fighting crime paid; and there was always a new fear on which to build a fresh crusade. Not much would change in this regard, whether under the mayoralty of a left-of-centre clergyman like Lyle Telford, or a red-baiter like C.E. Thompson.

Vancouver Past

When academic historians first took a serious interest in the City of Vancouver, they did so in a particular era. The year 1958 marked the centennial of the mainland gold colony and provided the occasion for a concerted effort to conceptualize the past of the province as whole. Whether one looks at Margaret Ormsby's classic *British Columbia: A History* (1958) or Alan Morley's more plebeian *Vancouver: From Milltown to Metropolis* (1961), the same themes emerge: with growth came improvement. The city, the province, and the country as a whole was on an economic upswing in the late 1950s, and its histories reflected the belief that this had been an inevitable outcome and a foretaste of future greatness.[23] In that light, the history of Vancouver was depicted as one of accomplishments; whatever did not fit that agenda was ignored or slighted. As the author of a 1961 overview wrote approvingly, "Many of [Vancouver's] people still prefer to forget that Vancouver was originally known as Gastown," a reference to the as-yet unrehabilitated brick-built warehouse district near the original city and the waterfront.[24] The shabby, scrabbling past was something to be left behind. *By Land and Sea We Prosper* was the original city motto: it might have served as the historians' as well.

By the 1970s historians of the city were moving away from boosterism and they developed a more critical approach.[25] In the first instance this involved finding the

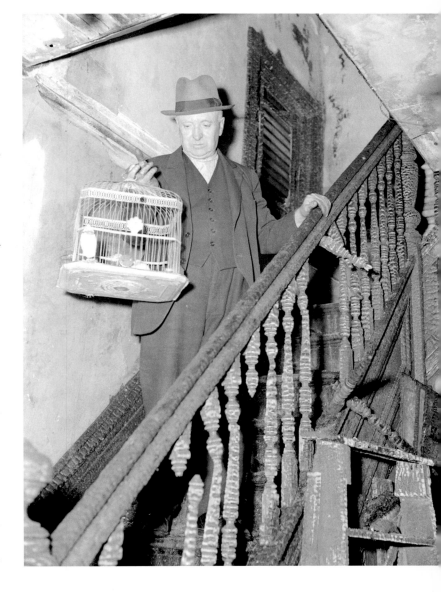

voices of Vancouverites (among them, the Chinese, the working class, and women) whose stories were not covered off in the earlier histories.[26] Eric Nicol pioneered this approach with a somewhat caustic local history that knowingly chided the pretentions of the wealthy and the wise.[27] It has only been in the last thirty years or so, however, that the basic premise of the "master narrative" of progress has been rigorously questioned.[28]

The present study stands apart from the existing literature because it focuses on a period that has been largely neglected, the years from about 1930 to 1960. Our concern is with the texture of life in the province's biggest city in a transitional phase. While there is much continuity through this period it is also one which is parenthetically enclosed by the Roaring '20s and the Swinging '60s, by the Suffrage Movement and Women's Liberation, by the interwar years and the Cold War years, by the 1923 Immigration Act that effectively terminated Chinese immigration and the rise of multiculturalism, by the collapse of the Vancouver Millionaires and the appearance of the Vancouver Canucks. In other words, the city passed from a phase in which older social bonds, behaviours, interests, and relationships were being loosened and/or abandoned through a period of intensified concern with order, conformity, structure, and restrictions. The new order—brought on principally by the economic and social crisis of the 1930s, the real exigencies of the Second World War, and the imagined exigencies of the Cold War—placed into sharp relief behaviours that were inconsistent with its goals of stability and security.

There was no shortage of problematic activities on which to pour public scorn. The decades between 1930 and 1960 saw a parade of moral panics. First there were the health panics: venereal disease, typhoid, tuberculosis, and even cholera were said to be symptomatic of a physically rotting city that was home to non-white races, the chronically unemployed, drug addicts, and the overcrowded poor. Public violence, smuggling rings, crime waves, heavy drinking, and the sex trade and the glamourization of sex in the city's trademark "supper clubs" and burlesque halls, all irritated a chapter of public opinion and launched one media and regulatory campaign after the next. Sexual identities and gender roles were increasingly policed and proscribed, the labour movement was declawed, and film and reading materials more aggressively censored. Teenagers—effectively a new category or subspecies of humans, one that supersedes older terms like "youths" and "juveniles"—were a growing

source of fear, particularly as the numbers of adolescents grew in the late 1950s due to the Baby Boom phenomenon. As well, the period was marked by fear of political enemies in the form of the Bolshevik revolution, the Axis Powers, and then the post-war Soviet Union, the People's Republic of China, North Korea, and Castro's Cuba, all of which framed contemporary understandings of Canadian political movements that were outside of the mainstream.

Who constituted Vancouver's "mainstream"? In the *Noir* era the battle to own "normal" was fought on a variety of fronts, some of which were subtle and complicated. Take, for example, crime and its depictions. As one historian observes, "crime and crime stories…can be especially revealing of the subjectivity of the law-abiding population." Put another way, what a community considers deviant reflects its own sense of normality. Crime stories, whether fictional or factual, are a source of identity and markers of the margins of what constitutes "society". Race was another boundary of difference. Asian-Vancouverites, along with Aboriginal residents had the flimsiest grasp on the rights of citizenship and thus were an easily patrolled edge. But the working-class (white or not) was also kept to one side when it came to things like freedom of speech and assembly. More subtly, womanhood was, as a whole, regarded as a kind of deviance: the *real* citizen was a white male, ideally "productive, responsible, and compliant."[29] Female sexuality and ambition were both regularly criticized and pushed to the edge of what was regarded by the media, politicians, and the courts as acceptable in the mainstream. This analysis was particularly sharp for working women who were accused of stealing the bread from the table of working men's families. The situation was worse still for homosexuals, whose "deviance" was almost unutterable before the 1960s. Doukhobors (the eastern-European immigrant sect who were branded as terrorists), the mentally challenged (who sapped the health of the race), non-Christians (implicitly disloyal to King, Queen, and Country)… these citizens were at best tolerated, though many were institutionalized and some were expelled in what one author wryly calls the "golden age of deportation."[30] So that leaves, who? Those for whom privilege and power is second nature, for whom the system created rights, and thus those who have rights to defend.

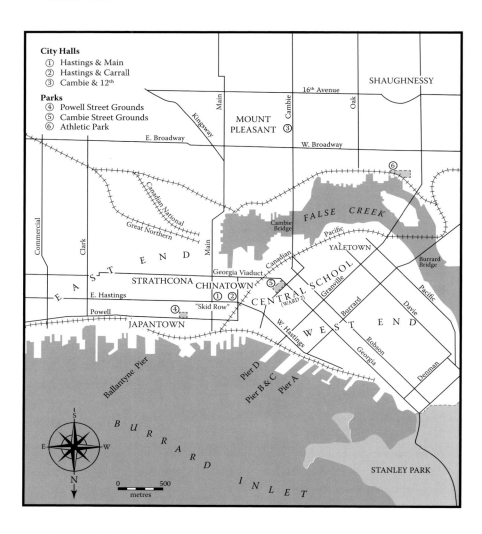

Map 1:
The view south from the waterfront,
ca. 1930-1960.

ROSS NELSON, 2011.

Reimagining Vancouver

Understanding Vancouver in the *Noir* era requires an adjustment of perspective. Readers unfamiliar with Canada's third largest city will need to know that its reputation as a guarded, polite, and somewhat boring city by the sea is one that was assiduously cultivated by journalists, historians, and politicians. The lens of *Noir* reveals the bare-knuckled harbourtown made up of no-go zones, shady entrepreneurs kept awash in cash by West End thrillseekers and East Van gangs, and music venues that fostered an emergent North American sound. American readers may see something familiar that disturbs their sense of exceptionalism. Canadian readers will find something here that challenges their sense of the city as civil, decent, *nice*.

Vancouverites of today, with few exceptions, don't know their town very well. It's a city of newcomers in which it is difficult to find anyone with deep roots. For some, that's a good thing. The distinguished Vancouver author and artist Douglas Coupland is on record as applauding this lack of history and Vancouverites' consequent freedom from the burden of the past. But that sort of thinking looks only to the future and is bound to end in tears. We would remind Vancouverite readers that this is a city of dividing lines and we challenge your notion of norms. Reorient your mental map. Vancouver *Noir* was a thriving East End at the heart of which was Main and Hastings. The Carnegie Library and Museum, City Hall, the City Market. The view from the suburbs imagines automobile approaches running from the south to the north along Main; you'll need to reverse that perspective. See the city from the Burrard Inlet waterfront, residential to the left, brick-and-mortar offices and shops to the right, dipping off to the Gastown warehouses and the grand Woodward's Department Store. That's Vancouver. You know it now as Skid Row, the Downtown Eastside, the poorest postal code in Canada. You've turned your back on that Vancouver because the money went with the Canadian Pacific Railway to the West End, the Canadians' *faux* Vancouver, the one that rises up from the CPR station, along Granville through a succession of grand, grander, grandest Hotels Vancouver, the Courthouse/Art Gallery, the Hudson's Bay store, and the cleaner, greener pastures of Kitsilano, Kerrisdale, Shaughnessy, and Point Grey beyond. One author, commenting on recent trends in street photography, points to "the class fractiousness of Vancouver whereby the East and West are indelibly marked and the Eastside, East End, East Van is the demonized, criminalized, orientalised zone of Vancouver's other...."[31] We argue that this is anything but news: the era of *Noir* ratcheted up the divisions between East and West, building on longstanding schisms to create an imagery of progress versus decay, integrity versus corruptibility, suburban modernity versus urban complexity, homogeneity versus robust diversity.

The West End (and its suburbs) stands as a critique of the British Columbian Vancouver. It is a critique of social class, race, gender, sexuality, morality, and household, a mirror held up to deviance. *Noir* is the fingerprint of that critique.

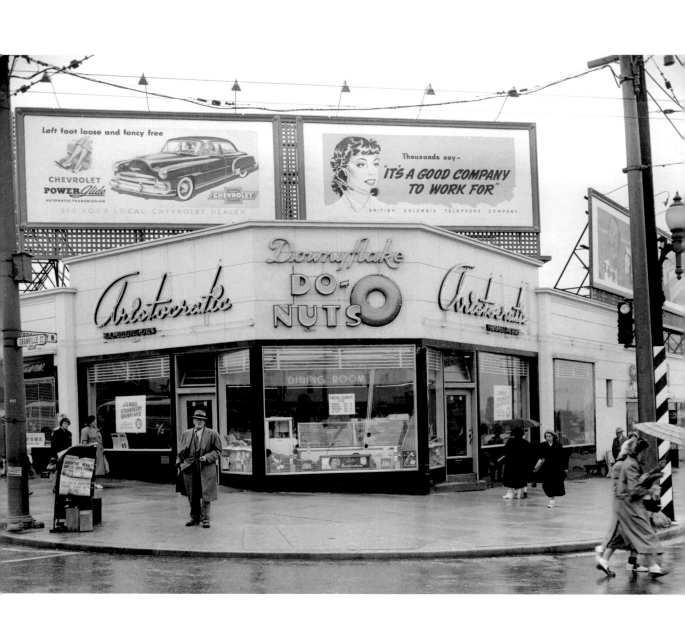

THE VANCOUVER WORLD: THE NOIR ERA

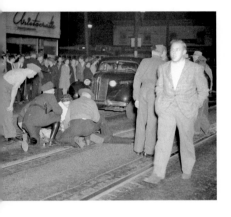

above: Treating a casualty casually. Granville at Broadway, 1943.

CITY OF VANCOUVER ARCHIVES 1184-744, JACK LINDSAY

left: One of Vancouver's trademark Aristocratic Restaurants, Broadway and Granville, 1951.

ARTRAY PHOTO, VANCOUVER PUBLIC LIBRARY VPL 81669

L IFE IN THE *Noir* ERA took place in public, and much of it in the streets. Cars had not yet completed their conquest of the city's arteries and Vancouver's sidewalks weren't broad enough to contain the crowd. Regardless of social class, as the photographic record shows, the citizenry showed up in public spaces for entertainment, outrage, celebration, and just plain out of curiosity. A more densely populated urban working-class core and more modest housing (along with no TV until very late in the *Noir* period) meant that the city streets of the downtown were the place to be. And the place to be seen.

And that was a problem for Vancouver's elites for whom fear of the crowd and the people of the streets has always been something like second nature. Civic leaders—particularly those on the west side— viewed "the street" as too spontaneous a space, too dangerous and corrosive to the vision of respectable society. The parade of mayors and councils were from 1930 through 1960 marching to a particular tune, one that was being called by "the real leaders of the city ... the gentlemen of the British Columbia Chamber of Mines, the provincial branch of the Canadian Manufacturer's Association, the Vancouver Board of Trade and the Shipping Federation."[32] Various expressions of elite attitudes toward the larger city include the Kidd Report of 1932, which called for massive public-spending cuts and limits on democracy, drew its leadership from the Board of Trade, Retail Merchants Association, and five Vancouver service clubs. There was, as well, the "Committee of 66" that sprang out of the Shipping Federation's "reorganization committee" in the 1930s, which included trademark upper-class Vancouver names like Van Dusen, Spencer, Woodward, Rogers, Buckerfield, Bell-Irving, and Malkin and in which Mayor Gerry McGeer was a leading voice. No less a figure of authority than Brigadier Victor M. Odlum was put in charge. Each of these bodies weighed in on social order issues, and not just on the business environment. From the early twentieth century on the collective interests

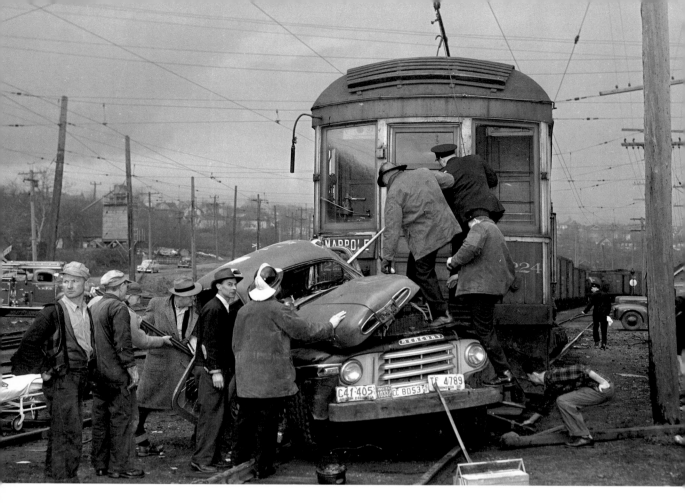

Trouble on the Marpole line, 1950s.

NEW WESTMINSTER MUSEUM AND ARCHIVES,
PHOTOGRAPH 3910002

at right/top:
Neither particularly fast, nor especially stealthy,
streetcars nevertheless seem to have snuck up
on a few pedestrians.

VANCOUVER PUBLIC LIBRARY VPL 8482

at right/centre:
A truck from the Dunsmuir Electric Company
takes the big sleep in the 1940s.

CITY OF VANCOUVER ARCHIVES 1184-3228,
JACK LINDSAY

at right/bottom:
The original Georgia Viaduct, often the scene of
accidents. In this case, a body has been thrown
over the railings by a speeding car, 1931.

CITY OF VANCOUVER ARCHIVES 99-2525,
STUART THOMSON

of west side elites turned to reform and control. Their goal was to make over the old milltown into a place fit for the middle-classes. They came to view the proletarian ownership of the city's downtown streets and its rich tapestry of lowbrow entertainments with both concern and alarm. They began to depict and understand the hard-knuckled streets and its glamourous neon-garlanded delights in *Noir* terms.[33]

The moral scares of the *Noir* era throw a spotlight on middle-class fears of both mass interests and the unregulated, out-of-doors spontaneity of the city. Whether it took the form of workers' movements, rowdy recreations, tired little beer halls, teenage "hoodlumism," or the popular cabaret scene, public tastes came under scrutiny. So, too, did the criminalized pastimes and enterprises of Vancouverites on the margin, particularly the sale and use of illegal stimulants, entrepreneurial approaches to sex, and incidents of public violence. These were all features of life in Vancouver, and many were captured on film in black and white to document what changes were, according to some, necessary.

There are *Noir* themes in this photographic record that reach deep into the city's past and tag along into its present. Combined, they present the essence of the *Noir* era. The neighbourhoods, the entertainments, the connections and the many more disconnects that characterize this period in the city's history were what photographers of the day were looking for. Something unique, something familiar, something bizarre and perhaps frightening, shocking. Vancouver *Noir* was this combination: the light, the dark, and the shadows.

The Look and Feel of *Noir*

The texture of this period and the characters that leant it a particular flavour are both unmistakeable and, retro-styles notwithstanding, unique to its own time. There was, for starters, the dress code of *Noir*. Hats. Trenchcoats. Furs. Beardless men with narrow moustaches and slicked-back hair. Women with perms in tight-fitting dresses. An unfiltered cigarette dangling from the corner of a mouth. Keeping in mind that this era enclosed the Great Depression, the Second World War, and a Cold War period of economic promise (not fully delivered until the 1960s), it's not difficult to imagine why so many of the faces in these photographs wear a seen-it-all-before insouciance. But these were also Hollywood's ascendant years. Visual images and models were everywhere and Vancouverites took plenty of cues from what they saw on the silver screen. Hollywood tried to get the look right, then the public mirrored it right back.

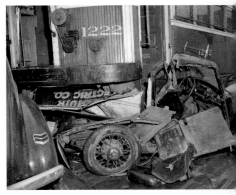

Every single day this was evident in the city's newspapers. The sins of the city were recounted in the most thrilling ways: "I know you hide your money…. Produce it and make it snappy," snarled a lone gunman. Printed in bold below a headline that screams, "Bandits in Week-end Orgy of Crime," this account from a December 1932 edition of *The Sun* both echoes and imagines silver-screen dialogue.

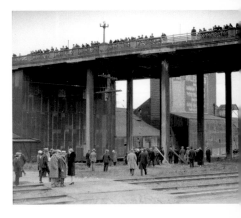

Cultures of youth spoke of different styles. While young males of East Van paraded their neighbourhoods in zoot suits, striking aggressive poses, their contemporaries on the Westside followed a more cerebral trajectory. Vancouver's first venue for jazz—the Jazz Cellar—opened in 1956 near Main and Broadway and its first "beatnik joint" followed in 1958 in Dunbar: the Black Spot.[34] What is widely regarded as Vancouver's first "rock concert" took place in 1956 at the Kerrisdale Arena when Bill Haley and The Comets played before 6,000 people. A year later, in August 1957, what may have been the first stadium concert in North America

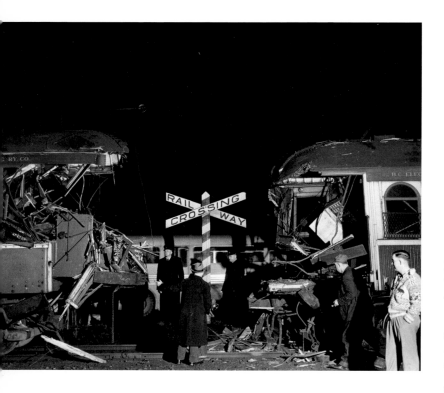

Two streetcars are pried apart after a head-on collision, ca.1950.

took place at Empire Stadium. Elvis Presley played for twenty-two minutes before a beyond-control crowd of 26,000. A near-riot broke out at the premature end of the concert, thus establishing Vancouver's credentials as a rock-and-roll town. [35]

Streetcars were another part of the fabric of *Noir* era life. Down to the 1950s, Vancouver had an extensive and far-reaching network of streetcars. They followed routes too narrow for the busses that came later, plunging down residential streets where there were few cars with which to compete.

While much has been written about the city's streetcar lines, it tends to be gilded in nostalgia. [36] Whatever virtues street railways had as mode of transit, they were often deadly. Collisions between streetcars and automobiles were frequent, but the steel frame and high platform of the streetcars stacked the deck in their favour. More grisly were the occasions when pedestrians fell under the steel wheels and were quickly quartered. The slick, rain-soaked streets of Vancouver guaranteed fatalities of this kind. Long before the fear of automobile accidents became an oppressive feature of modern urban life, the terror of falling under a streetcar was endemic. And for good reason.

Having said that, it is difficult to find reliable statistics on streetcar deaths. Is it possible that the streetcar was being vilified to make way for the automobile? Was the homely street-trolley yet another murderous part of the *Noir* landscape and vocabulary? Certainly the streetcar was under siege everywhere in North America in the *Noir* era and Vancouver was no exception. After the Second World War competition between public and private transportation intensified. A "Rails to Rubber" campaign, launched in Vancouver in 1944, gathered momentum quickly. [37] Even as new streetcars were being added to the fleet, plans were afoot to

replace them with buses and trolley-buses, both of which ran on the sort of smooth tarmac sought by car owners, rather than rails flanked by bumpy old granite cobbles, bricks, and blocks of wooden paving "stones." By the mid-1950s the trams were gone, with telltale results. One study suggests that the switch to electric buses crippled the Downtown: "The impact that this single act of modernization had on the Hastings area cannot be overstated—before its closure, over 65,000 transit users would flow through the Carrall Street Interurban Station each day." [38] BC Electric, the city's transit company, moved from the old downtown in 1955 to a new modernist skyscraper on Burrard, further gutting the city's old core.

The end of streetcars had a further effect on the neighbourhoods of Vancouver. Even now a tour of older streetscapes on the east and west side turns up the remains of corner stores, almost always placed right where the streetcar stopped. The corner grocery predated the earliest big food marts. There was one downtown food emporium—

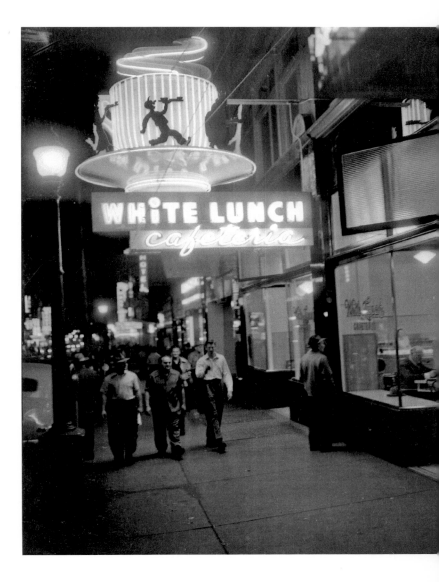

White Lunch Cafeteria, 124 West Hastings Street, 1950. A fine specimen of Vancouver neon.

Woodward's—and, although it remains a reliable source of nostalgia among long-time Vancouverites, it was the exception that proved the rule. On rainy mornings commuters might duck into the corner grocery, buy a newspaper or some gum or cigarettes, then race out into the drizzle to hop onto the streetcar. They could stop in on the way home to pick up a quart of milk, a tin of tomatoes, and the evening paper. The disappearance of the streetcar pretty much doomed that routine.

The automobiles of the *Noir* era may play the villain in this story but, really, who could resist their distinctive and alluring style? Early photos show the telltale spokes of the Model T and its contemporaries, but by the mid-1930s cars had become more smooth and sleek, more fully enclosed with narrower windows and thus more private inside. And, of course, with running boards. An often-published photograph from the Depression years shows a police car racing down Granville. As it passes a street-washing truck it sends up rooster-tails of spray that fly behind the feet of the four cops—two on each side—who are standing on the running boards, holding on for dear life, their eyes fixed on the mob scene they're about to wade into. The *Noir* era vehicles were an exuberant

Billboards and neon illuminate and cast shadows at Granville and West Broadway, 1949.

ARTRAY PHOTO, VANCOUVER PUBLIC LIBRARY
VPL 81056

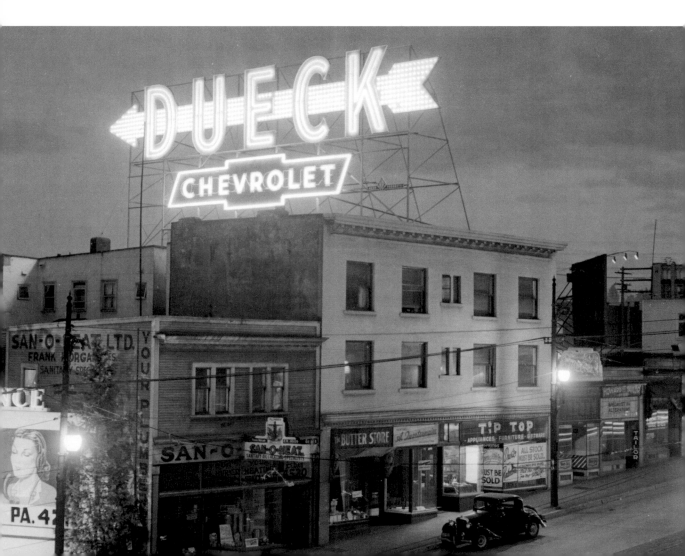

Depression-era rebuttal to Henry Ford's arch maxim: the customer "can have any colour he wants, so long as it's black." They embraced colour and went well beyond the functional, especially in the 1950s. They met all the safety standards of the day, because there were none.

The thirty years between 1930 and 1960 saw the automobile take control of the city's streets. One of the fascinating rituals of this era is the public funeral for fallen police constables, another example of how the automobile might be easily dismissed from the streets for a different purpose. But even this noble gesture fades in the 1950s, as the rights and expectations of car drivers grow. This *Noir* generation of automobiles, however, were still novelties in an era in which the rules of the road were still evolving—a reliable ingredient for mayhem. One 1933 account tells of how a scuffle between four men and "some autoists" near Hastings and Jackson in Strathcona ended with Carl Norberg, one of the brawlers, run down dead on the sidewalk.[39] A car was more than a set of wheels … it was a weapon. Police and newspaper photographs tell a harrowing tale of pedestrians cut down by cars and spectacular collisions between cars and other cars, streetcars, and even houses.

Reflected in the highly polished metal carapaces of the automobiles motoring through the city's avenues was Vancouver's special aura. In the 1920s and still in the 1930s, Hastings Street was Vancouver's "Great White Way," a title that would be progressively wrested through this period by upstart/uptown Granville Street. Vancouverites in the age of *Noir* were illuminated beneath cascades of neon light that lit up the night, every night. According to one source, there were 18,000 neon signs in Vancouver in 1953; "Only Shanghai had a greater concentration."[40] Every business seemed to vie for neon-drenched attention, from the huge grinning pig outside Save-On Meats to the delightful seahorse astride The Only (Hastings Street's cheap and cheerful seafood restaurant) and the globe atop the building that housed *The Vancouver Sun* newspaper. A former cabbie described the scene along Hastings Street poetically, "The lively scripted B.C. Electric Company neon above the entrance to the Hastings and Carrall main depot of the Interurban belt-car tramline. Their twelve-foot high regal neon crowns up top. And a favourite ally, the flaming flight of the red Blue Eagle up the street since 1944. How about the drama of hundreds of flashing white light-bulbs on the face of the very ornate 1917, 2000-seat Pantages Theatre (second location) that becomes the elegant early neon-art on the vertical marquee of the

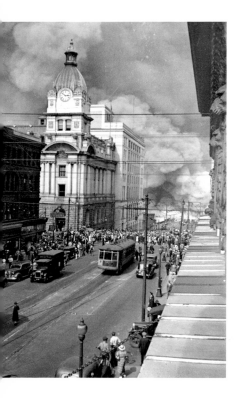

The view north on Granville as Pier D sends columns of smoke skyward, 1938.

CITY OF VANCOUVER ARCHIVES CAN N34, STUART THOMSON.

Beacon Theatre in 1930, transforming to the forty-foot high, curved-onto-the-roof, Hastings Odeon neon marquee by 1946 and converting to the Majestic in 1954. The high-turning, bright dance of the famous "W" in the sky over Woodward's mainmast store. Such a show-off! The cool smirk of the levitating Smilin' Buddha casting his spell on the late night slope of the strip. Always comical and mystic. What fun, then. The whole gang. Charms on a chain in bright street night."[41]

Hastings was a living, lively, welcoming street. From Main Street west it was dotted with vaudeville theatres and movie houses, including the Royal, the Rex, the Crystal and the Savoy Music Hall.[42] It was a neighbourhood of many delights, as East Van native and politician Bob Williams recalled, "…adjacent to the [B.C. Electric Building] was the Beacon Theatre which had been the Pantages Theatre before that. And when I was a kid the theatre across the street was the Rex; and the Lux lasted until relatively recently just further east. For a kid who would take that crazy [interurban] train into town, even from Grandview…it was exciting because Sally Rand and the striptease would be downtown; the fan dancers and magicians and all of the old vaudeville acts—it was really the centre of the world for a kid."[43] For refreshment, a Vancouverite on the city's strip could tuck into a plate of fried oysters at The Only and drink coffee in the Mount Shasta, the Common Gold, the Ovaltine, the New Station or the Blue Eagle, most of which were open twenty-four hours a day.[44]

The Waterfront

What gave Vancouver its particular tone, however, was the waterfront. This is a port city and the opening of the Panama Canal had driven home that fact in the 1920s. Grain elevators, millyards, and the Dickensian-looking Rogers' Sugar Refinery defined the industrial soul of the city, as did the shipyards, dry docks, and boatyards, the tugboats forever steaming from one assignation to the next, the lights of the ferryboats crossing the Inlet, those of the night ferry to Victoria, and the endlessly changing rotation of freighters that tied up along the downtown piers.

The waterfront touched the soul of the city in other ways. The smog and fog that settled regularly across the city centre was a constant reminder of its presence. False Creek's eleven sawmills grinding out continuous plumes of smoke, the rotten egg smell of the Yaletown gasworks,

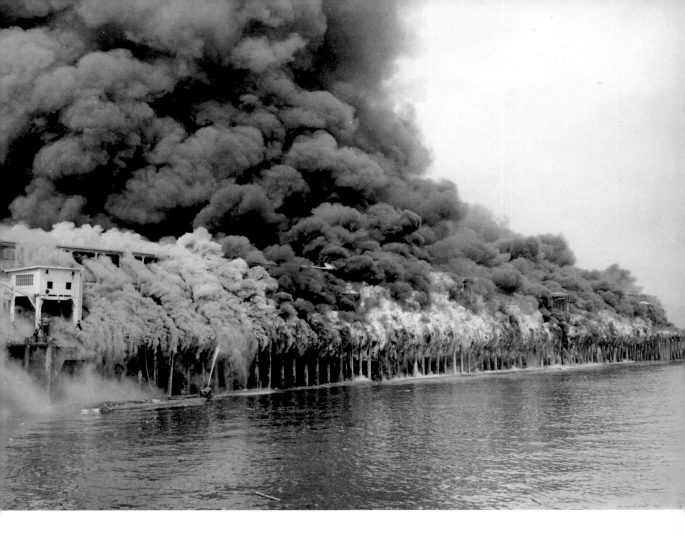

A view of the blaze from the waterfront, 1938.
CITY OF VANCOUVER ARCHIVES 152-12.5

the stagnant waters of False Creek, the oily slicks on Coal Harbour, and the sharp tang of creosote rising from the railyards that snaked in along the north, east, and south flanks of East Van, Strathcona, Chinatown, and Yaletown. In the middle years of World War II, more than 17,000 men and women worked in the city's shipyards, churning out "Liberty Ships" at the rate of one a week. In a city of barely more than 400,000 in the 1940s, this army of coveralled working stiffs connected the whole of the working-class community to the waterfront. So, too, did the goods— legal and illegal—that came into port.

The arrival of shipping from exotic ports was always a source of interest and comment. The newspapers carried notices of ships' comings and raised concerns that the port was teeming with smugglers. Vancouver had earned a reputation as a centre for the traffic of opium, which moved deeper underground in the early 1920s. One raid in the spring of 1930,

for example, seized nearly seventy-seven tins of opium with a street value reckoned at about $8000. The goods arrived on the Canadian Pacific steamer, the Empress of Russia and were being sold out of the Grand Hotel on Water Street.[45] The illegal production, movement, and sale of liquor was an outcome of 1920s prohibition, one that persisted for decades in a variety of forms. Much of that business, like the narcotics trade, was part of the waterfront scene.

The port city made its livelihood from what came ashore and what was shipped to other countries. The longshoremen and stevedores were the shocktroops of Vancouver's maritime economy, but that profound connection with the water made the east end vulnerable to disasters. Whenever a dock caught fire and its oil-soaked piles fuelled an inferno, or when a barge slipped loose and toppled a bridge, the working people of Vancouver felt the damage personally. It affected their jobs and communities. The fated crossing at Second Narrows was knocked out of commission in September 1930 when a log barge got jammed under the swing span, pushing it over as the tide continued to rise. Pier D, near the foot of Granville, caught fire in 1938 and its creosote-coated wood burned ferociously for hours. In March 1945 the Liberty Ship, *The Green Hill Park,* caught fire alongside Pier B. The explosion in her hold killed eight longshoremen, shattered windows throughout the downtown, and scattered debris well into Stanley Park.[46] The United Grain Growers elevators caught fire in April 1953, sending up a wall of smoke through the East End. Worst of all was the disaster in 1958 that saw a new, partially completed steel span across the Second Narrows collapse into the saltchuck, taking eighteen ironworkers and other labourers to their deaths.[47] And there were, as well, countless sinkings, drownings and other calamities. Invariably, there was always a crowd and a photographer on hand.

In retrospect, it is interesting to note that posh neighbourhoods with a waterfront view were disappearing by the 1930s. The Edwardian mansions of the West End were being abandoned by their wealthy tenants in favour of land-locked islands of leafy asylum in Shaughnessy, Point Grey, and Kerrisdale—far from the harbours that nourished the city economy.[48] This put greater distance between the working people of the city and their employers. It also spells out the different ways in which the city was perceived. *Waterfront* was not linked in the popular imagination of the day with million dollar views; it was synonymous

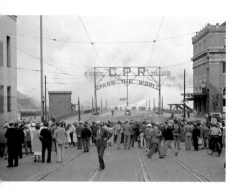

At the foot of Granville Street, crowds gather to watch Pier D disappear in flames, 1938.

CITY OF VANCOUVER ARCHIVES 260-893,
PHOTO BY JAMES CROOKALL

PURVEY • BELSHAW

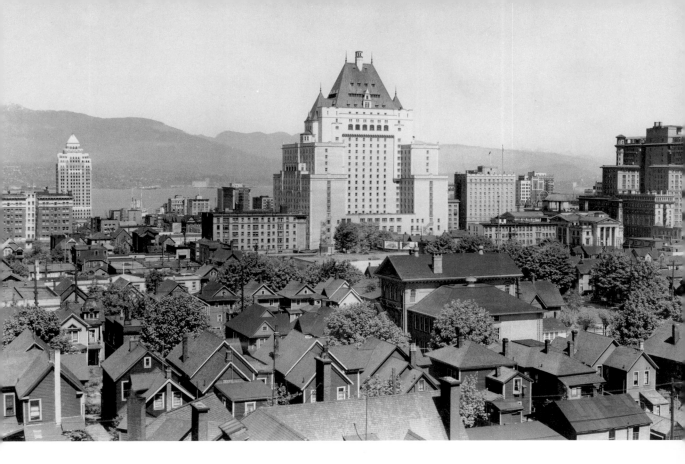

instead with industry, grit, smuggling, pollution, unsanitary floathouses and shanties housing the urban detritus, and organized labour ... classic elements in any *Noir* tale.

The Centre Cannot Hold

The movement of city dwellers to the suburbs was just getting underway in earnest in this period. The migration of large numbers from the city centre to outlying neighbourhoods accelerated in the 1940s and '50s and contributed inevitably to a decline in the downtown economy. The day of Vancouver's bedroom communities only came into full bloom as the age of *Noir* came to a close. But suburbia was built on a condemnation of the older parts of the city. In that sense, encouragement to move to the fringe helped construct an image of the centre that was decaying, morally dubious, unhealthy, and dark.

Of all the out-migrations from the old downtown, none was as significant as the removal of City Hall itself. Between 1886 and 1936 City 61 moved five times, but—until the last move—it was always located in the old Downtown. Down to the late 1920s it was located

next to Hastings and Main. From 1929 to the mid-thirties, it was housed in the Holden Building, an elegant brick office block on Hastings near Carrall. It was Mayor Gerry McGeer who had a vision for the building and was ruthless in seeing it brought to reality. In 1936 it was built anew on a ridge across False Creek from the city core. City Hall had fled the old centre. One authority on its design said "the hard-edged classicism of the austere white walls and column-like shafts appears in government buildings of the 1930s from Munich to Moscow."[49] Perhaps this suited McGeer's authoritarian disposition; to be sure, he wanted to capture in its design an "expression of the spirit of modern life," one that was evidently more suburban.[50] Harder to lay siege to, less vulnerable to the populist pressures of the city streets, the new City Hall was the hub of a suburban revisioning of the city it served.

As a whole, the city's centre in these years was shifting from an older downtown to a newer and more elegant uptown. Hastings Street was being eclipsed by Granville. Officially, the "west side" begins at Carrall Street, but that's in the heart of the old downtown. The jog in the alignment of streets at Cambie, at Victory Square, that's what really marks the eastside from the west. And the west side had been groomed well from the 1880s on. By the 1920s, the helm of industry and finance was in the heart of the area bounded by West Hastings, Granville, Georgia, and

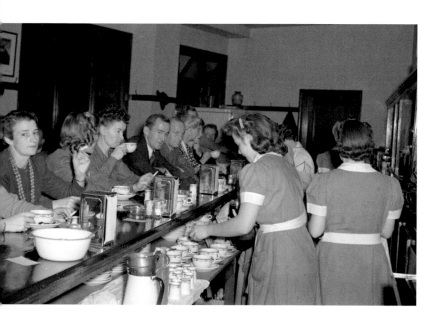

A busy downtown diner, 1942.
CITY OF VANCOUVER ARCHIVES 1184-1407, JACK LINDSAY.

Burrard. Within this golden zone or along its boundaries one would find the Vancouver Club, three *Hotels* Vancouver, the principal banks, federal buildings, the provincial courthouse, brokerages, and law firms. The Marine Building stands like an art deco exclamation mark at the northwest corner of this rectangle of riches, one that announced where the financial power in the city resided. It was perhaps the most distinctive landmark of the era, one that pointed in every way imaginable— right down to the seahorse motifs— to the city's waterfront orientation.[51] Completed in 1930, just as the

Depression got underway, the skyscraper (at twenty-one storeys) is arguably the finest example of art deco design in Canada, one reason why it went badly over budget. It was picked up (for less than half its construction costs) by Fred Taylor and the British Pacific Properties, the development firm that would champion the elite West Vancouver suburb with something like the same name, and the construction of the Lion's Gate Bridge. Taylor and his wife moved into what was meant to be the observation deck of the Marine Building. It was "an art deco masterpiece, with a soaring seventeen-foot ceiling, a *trés chic* black marble fireplace, and wood panelled walls. A giant chandelier copied from [the] Rockefeller Center in New York illuminated the living area."[52] The main drawback to this arrangement was the fact that the elevators were run by operators—originally pretty young women in playful sailor suits—and they booked off work at the end of each night, effectively imprisoning the Taylors 300 hundred feet up in the air until the morning. Nevertheless, as a symbol of the glamour that stood as a counterpoint to the poverty of the Depression, this took some beating. The penthouse passed into other hands in the 1940s. A wealthy but mysterious Mrs. Mary Fisher took it over and the penthouse attained some notoriety as a popular haunt for the city's young and heavy-drinking ultra-elite.[53]

Further to the west, in the West End proper, the piecemeal evacuation of the city's white-collar elite to the southside was underway, but they left behind their stately homes—which were converted to lodginghouses—and their Presbyterian, Methodist, and Anglican churches. The suburban tracts of landscaped avenues and the blocks of banks and business-suits in the uptown core were the shining model of what the old scruffy milltown could become. This was the light. In the east was the *Noir*.

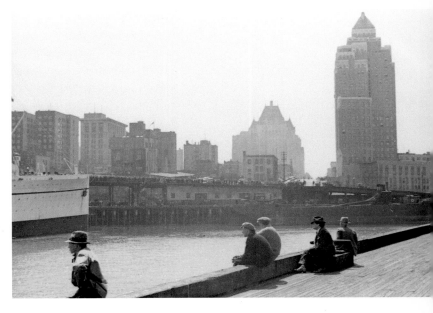

The view from Pier A in 1930, with the newly completed Marine Building in the background.
CITY OF VANCOUVER ARCHIVES 260-271,
PHOTO BY JAMES CROOKALL

East Van

The eastside of Vancouver is a rolling, flowing cascade of neighbourhoods and activities. The waterfront industries stretch its full length. So, too, the old downtown businesses and saloons, hotels and flophouses, coffee shops, soup kitchens, and groceries that run along either side of East Hastings Street. And there's more: the clutter of languages and eruptions of ethnic architectural touches; new immigrants with their tiny shops with a still-exotic clientele; old immigrants in their enclaves like Chinatown, Little Tokyo, or huddling at the WISE (that is, Welsh Irish Scottish English) Club. Union offices, massive brick schools, temples for every faith imaginable, and streets lined with compact woodframe houses on twenty-five to thirty-three foot lots.

Each neighbourhood had its own sense of direction, its own map. The Vancouverites who made their homes near to the waterfront were intimately tied to those fated spaces. The streets of the East End led to the mills and packinghouses on the Inlet and the switching-yards of the Canadian National and Great Northern Railways, east of False Creek. The gasworks, warehouses, and cooperage of Yaletown, and the shipyards and mills that ringed False Creek belonged to the workingmen and women of Central School, Mount Pleasant, and Fairview Slopes to the south. The lumberyards of the North Arm depended on the sinews of the residents of Marpole. Commuting to work typically meant walking, hopping a streetcar, perhaps riding a bicycle. This was starting to change in the late 1920s. The boom years had brought some stability to the waterfront and shoreworkers were among those who benefited. What had been an industry dominated by single men living in the rooming houses of the old downtown was becoming a workforce made up increasingly of married men with homes in Mount Pleasant or as far afield as South Vancouver.[54] Nevertheless, suburban "industrial parks" were a thing of the very distant future: the city's heart was still where industry lived.

We have already visited Central School (Ward Two), a working-class neighbourhood of shingle-sided two storeys, its skyline dominated by the Catholic Cathedral spire on Dunsmuir. To the northeast, pinned between the Georgia Viaduct warehouses and the thriving retail strip of East Hastings, stood Chinatown. The largest expatriate Chinese community in Canada, Vancouver's Chinatown was second in North America only to the diaspora in San Francisco. Chinatown grew up

mostly on the flats north of False Creek but by the 1930s stretched from Canton Alley—and sinister sounding Shanghai Alley—in the west to Gore Street in the east. The community was overwhelmingly male, due to historic circumstances (that is, labour recruitment practices) and the 1923 Immigration Act which effectively banned immigration from China. Cramped within borders imposed by City Hall, yet overflowing with services aimed mostly at an unmarried male constituency—that is, the sort of folks who would benefit from a laundry and a cooked meal—Chinatown enjoyed a complicated relationship with the rest of the city.

On Gore Street, where Chinatown ends Strathcona begins its march to Clark Drive. This was the core of the East End, a neighbourhood of closely packed working-class homes in narrow streets threaded with alleyways. To the east the roadways widen to a grid that orients toward the Inlet lumberyards, canneries, and the sugar refinery, all jammed shoulder-to-shoulder along uninterrupted ranks of docks, most of which are now long gone. To the south the growth of Strathcona was blocked earlier in the century by the False Creek mudflats, a slightly less grimy and suspect obstacle than the railway yards and warehouses that replaced them. Industry and rails thus fenced in the city's oldest neighbourhood.

Strathcona is Vancouver's doorstep, the community that welcomes newcomers, mostly from eastern and southern Europe and east Asia. Of all Vancouver's communities, it was the most diverse, including Chinese, Japanese, Russians, Jews, Italians, Blacks, Germans, Poles, Croats, Greeks, and others. It was also the least British: only a quarter of the men in 1931 and a third in 1941 were ethnically British, rather than the figure of three-quarters for the city as a whole.[55] The neighbourhood was liberally sprinkled with cold water apartments, cramped "coolie" housing, gambling halls, bootleg operations, communist organizers, racist agitators, newcomers on the way up and out, and Vancouverites on the way down.

Nothing says "tough neighbourhood" like a local boxer. Felice DiPalma (aka Phil Palmer) lived on 716 Hawks Avenue at East Georgia and racked up forty-one pro fights at Madison Square Gardens in New York. Jimmy "Baby Face" McLarnin, a Strathcona School product, beat the world welterweight champion, Young Corbett III, in a first round knock-out on May 29th, 1933, in front of a Hollywood crowd.[56] Inspired in part by McLarnin, another East Vancouverite—criminal lawyer (and much later Supreme Court judge) Angelo Branca—became a successful

middleweight boxer himself and started up the Queensberry Athletic Club in the 1930s. There followed a spirited and not-particularly-good-natured rivalry with the posh West Side's Meraloma Club.[57]

The city's largest cluster of Afro-Canadians settled on the western edge of Strathcona, into an almost legendary neighbourhood between Prior and Union Streets. Nicknamed "Hogan's Alley"—possibly for local musician Harry Hogan who lived at Union and Dunlevy, but just as likely for the contemporary comic strip of the same name—it was a lively block with a reputation for extraordinary music, no frills food, illegal liquor, a little pandemonium, sexual (mis)adventure, and sometimes violence.[58] It was also an intersection of Chinese and Italian settlement, the entranceway marked by Scat Inn, just off of Main and Union. The Scat offered up eats and entertainment, as well as whisky and beer at two-bits a glass each. On Prior, Buddy's Beer Garden was a centre for ale, whisky, rum, gin, and well-established craps and blackjacks games—penny ante and high stakes alike. The heart of Hogan's Alley, however, was just to the east, in the passageway behind the houses fronting Prior and Union, extending about two blocks to Jackson. Peter Battistoni recalled years later how "women who belonged to society" would wind up in the neighbourhood, looking for cheap booze and a cheap thrill.[59] Some never left.[60]

To the north of Hogan's Alley and Chinatown was the focus of the city's retail commerce and entertainment. Hastings Street in particular was a busy corridor of stores and cinemas, a space of trade and traffic that was regularly shared by most Vancouverites. By the 1930s the shopping strip stretched nearly the length of the city and its nearest suburb—from Burnaby Mountain in the east to the doorstep of the Marine Building. At Main and Hastings the city's races met at Vancouver's Four Corners. On one point stands the Carnegie Library—a gift from the Scots Pennsylvanian steel magnate, it was the city's premier library until the late 1950s—while

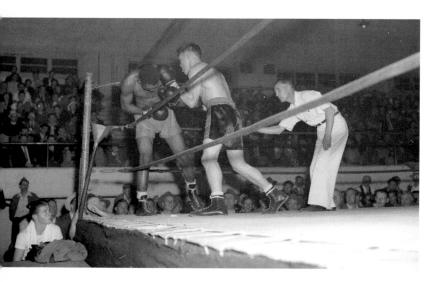

Boxers duke it out at the PNE Forum, ca. 1940-48.

CITY OF VANCOUVER ARCHIVES 1184-2536, JACK LINDSAY

banks and a towering brick professional building stood on the others. Until the 1930s, City Hall was located here, right beside the Carnegie Library. To the north of the Four Corners one found the headquarters of the Vancouver Police and Fire Departments.

The Hastings and Main downtown was, in the *Noir* era, still a vital and crowded commercial and social zone, albeit one on the skids. There were nightclubs and cinemas, vaudevillian opera houses turned into movie theatres, a multitude of small street-level shops and as many businesses one floor up, squat but reassuringly solid neo-classical banks, a few office buildings, and large department stores: Woodward's, David Spencer's (from 1948, it was Eaton's), and the Army & Navy. But it was *down*town, as opposed to the *up*town of Granville and Georgia. Peter Trower once described it thus: "Shabby, stolid, once-imposing office buildings rubbed shoulders with grubby hotels, pool halls and penny arcades. The companies that … rented these cut-rate offices were a mixed bag indeed: shyster lawyers; fly-by-night import-companies; wholesalers dealing in cheapjack novelty items; abortionists, extortionists, crooked tax-consultants and dubious jewellers."[61] For West Siders, a trip to Strathcona was "slumming." "In those days," one old-timer from the eastside recalled, nobody from the West End "would ever *think* of going down to the East End—wouldn't dare…."[62] Holdups were regarded as a regular occurrence. In 1932, for example, a two-week long wave of hold-ups involving guns and violence swept the downtown. Three men were arrested and sentenced for robbing office workers, service station attendants, a bus driver and a streetcar conductor of sums ranging from $4 to $25. These petty but frightening attacks were carried out by residents of, respectively, the Stanley Hotel on Cordova, 702 Union Street, and nearby 461 Keefer Street; the oldest was twenty-eight and the youngest "bandit," seventeen years of age.[63] On the whole, the better classes believed that the older downtown and

Crowds begin to gather on Hastings Street, Victory in Europe Day, June 1945.
CITY OF VANCOUVER ARCHIVES 1184-3044, JACK LINDSAY

The four-legged woman at the"Freak Show,"
Vancouver Exhibition (later the PNE), 1941.

Strathcona generally offered the city little more than easy thrills and danger. There was some truth to this.

The old downtown was the epicentre of all kinds of commerce, including the illegal kind. This was where much of the city's sex trade had long resided, on an isthmus of sin between the upscale West End and the respectable working-class of Grandview-Woodland and Fairview. It was also where the loggers who discharged from camp for the season found digs through the winters, drawn by inexpensive accommodations in flophouses and the promise of watered-down beer. The term "skid road" originally applied to the track along which logs were dragged out of the woods to Hastings Mill in the 1860s; over time the whole of the old downtown carried the tag of "Skid Road" or "Skid Row," increasingly a reference to social and moral decay.[64] The area around the Four Corners and south along Main Street was ground-zero for particular kinds of crime. The many flophouses and flea-bitten hotels, the abundance of beer parlours, the pawnshops and little, vulnerable coffee shops, and the substantial banks that grew fat off the savings of loggers and local businesses combined to create a zone in which robberies and murders took place regularly. In 1944, for example, three people were murdered in two separate incidents within a few feet of one another at the Four Corners. Both cases involved the proverbial lovers' triangle, although one was complicated by a bootlegging and "blind pig" operation (an illegal drinking establishment), in which the police found a substantial quantity of stolen goods.[65]

Hastings Street, with its gaudy neon lights, cheap eats and cheaper hotels, burly longshoremen, "fallen" women, and human derelicts was the *Noir* neighbourhood *par excellence*, the persistent milltown that shamed the metropolis. Malcolm Lowry described it in 1947: "No matter what yoke they were reeling under, no matter how starved, I believe you would never see in France … the appalling sights of despair and degradation to be met with daily in the streets of Vancouver…."[66] Lowry wasn't thinking of Arbutus and 41st—for him "the streets" meant only one part of town: the old downtown. Greg Marquis has described "the entire downtown" as a "segregated district, insulating the more comfortable working- and middle-class residential areas from disreputable behaviour."[67]

There was, still further to the east, another site of classic *Noir* encounters. Beyond the vast expanse of East Van proper, lay the city's kitsch paradise: an enormous tract of land given over to the low-brow

entertainments that made up the Vancouver Exhibition Association (re-named the Pacific National Exhibition in 1946 to mirror its more professional and business-like aspirations). In Vancouver's alphabet of deviance, nothing spelled *Noir* like "PNE." This was where gamblers could get a legal fix, betting on the ponies at Exhibition Park through much of the year. "Happyland"—the name given to the amusement park—was a thrill-seeker's paradise, with some of the best rollercoasters in the country. The PNE as a whole was a shrine to low tastes. It exercised a powerful attraction on local youth, but it was also a magnet for hustlers and hucksters, gamblers and carnies,

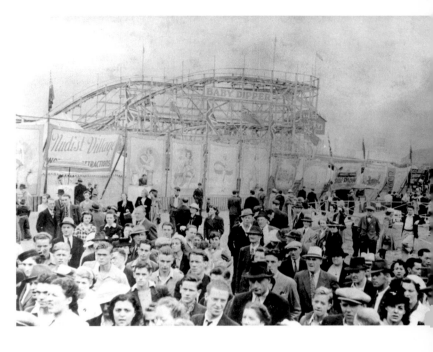

Crowds outside the Exhibition's Nudist Village, 1940.

CITY OF VANCOUVER ARCHIVES 180-792

pickpockets, embezzlers, racketeers, and forgers. Its denizens promised low budget diversions to the gullible and immature. The police made regular appearances at what they must have viewed as a honeypot for criminals. Counterfeiters were familiar targets. But it was the rides that drew the greatest attention, especially when something went badly awry, such as a fatality on the Giant Dipper in the mid '30s when a teenager was thrown from the ride after trying to do a handstand on the car. Other features, like the "Nudist Camp" and the touring "Girly Shows," continued to defy wholesome values. Strip acts were a regular part of the PNE during the 1950s, at least partly managed by Isy Walters, the owner/operator of the Uptown nightclub venues, the Cave and Isy's Supper Club. There was nothing subtle or discrete about this: visitors to Isy's Black Tent Show had to "pass between the legs of a fifty-foot plywood cut-out of a black burlesque dancer at the tent's entrance on the fairgrounds."[68] They were one reason the PNE was regularly reckoned to rank among the top ten fairs in North America. The crowds returned annually, like sockeye to the Fraser River.[69]

The most explicit celebrations of deviance at the PNE, however, were the "Freak Shows." A bizarre yet almost universal element of mid-

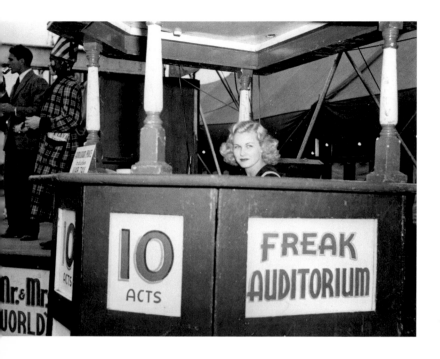

An attraction at the Exhibition, 1941.
CITY OF VANCOUVER ARCHIVES 180-1020,
GORD SEDAWIE

twentieth century entertainment, exhibits of unusual humans performed the same disturbing yet reassuring function at the PNE as it did across North America. "Freak shows," as one study puts it, "are guided by the assumption that *freak* is an essence, the basis for a comforting fiction that there is a permanent, qualitative difference between deviance and normality, projected spatially in the distance between the spectator and the body onstage."[70] Offering shock, titillation, and amazement to the curious, Freak Shows encouraged the customer to gawk at other humans whose differences reasserted the crowd's "normalcy." Difference and diversity in this era was consistently a source of amazement, disgust, and reassurance, and certainly not the multi-layered "mosaic" it became in the 1970s and '80s. Circuses and sideshows like those at the PNE created a common vocabulary of images in Canada and the United States, one that could always fall back on a bearded lady or a fatman as a stock—if dark—character as a way to define the abnormal and, thus, the normal.

The question is: what was "normal"? On the eve of the Depression the city was divided by class and that, more than anything else, determined how everyone fit into the picture. And these divisions could be seen in the fabric of neighbourhoods. For example, there were a half-dozen cricket ovals in Vancouver: four of them could be found south of False Creek and west of Main, one at Stanley Park's Brockton Oval, and the last in South Vancouver near Fraser Street (at the time an almost bucolic suburb). There were none in the East End. By contrast, eleven of twenty baseball diamonds were located on the eastside and in the old Central School neighbourhood; the largest outdoor sports facility in East Van was Con Jones (later Callister) Park, a five thousand-plus seat stadium built mainly for soccer but sometimes used for rodeos, too.[71] Denman Arena (which had seats for ten thousand) burned to the ground in 1936

and was replaced in 1948 by the Forum at the PNE grounds. [72] When the British Empire Games came to Vancouver in 1954 Point Grey got the Empire Pool at UBC; East Van got Empire Stadium, not a mile from the Forum. To be sure, all classes gathered at these venues but there's no mistaking a pattern: rugby and cricket in the west; soccer, baseball, and trackside gambling in the east. Working class pastimes were clearly not the same as those enjoyed by the city's middle classes.

These various neighbourhoods were, together, the stage on which Vancouver's campaign against sin, crime, corruption, deviance, and socialism was played out. What they had in common was an orientation toward the waterfront, a simple reality that was not shared by the residents of chi-chi Shaughnessy or upmarket Kerrisdale.

Attacking the East End

The *Noir* era witnessed dramatic changes in the ways in which the city viewed itself. More particularly, it was three decades in which the city turned on itself and began consuming its own. This may have begun with Ward 2, but it certainly didn't end there.

In 1937 Alderman Helena Gutteridge headed a civic housing survey project that discovered more than five hundred Vancouverites (including no fewer than seventy-five children) living in waterfront houseboats or shacks built on piles. This was not a chic artsy alternative to more conventional housing: some of these homes were located in the midst of sewer seepage and outfalls along False Creek, others could be found in equally grim situations on the Marpole foreshore of the Fraser River and along Burrard Inlet as far east as Boundary Road. [73] These latter accommodations constituted "filthy and distressing" conditions, according to the Gutteridge survey. The *Daily Province* reported "few of the habitations are equipped with sanitary conveniences. Hardly half are equipped with electric light." None were connected to city water supplies. [74] The shanty owners didn't pay taxes, true, but they got nothing like basic utilities either. [75] Nor, technically, were they actually *in* the city. They were right at the margin: physically, socially, politically, and aesthetically. Despite the bad press, the Marpole, Coal Harbour, and Cambie Bridge shantytowns, along with those at the north foot of Kaslo and Renfrew Streets, were described by some commentators as "bright and cheerful." Regardless, as early as 1930 the City began to purge the "eyesore" floathouses from Stanley Park and a newly acquired extension—

Deadman's Island. Eviction notices were served on more than three dozen households. The idea that people—especially poor people—would reside in what the elite saw as its jewel, the largest urban park in Canada, was unacceptable. Small but well-established communities in the Park—mostly regarded as "squatters" came under fire, literally. Having cleared out the remaining settlers in Brockton Point, their houses were torched in 1931 by the city Fire Department.[76] These were merely the first of the clearances in the age of *Noir*.

The City Fathers had no difficulty buying into the idea of eviscerating communities that crossed the line into unacceptability. Vancouver's history is marked by a succession of attempts to define and redefine who belongs and who does not, beginning—at the very least—with the arrival of European capital and industry. First Nations villages and rancheries were shoved out of the way and new, foreign definitions of "citizenship" were introduced. In the late nineteenth century racialized neighbourhoods began to appear and were repeatedly under attack. Race riots and anti-Asian protests mark every decade from the city's inception to the 1950s. There were, as well, industrial disputes that turned violent, including general strikes in 1918 and 1919, and unemployed workers demonstrations in 1922. But the 1930s mark the beginning of a period

Houseboat settlement on Coal Harbour, 1953. Cleared a few years later to make way for the Bayshore Hotel.

ART JONES PHOTO, VANCOUVER PUBLIC LIBRARY VPL 82308

of different, more direct assaults on the "outsider." Complicating matters was a redefinition of racial inclusion that took place as fear of global communism, or the Red Scare, replaced the Yellow Peril. Generally, this was a period in which the East End came under repeated scrutiny, its residents attacked by police and the power of City Hall. In a compressed period of time, whole neighbourhoods disappeared or were put up on the chopping block of urban renewal.

In the age of *Noir*, Vancouverites talked openly and fearfully about "Race." It was a category, but one that was granitic, cold, impoverishing and dehumanizing. The literal "categories of race" include those in Police Commission reports which parsed out arrest rates; topping the list were those whose "Racial Origin" was "Canada" (at 3,783 in 1948), followed by China (2,374). The criminality of the British was less obvious because the English and the Scots had their own categories but a combined total of 2,850. Incorrect readings of data at the time suggested that the British were more law-abiding than the local-born and significantly more so than the dependably crooked Yellow Peril. In these years the complexion of prejudice and racialized experiences were in flux but, on the whole, the Asian communities of the East End witnessed little improvement. White hostility toward Asians was direct and ugly, and systemic and stealthy. The lives of Asian Vancouverites were parenthetically enclosed by what the language of *race* would tolerate and what it would not. Insofar as the Asian community of these years lived almost entirely in the old downtown and the East End, this language of discrimination reinforced an image of deviance that tarred the whole neighbourhood.

Vancouver's Chinese community has roots in the building of the Canadian Pacific Railway, but it was forged on the anvil of anti-Chinese legislation. Head Taxes (beginning in the nineteenth century) were originally meant to discourage Chinese immigration but the tax eventually became something of a cash cow. A largely male community to begin with, Chinatown's peculiar demography was ironclad in 1923 by the Dominion Government's Immigration Act. This legislation creating an Asian bunkhouse community at the centre of Vancouver in which benevolent associations or *Tongs* often stood in for family. In 1931 nearly ten per cent of Vancouver's population was born in China, twice the share of Seattle in 1930.[77]

As a ghetto, Chinatown had its own separate rules but was constantly under the watchful and critical eye of the nearby Vancouver

"Slums" in the 300 block of East Cordova, 1943.

CITY OF VANCOUVER ARCHIVES 1184-638, JACK LINDSAY

World Tower (later rechristened the Sun Tower, named in both instances for the rabidly anti-Asian daily newspapers housed therein). *The News-Herald* (born 1933, expired 1957) and *The Province* newspapers also stood sentinel near the boundary between the East and West Ends at Cambie Street and encouraged white journalists to produce bales of newsprint freighted with stereotypes that further segregated the whites from the non-whites, the Asians from the non-Asians of Vancouver.[78] The Yellow Peril was only the most familiar and hackneyed of racist slurs and moral panics in the arsenal of the press pedlars. "Lowly John Chinaman" served as shorthand for every member of a community of "pedlars in silk slippers."[79] Worst of all, fears of a "white slave trade" orchestrated by sinister Chinese gangsters preying on young white women made for another familiar narrative. Lured to Chinatown opium and gambling dens by the promise of an edgy thrill, the cream of Euro-Canadian womanhood was in terrible danger. Young white men, likewise, often turned to Chinatown or the many bars on Carrall, Main, and East Hastings for cheap beer and women: one journalist's account from 1954 describes this environment as "a festering collection of decrepit buildings, cheap cafes, three-dollar whores and the bulk of Canada's drug-addict population."[80] Their corruption was a worry, but less a source of fanatical terror than what might befall good, white girls. Little wonder that Vancouver's racial divide proved so resilient.

There were plenty of moral panics in the first half of the twentieth century in Vancouver but none had the persistence and vehemence of the white establishment's fear of the Chinese. In 1928 W.H. Malkin was elected mayor, running on a platform that called for action against Chinese who dared to move away from their prescribed neighbourhood.[81] Efforts on the part of the Chinese to establish homes in other neighbourhoods continued to meet with opposition from white community leaders and City Hall for years to come. Residents and business groups in South Granville, Kitsilano, the West End, Dunbar, and Little Mountain all protested the intrusion of Chinese into their midst. When one young and upwardly mobile Chinese-Canadian couple attempted to breach the whites-only enclave of Dunbar/Southlands in 1941, two dozen of the local residents showed up at City Hall with an eighty-three-name petition.[82] Alderman Halford Wilson took up the issue, as he had many times in the past, working diligently to zone against residences in businesses, effectively using building codes to keep Chinese grocers

in Chinatown. He lobbied, too, for a licence quota for Asian businesses. Even some members of the white elite of the province found his tactics distasteful and "smacking of 'Hitlerism'."[83] Nevertheless, the tide was still flowing with the likes of Malkin and Wilson: Chinatown continued to serve as the city's principal Asian barrio, and its poverty and differentness were simultaneously created by city regulations, decried by white journalists and elites, and celebrated by tour organizers.[84] On this front, not much changed before 1956 when anti-Asian discrimination in real estate purchases skidded to an end. But this speaks only to the experience of those Chinese-Vancouverites with money enough to dream of life far beyond Pender Street. For the majority of their community, things were considerably more restrictive, even bleak.

The 1930s began as a desperate decade for many in the Chinese community. Badly neglected by Vancouver's civic officials—who felt it was improper that Chinese unemployed should receive the same amount of "relief" offered to Euro-Canadian unemployed men—large numbers became dependent on the Pender Street soup kitchen. So meagre were the rations that 175 men are thought to have starved to death between 1931 and 1935.[85] Many Chinese Canadians did not share in the improved economic conditions that came with the Second World War. Overcrowded housing in Chinatown survived into the 1950s, the worst of which was described colloquially by non-Asians as "the black hole of Calcutta." As well, according to historian Jill Wade, the denizens of East Pender Street's boarding houses experienced "insufficient light and ventilation, fire danger, disease risks, vermin, deficient sanitary facilities, structural disrepair, and poor maintenance."[86] The image of the emaciated, bent Chinese male—an unhealthy sign of difference in mid-century Vancouver—would be slow to disappear. And if the Depression didn't kill them, demographics might. The number of people in the Chinese community was falling as time claimed the lives of more and more men, as the ban on immigration from China blocked the possibility of a new generation arising in the community, and as the prospects of marriage with non-Chinese remained highly exceptional. The dying outnumbered the birthing by two-to-one.[87] By all signs, there was trouble in Chinatown.

Perhaps the apparent collapse of the Chinese community allowed some white Vancouverites to take their prejudices in a new direction. As early as the mid-1930s, the very things that distinguished the old Chinese

Floathouses at the foot of Columbia Street on False Creek, 1940s.

CITY OF VANCOUVER ARCHIVES 1184-1893, JACK LINDSAY

enclave as a foreign and venomous community poised to strike at the bosom of Vancouver, suddenly became exoticized. Chinatown was now, according to some, a fragment of "the inscrutable Orient," suitable for tourism and slumming. This transformation of the way in which the Pender Street neighbourhood was presented began with the Jubilee celebrations of 1936 and scaled the heights of absurdity rapidly. What was deviant and frightening was still deviant, but now it was also marketable and swathed in neon lights like those decorating the Ho Ho restaurant or the Kublai Khan nightclub. A 1943 promotional blurb drew attention to the exotic qualities of Chinatown, equating deviance from what was familiar and safe (to the white audience) with excitement and intrigue: "Chinatown! pungent, mysterious, wicked Chinatown where one bought jasmine tea and wicker furniture and rich embroideries, always with a feeling of danger lurking in the dim shadows of the dark shops."[88] Despite plummeting arrest rates among the Chinese community by the 1950s, there was no sense in the (white) public mind that the moral hazards of Chinatown had disappeared, just that they were no longer as great and were, as a consequence, safe to romanticize into something that fit more closely to the standards of *Noir*.[89]

Westsiders' ignorance of the Chinese community was an almost inevitable outcome of the social barriers the former erected. By 1941 only one-in-twenty of the Chinese population in Vancouver had been allowed to become naturalized Canadians, a discrimination championed aggressively by Vancouver's Members of Parliament in Ottawa. Although Asian males received voting rights in 1947, full rights of citizenship were denied the Chinese-, Indo-, and Japanese-Canadians (as well as the Aboriginal community) until the 1960s, after the age of *Noir*. Politically, these peoples had a voice, but it was muffled.

The westside-eastside schism kept the communities apart on a day-to-day basis. For someone like Tong Louie, the second son of pioneer food wholesaler, H.Y. Louie, the prospect of attending the University of British Columbia in the 1930s was exciting but daunting: "Tong knew that few Chinese students ventured onto the developing campus.... In 1931 there were twenty-seven Chinese students in the entire university, ten of whom were women. After all, what was the purpose of a university degree when you were barred from the professions for which you trained? [...] As a young person who had grown up within the strict confines of

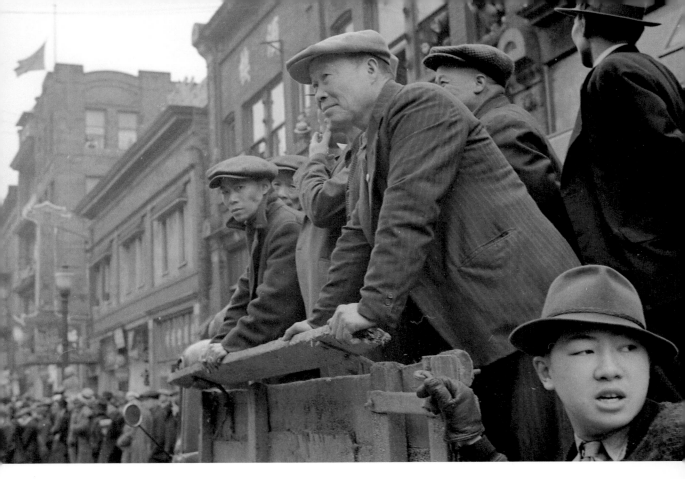

Chinatown, confronting the occidental world full-on for the first time, Tong could not avoid a heavy jolt of cultural shock...."[90] These were years—and they were to last well beyond the 1960s—when Chinese-Canadian membership in Vancouver's leading community and business associations was forbidden (as it was for other Asians, for Jews, and for women as well). These solitudes were slow to shift substantially and "race" continued to define the dynamics and the shadows of Vancouver.

The residents of Powell Street, a few blocks to the north, fared much worse than the Chinese population. This was "Japantown," "Japtown," "Little Tokyo," the centre of the city's eight thousand-plus Japanese community. Even though the old neighbourhood lost ambitious and upwardly mobile Japanese-Canadians who moved away in the 1920s and '30s, it maintained a role within the larger local Japanese diaspora until the crisis of 1942-45. After years of being a target of noisy white racist attacks, the Japanese-Canadian community came under a more purposeful siege following Canada's declaration of war against the Japanese Empire. The process of documenting, detaining, concentrating, and shipping into

Onlookers in Chinatown for a funeral procession, 1939.
CITY OF VANCOUVER ARCHIVES 260-1008, PHOTO BY JAMES CROOKALL

the Interior and beyond took in almost all of the Japanese-Vancouverite population. Some were put into cold storage at the PNE barns for weeks until being sent east. Despite cooperation from the Japanese community itself—desperate to ensure that families were not broken up—the treatment of the "enemy aliens" by the state was sometimes brutal. Evacuees quarantined in the city's Immigration Sheds on the waterfront rioted on 13 May 1942. Tear gas and bullets were used to subdue the protest; thereafter, the evacuation was accelerated.[91] The end effect of the Internment and the post-war "repatriation" to Japan of as many as 10,000 Canadians of Japanese ancestry was to destroy Little Tokyo. The neighbourhood was, by all accounts, one of the tidiest in town before the war. By 1945 it was economically and socially gutted; only the husk of a community remained. Japantown now had a haunted feel about it, as though it had fallen between the cracks of history. The neighbourhood begins the period as "exotic" but ends the era as traumatized and tragic: in both regards classic material in the language of *Noir*.

An early morning mist lifts over a neatly parked line of confiscated cars at the Exhibition grounds in 1942. Their owners await expulsion to concentration camps in the Interior.

CITY OF VANCOUVER ARCHIVES 1184-88,
JACK LINDSAY

The last in a list of attacks on the east end began in the late 1940s. In 1948 UBC professor Leonard Marsh issued *Rebuilding a Neighbourhood* as part of a study supported by civic and federal funds. In this context, "rebuilding" was a euphemism for demolishing and replacing with a newly planned and sanitized community. Words like "blighted," "slum," "derelict," and "unsavoury" were tossed about in a debate about the future of the area between Main Street and Clark Drive, a debate that scrupulously avoided engaging the local residents. This campaign targeted Strathcona as a whole, but in particular it had Hogan's Alley— the Afro-Canadian neighbourhood on Union Street between Gore and Main—and Chinatown in its sights. The venerable mythology of the

Yellow Peril was trotted out and the entire neighbourhood was tarred with the broadest of brushstrokes. A local MP, for example, rose in the House of Commons in 1957 to tell his colleagues that "The whole of the area contributes to the toll which we pay in disease, crime, delinquency and vice."[92] And, evidently, the old downtown generated far less civic revenue than it might. Which was no surprise given that city managers had systematically neglected the infrastructure in the neighbourhood. The potholed streets with their open ditches were only the most visible signs of disrepair. Sewers, sidewalks, street lighting, and other civic amenities that were taken for granted elsewhere in Vancouver were in need of repair, replacement, or even introduction.

Profiling, 1942 style.

The city neglected the downtown East End because, from the Marsh Report on—if not earlier—there was a sense that spending on anything other than policing was simply throwing good money after bad. By the mid-1950s, plans for freeway construction through the downtown were well-advanced.[93] This initiative would have razed much of Chinatown and the old warehouse district known as Gastown (described as "overpoweringly squalid and sinister" in the post-war years).[94] Skid Row, long perceived as an obstacle to moral, racial, and economic progress (not to mention public hygiene) was now an impediment to the movement of cars. Hogan's Alley was subjected to by-laws intended to make residence in the neighbourhood a decreasingly feasible proposition; almost inevitably, it fell to the wrecking balls and cement mixers to make way for the Prior Street on-ramp of the new Viaduct.[95] As the age of *Noir* came to a close, the community of Strathcona—still mostly made up of Asian-Canadians and immigrants whose first language was not English—was rallying in protest against this project. Their victory was still a few years away; in the meantime

they could hear the rumble of bull-dozer engines, idling as they await-ed the call to destroy whole city blocks. These purges (proposed and achieved) underline the divisions within the city and the struggle of one group to impose its vision on the rest of Vancouver.

The West End

According to Ray Culos, born in the East End in 1936 and raised on Union Street in Strathcona, "I never knew where the West End was until I was much older."[96] These were two solitudes, separated by social class, location, and race. Photo-essayist Bill Jeffries sagely observes of Vancouver, if Chinatown and Strath-cona "was our 'local colour,' its inverse was the ordinariness of the rest of the city."[97] What could be found in the West End, if one ven-tured there from the East End, was "normal." And yet it had its own kind of *Noir*.

Notwithstanding the west-sid-ers who intermittently took advan-tage of the lower pleasures offered downtown, their view of the city centre operated on a different axis. The uptown crowd of financiers, brokers, bankers, lawyers and other

Granville and Georgia, 1956. The Birks Clock on the corner was the Uptown meeting point and landmark.

LEN MCGREGOR PHOTO, VANCOUVER PUBLIC LIBRARY VPL 83040B

professionals who commuted in from south of False Creek, might seal a deal at the Vancouver Club, catch a cocktail over lunch at the new (third) Hotel Vancouver after it opened in the midst of the Depression, or dine and party in style in the 1950s at a supper club like the Cave or the Palomar. At the end of the day they could hop into their cars and spin

south under the art deco arches of the Burrard Bridge (opened in 1932) or test their nerves on the wooden deck of the Granville Street Bridge (rebuilt in steel in 1954). Their manicured lawns and domestic servants awaited them far from the madding crowd, as did the city's golf courses and country clubs the morning after. For them, Vancouver was neatly organized city streets, classy hotels, and tennis whites. We see some of this city in the intentionally stylized *Noir* era photographs of James Crookall and Jack Lindsay. In one, a pedestrian in a fedora and a trench-coat walks along the broad avenue of Georgia Street, two Hotels Vancouver and the Courthouse in sight. The sidewalks are not crowded or littered. There is open space and architectural whimsy. It is all sturdy and solid, like a fat bank account.

The elites of the city took advantage of the 1930s Depression. While the resident and the transient unemployed fought in the streets against the VPD, the well-to-do bought materials and labour cheap to build extravagant homes deep amidst the manicured reaches of Shaughnessy, Point Grey, and Kerrisdale.[98] Against this trend, the downtown saw little construction: the third and last Hotel Vancouver was the outstanding exception until the 1950s. There was even less growth in the old city centre to the east. Overall building permits for dwellings, too, plummeted after 1929 from nearly two thousand in that year to as few as 190 in 1934; the 1929 level would only be reached again in 1941 and 1944-49, after which time it once again fell.[99] The fact that housing starts were so few and far between in a city that was—Depression or not—still growing points to the fact that conditions for many were worsening.

Evidence of uneven enjoyment of wartime and post-war prosperity was abundant at the swanky second Hotel Vancouver. The gorgeously Edwardian, fifteen-storey tall building at Granville and Georgia was part of a complex of high-end pre-Great War structures at this intersection that included the Birks Building with its landmark clock, the Vancouver Block, the Vancouver Opera House (alias the "Old" Orpheum and, later, the Lyric Theatre), and the Hudson's Bay Department Store. Of these, only The Bay and the Vancouver Block remain. The Canadian National Railway built this iteration of the Hotel Vancouver, but soon found itself entangled in a commitment to construct another hotel (the current version) in partnership with the Canadian Pacific Railway Company. That work was completed during the 1930s and Hotel Vancouver II enjoyed a brief stay of the wrecker's ball by serving as a barracks for

the duration of the war. In January 1946, returned soldiers organized themselves into an "occupying force" and took over the mothballed building, demanding that it be repurposed for veterans' housing, which it was for two years.[100] In 1949 it was finally demolished and, like much of the rest of Harland Bartholomew's Central Business District, the site languished for decades as a dreary, dank, gravel parking lot.

As the fifties opened, the downtown was—like the old Hotel Vancouver site—set on a course of decay. According to David Spaner, "The city had come through the Depression and the war and, in the 1950s, was trying on a pretence of picture-perfect normalcy."[101] But the end of wartime industries, the sudden expansion and extension of the suburbs, and an official view of the downtown as a space that would be

A movie promotion on Georgia Street, near the Strand Cinema, 1940s.

CITY OF VANCOUVER ARCHIVES 1184-2274, JACK LINDSAY

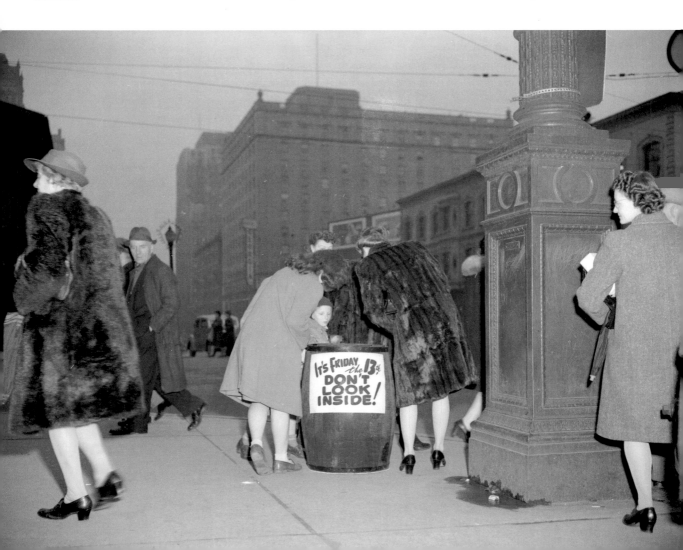

improved by elevated highways and overpasses, combined to sap energy and people out of the centre. When photographer Fred Herzog arrived in 1953 he found Vancouver "engagingly seedy and colourful."[102] One force that contributed to making the city picturesquely decadent was the loss of population from the downtown.

The rise of post-war suburbs needs to be seen in the context of *Noir* era concerns. As the city became seen as increasingly dangerous and dirty, the appeal of a residence beyond the city limits grew. Point Grey, Kerrisdale, and Dunbar absorbed some of the movement within Vancouver proper but it was to Burnaby and to the North Shore that larger numbers would move in these years. In the late 1930s, an exclusive suburb was created on the hillside above West Vancouver: "British Properties." Linked to the city by the Lions Gate Bridge, this suburb—and others like it—wouldn't take off until they were ornamented with shopping malls, the first of which was Park Royal.[103] Brentwood Mall in North Burnaby followed shortly and is noteworthy for having an Eaton's department store in 1961—the first suburban branch in the country. Like Park Royal, Brentwood accelerated the growth of housing tracts, in this case pitched at a lower-middle-class community with roots in the downtown and the eastside of Vancouver who wanted to move beyond Vancouver's eastern Boundary Road.[104] The dispersal of retailing, the creation of bedroom communities, the building of highways and bridges to facilitate movement to the periphery all had the effect of draining energy, activity, and money from the city of Vancouver. People left because of the decay but their departure only made it worse.

Accounts of crime in Vancouver's newspapers carried a *Noir*-ish tone throughout this era. One front page story from 1947 with the headlines, "Paid Killers Sent to BC, Court Told," deserves to be quoted at length:

A fantastic story of paid killers operating in Vancouver's underworld, of dope caches hidden in Stanley Park, and of an octopus organization whose tentacles stretched down the Pacific Coast to Arizona and Mexico, was unfolded Thursday from a General Hospital bed.

The story was recounted soberly by John Van Treel, a U.S. secret agent who led a detective story existence as a bogus member of a narcotics gang.

Van Treel, whose year-long association with the Vancouver underworld and its international connections helped to convict the notorious white-slaver and dope trafficker, "Professor" R.D. Linville in the U.S., was testifying before Magisrate Mackenzie Matheson in the Elliott-Rossi case.

Herman E. Elliott, 44, 1235 Bidwell, and Louis Rossi, 37, 2305 West Twenty-Second, are charged with possession of narcotics.

POSED AS A DEALER

Van Treel gave his evidence in General Hospital where he is recovering from a heart attack.

An undercover agent for the U.S. Federal Narcotic Bureau, Van Treel lived in three countries to collect evidence.

His story, as he told it in the hospital court, was as tough and exciting as a bit of Raymond Chandler detective fiction.

He told how he posed as a narcotics dealer in Vancouver and took part in numerous opium parties which went on in hotels and apartments in this city.

DOPE CACHES IN PARK

Then he described his attempt to get Elliott to make a trip to Mexico, "where I could get set with people in the trade."

Seattle, Portland, California and Arizona were all mentioned in Van Treel's evidence.

"Professor" Linville was to call Elliott, who was on an opium party, and discuss the proposed "Mexican buying trip" with Elliott and Van Treel, the U.S. agent said.

Van Treel testified of a drive to Stanley Park with Elliott and said the latter stopped, walked into a bush and came out with a six-ounce jar of opium.

Back in the hotel room, Van Treel was given a "bindle," a small quantity of prepared opium wrapped in paper.

Fifteen "bindles" were submitted as Crown evidence.

The drugs were turned over to the RCMP by Van Treel who

"simulated the effects" of smoking and eating opium.

Crown Prosecutor Gilbert Hogg told how Mounted Police wired an opium party room and listened to recordings made next door.

During the investigation, Van Treel said, the Vancouver family of another U.S. secret agent "had been threatened."

He testified that Rossi told him "there's some pretty good stuff here—you can double your money on it."

"From Ottawa Holdup"

Rossi told him that one dealer had three to four thousand capsules of heroin and was asking $3.50 to $4.50 a capsule.

Rossi told him that most of the "stuff" had come from a holdup of an Ottawa drug company and suggested the dealer "might come down for quantity."

Van Treel told how he went to Rossi's home and was given a "sample capsule" to prove it was good. The "sample" appeared in crown evidence.

Rossi told him, Van Treel testified, that Elliott was "hiding out" because "two heavies (paid killers) were in town."

Racing Racket

Van Treel then returned to the U.S. and declined Rossi's offer with a wire in code which read: "Never mind the cabin, cannot make it this trip."

Van Treel also told how the ring operated a racing racket in Portland, Oregon, which wired pre-finish results to Vancouver.

He described a hidden walkie-talkie that gave "last stretch" standings to a downtown base. These pre-finish results were wired to Vancouver.

After a legal tussle, with Angelo Branca defending Rossi, the case was adjourned until next Thursday. W. J. Murdock is acting for Elliott. Mrs. Elliott, also charged, died several weeks ago.

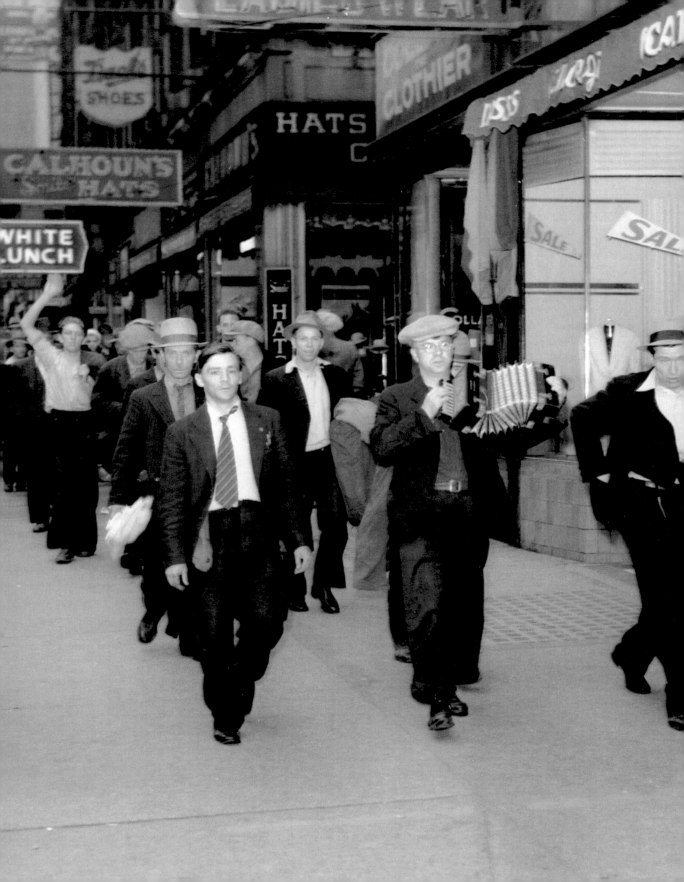

THE LEFT COAST: PROTEST AND UNREST

"Tuesday night, and it is still pouring with rain, coming down in buckets full. In the past hour three Catholic lads have come to St. Vincent's Home without a dry stitch on them. Every bed in the Home is occupied; the sisters have found a corner and a blanket for one…if we had fifty rooms here they would all be filled…"[105]

above: Some 17,000 men and women rivetted and welded ships in the industrial slough that was False Creek during the war. At a launch in 1942.

CITY OF VANCOUVER ARCHIVES 371-1127

left: Protesters from the Post Office and Art Gallery sit-down strikes march down West Hastings Street, June 1938.

PROVINCE NEWSPAPER PHOTO, VANCOUVER PUBLIC LIBRARY VPL 1301

V ANCOUVER HAS A REPUTATION for being unhurried, laid back. In the age of *Noir* it was a city on a constant coffee jag. Labour conflict and protest was part of the story. British Columbia's working people organized early on into strong unions fronted by an ideologically charged Vancouver Trades and Labour Council. A "Free Speech" riot took place in January 1912 when Vancouver Police charged into a crowd of several thousand at the Powell Street Grounds, swinging whips and truncheons.[106] There were general strikes in 1918 and 1919; in the latter the VTLC's leadership had to fight for their lives as an anti-labour mob stormed their offices with an eye to hurling people out the windows. The 1920s witnessed a growing mobilization of labour but it was the 1930s and a global Depression that ushered in an age of pitched battles. The period opens with a string of violent confrontations on the streets between working people and the unemployed on one side arrayed against the police on the other. It ends with the first of many rock concert riots: when in 1957 the crowd at Empire Stadium charged the stage after an Elvis Presley concert ended prematurely, beer bottles rained down on city police defending the stage and hand-to-hand combat ensued.

East Vancouver crowds were tough, bred on waterfront labour and millwork. The kind of jobs to be had were dangerous and unreliable, especially forestry and fisheries work. These industries were difficult to organize, as well, because they were subject to invasions of less skilled workers. And because the work was, itself, mobile. Logging camps moved one season to the next and, as in the fisheries, workers had to go

where the work was. The routines of Vancouver's roughest working class involved a season in the woods, on the water, or in mines followed by a winter's sojourn in the hotels and taverns of East Hastings Street. These were men who were used to being out of doors. No surprise, then, that the Powell Street Grounds, the Cambie Street Grounds, and the streets served as their meeting halls. They were pros at loitering and watching the world go by, easily roused to anger, and unwilling to bend to any authority that treated them with disrespect.

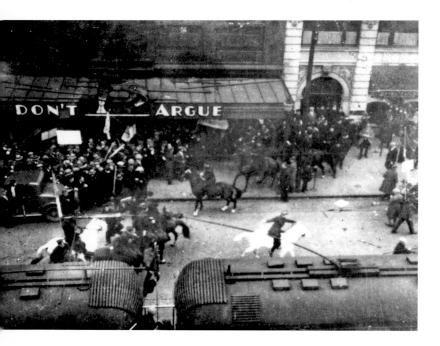

The Don't Argue was a tobacco shop which allegedly ran a good bookie business on the side. It also served as a good backdrop for a riot, n.d.

VANCOUVER POLICE MUSEUM, 887

Throughout the *Noir* period, working class and left-wing organizations were frequent targets of reformers, politicians, newspaper owners, and the VPD. The story of working people in this period is complex and expansive, but even a glimpse such as this can point to the many ways in which workers and their movements were displayed as deviant.

The Dirty Thirties

In the 1930s economic collapse and record levels of unemployment dominated the headlines across North America. But Vancouver experienced the Depression in its own way. The number of waterfront workers fell by forty percent from 1928 to 1932, as the amount of grain and lumber passing through the port collapsed.[107] It was reckoned in 1932 that 34,000 of 250,000 Vancouverites were jobless, many of them hanging on by their fingernails to their homes. Some of these "locals" were part of the annual round of shipping out to log or fish or mine and then winter in Vancouver's boarding houses and cheap hotels, pockets loaded with savings; when the cycle simply stopped and they could not find work, they found themselves trapped in the city centre. The resident unemployed tramped the city streets every day, looking for handouts, queuing for civic relief or a soup kitchen meal, dining in downtown cafes where city relief scrip was hon-

oured. As well, tens of thousands of transient unemployed from east of the Rockies—overwhelmingly young, single males—took one look at homelessness in a frosty prairie winter and headed for the milder weather of the west coast. [108] The non-resident unemployed made impromptu camps along Burrard Inlet, under the Georgia Viaduct, near False Creek, and on the edge of the rail yards in Strathcona. These "hobo jungles," thrown together out of odds and ends of wood, canvas, and sheets of scrap metal, contained roughly one thousand men and were regarded by the local press and the authorities as a source of radical and medical infection.[109] City Relief Officer H.W. Cooper agreed that the jungles were "a hot-bed for every form of disease, physical, moral and social."[110]

The numbers tell only part of the story. In the 1930s, unemployment was not offset by social programs designed to maintain civic order and create the illusion of economic normalcy. This was a generation that regarded "the dole" as an emasculating handout. But it was also a desperate cohort made up, in very large measure, by men who were battle-hardened during the Great War. Within a short time the population came to reject the notion that unemployment was a sign of personal weakness and they came to accept that the economy was, in fact, in ruins. This pitted a large body of desperate and tough individuals against a system that caricatured their claims on it for support as so much Bolshevism.

The moral panic around the unemployed—that is, the fear that they constituted a genuine menace to society—was fed in some degree by First United Church's Reverend Andrew Roddan. Describing the scabrous encampments of the unemployed under the Georgia Viaduct, he said: "When I stood in the jungles and saw the conditions there I did not know whether I was in Russia or in Canada." It was, he added to drive the point home, "a breeding place for Bolshevism."[111] Offering Christian redemption as an alternative to revolution, Roddan cultivated a visible presence among the unemployed at his soup kitchen and was lauded from one end of town to the other.[112] In the *Noir* era, however, he quickly became a caricature, albeit a mostly positive one: a larger-than-life crusader who stood up to eastern Canadian indifference. As an advocate for the unemployed who called upon the well-heeled to tend to their needs, he also highlighted the presence of an army of unemployed and their potential to do harm if neglected. According to some, crusaders like the Rev. Roddan "did more to keep the red element in check than

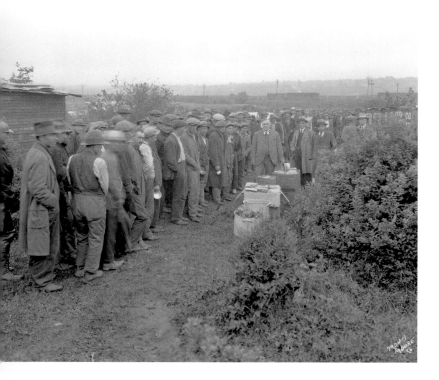

The northeastern edge of False Creek was the City Dump. Rev. Andrew Roddan mans a mobile soup kitchen in one of several hobo jungles, 1931.

CITY OF VANCOUVER ARCHIVES RE N4.4, W.J.MOORE

any other influence." Roddan, never shy of a favourable word in local press, agreed and claimed "One civic official publicly stated that if it had not been for [First United's] services [to the unemployed] there would have been bloodshed on the streets of Vancouver."[113] Ironically, his very efforts furthered the moral panic that contributed to the marginalizing of the poor in the city by making them more fearsome than perhaps they were.

Roddan was not, of course, the only cleric working this particular field. The Central City, Beulah Rescue, Sunshine, Beacon Light, and Gospel Light Missions, along with the Salvation Army and others all filled a gap in the social welfare system during the Depression. The Water Street Mission on Columbia Avenue had a nightly attendance of eighty-plus, with a Sunday congregation of around one hundred; each week the Mission fed roughly four hundred. In all there were twenty-eight churches and mission halls along with three United Church temples operating between Campbell Avenue and Cambie Street. This was Roddan's backyard, his competition. Although he might take credit for beating back the communists, he did less well against the other churches: Sunday evening attendance at First United fell from six hundred and forty-nine at the start of the Depression to fewer than two hundred on the eve of the war.[114]

Did Roddan and other "skypilots" of the day save the city from radicalism? A litany of strikes and demonstrations and riots says otherwise. Getting out support for protest wasn't difficult with this exceptional concentration of unemployed in the city's East End. The *Noir* era begins with vastly more people on the downtown streets. Together the unemployed, the underemployed, the hobos, the dispossessed, the sympathetic, and the outraged gathered in public spaces to listen to powerful, galvan-

izing speeches by radical leaders, union organizers, and evangelicals.

The demonstrations and riots had begun, in fact, on 5 December 1929, not two months after the Wall Street Crash. On that date the Vancouver Unemployed Workers' Organization, organized by the Communists, marched more than four hundred jobless men through the downtown streets.[115] Two weeks later a body of unemployed stormed the city relief office near Central School and the day after that hundreds marched in a show of solidarity.[116] The Communist Party organized more than one hundred demonstrations in 1930 alone. [117] On 22 February 1932, six thousand unemployed took to the streets, marching across the old downtown from Powell Street Grounds to Cambie Street Grounds.[118]

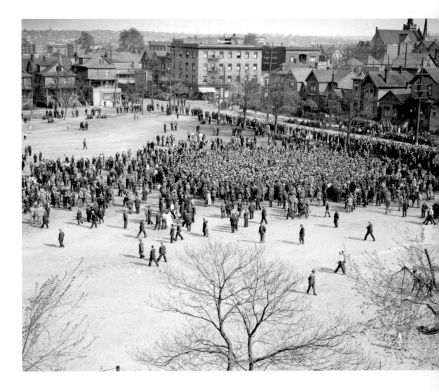

May Day protesters crowd into the Powell Street Grounds, 1932.
CITY OF VANCOUVER ARCHIVES 99-2643, STUART THOMSON

City Hall had two responses to unemployment: the dole and the nightstick. Of the latter, it has to be said that the City tried to use some finesse in its application. All public marches required a permit, and the City used its exclusive control over the permit system to ban many an outdoor protest. But that also meant that any event that took place without a permit was effectively illegal. Charges of civil disobedience were generously bandied about. Chief Constable W.J. Bingham was never reluctant to send in whip-swinging mounted police, and he often leant a hand. He also mounted an undercover operation, sending agents into more than a hundred unemployed workers' and "Communistic" meetings in 1930. Although he was satisfied that "Soviet Agents" were ineffectual, by June 1931 Bingham was seeing an increase in demonstrations involving between two thousand and five thousand protesters. A few months later, with more than fifteen thousand unemployed registered with the City, hundreds living in the hobo jungles, and with fears of typhoid on the rise, the City and the Provincial Government successfully

pressed Ottawa to evacuate the non-resident unemployed to mountain camps in the Interior. As the Depression stretched on the City responded with tighter requirements for financial relief to the local unemployed as well as the transients. The principal prerequisite was "destitution," not mere joblessness. In 1934 alone nearly fifty-three thousand investigative calls were made on the homes of Vancouver's unemployed by a special division of the City's relief office, some of which resulted in deportations and criminal convictions where fraud was indicated.[119]

The spring of 1935 saw a renewal of conflict between the working class and the Vancouver elite. At the establishment-only Vancouver Club, the city's wealthy and powerful gathered to plan a response. They heard a call to arms against the communist menace. The response of the city's elite was not for the faint-hearted. The "Committee of 66" was a who's who caucus gathered under the banner of the Shipping Federation. Their "mouthpiece" was local radio personality Tom McInnes "who made no distinction of any kind between unions and communists."[120] A further outcome was the establishment of the Citizen's League, led by ex-military types and Colonel C.E. "Doc" Edgett, who had served as

Vancouver's working-class movement demands the release of prisoners from the city jail, 1938.
IMAGE C-07959 COURTESY OF ROYAL BC MUSEUM, BC ARCHIVES.

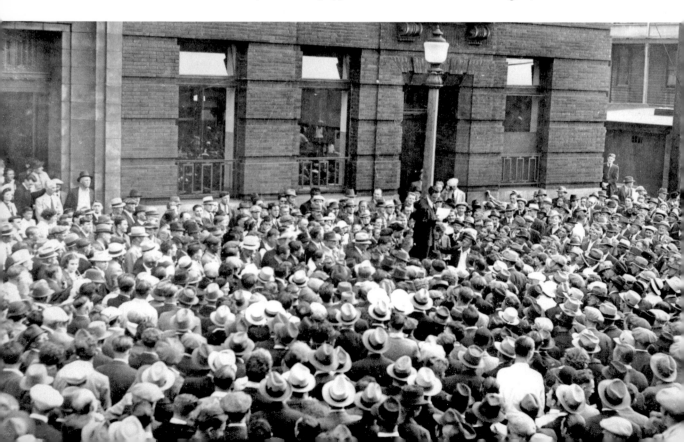

Chief Constable. The League raised money for 750 special constables to aid in the struggle against the "Red Menace," described by *The Sun* as "nameless vagabonds of chaos."[121] Their efforts were paralleled by the City and individual employers who put into the field a cadre of detectives, private investigators, informants, infiltrators, and spies. Cloak and dagger work became a management tool and a feature of the growing tension in the Eastside.[122]

These developments proceeded parallel with uprisings in the city centre. In April of 1935 some two thousand unemployed men who had earlier been packed off to relief camps in the province's hinterland returned to the city to engage in demonstrations downtown. On the night of the 22nd April, Mayor Gerry McGeer enjoyed a meal in the company of Nazi government representatives on board a German warship in the harbour. The next day he confronted several thousand protesters in the streets of his city with the Riot Act in hand.[123] One eyewitness recalled, "I was the person that stood closest to him when he read the Riot Act.... He had three police force representatives with him: one city policeman, one provincial and one RCMP. The other person next to him was his bodyguard, a city detective sergeant. McGeer didn't articulate, he mumbled. The only thing anyone actually heard was the last phrase, 'So help me God.'"[124] Although the crowd peaceably cleared the streets that afternoon, subsequent VPD raids on the offices of Left and labour organizations catalyzed a street battle around Hastings and Carrall that night. This was hardly the end of things.

The unemployed bolstered the numbers of longshoremen during the 1935 Ballantyne Pier Strike. "We are up against a Communist revolution," claimed McGeer, "and we are going to wipe it out without delay."[125] Much of the muscle necessary to launching a successful strike was, however, on its way out of town: the "On-to-Ottawa Trek" was just setting off, taking hundreds and hundreds of unemployed east inside and on the roofs of boxcars. Defending the CPR's port facilities on June 18th were three dozen mounted RCMP, others in sniper positions with machine guns, some forty Provincial Police with billy clubs, twenty mounted City police, and fifty on foot. When a procession of smartly dressed, respectable working men and women marching behind a Union Jack were tear-gassed and charged by baton-swinging mounted police, the "Battle of Ballantyne Pier" began. The tide quickly turned against the strikers. Motorcycle police rode through the East End, ferreting out hid-

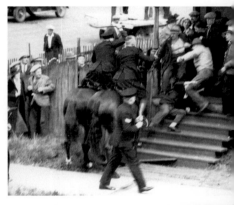

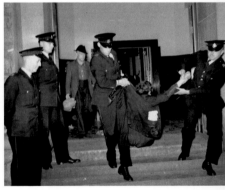

top: House-to-house fighting in the Powell Street Riots of 1932.
CITY OF VANCOUVER ARCHIVES 371-1127

bottom: The RCMP clear the stragglers from the Post Office sit-down strike of 1938.
PROVINCE NEWSPAPER PHOTO, VANCOUVER PUBLIC LIBRARY VPL 1275

Tear gas gets in your eyes. A VPD constable escorts a sit-down striker from the Art Gallery in 1938.

CITY OF VANCOUVER ARCHIVES RE P8.1, STAN WILLIAMS

.ing rioters by hurling tear gas bombs liberally into stores and homes.[126] That's not to say the strikers turned tail and ran: among the dozens injured during the battle were cops who found themselves separated from the main body of police. One of the casualties was a young constable, Len Cuthbert, who was dragged from a smashed up police car by an angry mob of men who beat him to a bloody pulp. (Cuthbert would reappear in another *Noir* tale in the late 1950s.)[127] The waterfront protests were echoed in Vancouver's freshwater twin, New Westminster, where the level of conflict rose to what one newspaper called a "miniature reign of terror" that included vicious assaults by the police, gunplay between strikers and strikebreakers, and attempts by the organized dockworkers to burn out the scabs.[128]

These confrontations constitute a classic *Noir* moment, when the East End, its citizens and their organizations were decried as "non-British" and foreign. Not only were they disloyal and deviant, they were told that they were simply not part of *this* society.

The spring of 1938 would see further demonstrations and pitched battles. In the three years that followed Ballantyne, discontent continued to grow, particularly in the Relief Camps of the interior. By 1938 the unemployed workers' movements and the Left generally was strong or desperate enough to risk another stand. On May Day more than fifteen thousand demonstrators

again took to the downtown streets, parading from downtown to uptown and on to Lumberman's Arch in Stanley Park. The unemployed and their supporters continued to organize. Meetings were held, public support was rallied in and around the big department stores (particularly The Bay), and they stood on street corners "tin-canning" for change. Finally, it was decided that the strikers would occupy three buildings in the uptown neighbourhood. The Georgia Hotel, the Art Gallery, and the Post Office were systematically overrun with protesters who began a peaceful sit-in. These three spaces—respectively, one privately owned, one a city building, and the third a federal office—

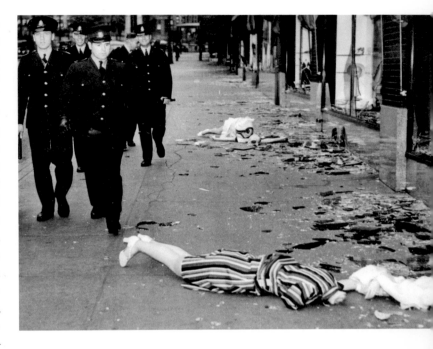

Shattered windows in the heart of the city as the unemployed lash out on Bloody Sunday, 1938.

IMAGE 0-07956 COURTESY OF ROYAL BC MUSEUM, BC ARCHIVES.

saw very different responses from their owners. The Georgia Hotel was the first to clear, the sit-downers having won the promise of about $500 in relief to the unemployed. The government-owned buildings, however, witnessed a month-long siege that gripped the city. Although the sit-downs didn't stop business, they embarrassed the authorities. The VPD took on the Gallery protest with uncharacteristic restraint but on the 20th of June lobbed in tear gas canisters and cleared out the strikers. The RCMP, for their part, waded into the Post Office without warning at the crack of dawn, flushing out the strikers in a rain of tear gas and truncheon attacks. The leadership of the sit-down was specifically targeted by the Police: Steve Brodie, for one, was viciously beaten and hospitalized.[129] As the strikers and their supporters raced down Hastings and Cordova Streets, the police in hot pursuit, a window-smashing campaign got under way. One mounted cop even chased a suspect into The Only Seafood Cafe.[130] A crowd of two thousand people besieged the VPD headquarters near the Four Corners, demanding the release of those protesters who had been rounded up by the tear-gas-tossing, club-swinging VPD. Loaded rifles in hand, the police stood their ground. After this crowd dispersed another, five-times larger, gathered at the

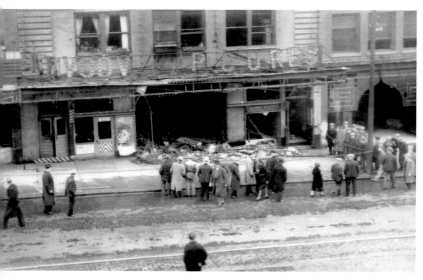

top: A bomb, allegedly planted by fascists, rips open the Royal Theatre at 144 East Hastings in March, 1933. Windows across the street were blown out by the blast.

STUART THOMSON PHOTO, VANCOUVER PUBLIC LIBRARY VPL 9116

bottom: Boilerworkers and shipbuilders gather at Athletic Park for a union meeting during wartime, 1943.

CITY OF VANCOUVER ARCHIVES 1184-1282, JACK LINDSAY

Powell Street Grounds a few blocks away.[131] What the cameras saw was the frontlines—the tear-gassed strikers, the police billy clubs raining down on the heads of protesters, the smashed store windows down Hastings Street. These were powerful images of a city looking over the precipice.

The Left

The vitality of the Left in Vancouver during the *Noir* era was remarkable. Annual May Day marches would start at the Cambie Street Grounds and head down Georgia to Stanley Park, with banners, floats, and marching bands as part of the procession. Once, when the City stepped in to stop the march—it effectively tramped from working-class Central School right through the heart of the middle-class West End—the parades and demonstrations rerouted through East Van, from the Powell Street Grounds to Hastings Park.[132] These events carried on from the Depression through the 1950s.

The city's labour-left had many homes. Con Jones Gambling Hall was reckoned by the VPD to be a hangout for "idle left-wingers." Andrew Parnaby provides a list of residences used as meeting rooms for the Communist waterfront organizers in the early 1930s—all of which were in the downtown eastside: "the Victory Rooms on Powell, Glen Apartments on Hastings, and the World Hotel on Cordova Street were particularly alive with talk of waterfront politics." But the whole of the downtown hummed with talk of a new hard-left union to fight the disfigured capitalism of the depression. All along the waterfront, in cafes and trams, beer parlours and shoeshine shops, shore workers heard the call to a more militant challenge to the established order.[133]

If the authorities in Vancouver persecuted and marginalized the Left, they were no less rigorous in punishing the Right. Fascism found a following in the Italian communities and National Socialism ("Nazism") had supporters among the local Germans and Austrians, but the booming economies of Italy and Germany caught imaginations outside of the

Eastside. In 1933, a meeting of the Workers Unity League at the Royal Theatre was disrupted by a bomb that destroyed the lobby and shattered windows in the buildings across Hastings Street; local lore has it that fascists were involved.[134] The movement certainly had its followers in the years before Dunkirk. According to one account, the editor of *The Province* newspaper took the stage at the Rex Theatre in the late 1930s and lectured the audience about the economic benefits of fascism. An Italian-Canadian source from East Van claimed that, in the same period, the civic government welcomed club applications for Fascist or Nazi parties and clubs.[135] The internment of Japanese-British Columbians is a well-known story but when it is set beside the internment, as well, of Italian-Vancouverites, its anti-fascist context becomes crystal clear. The rounding up of suspected spies among the Italian community in the Eastside began in 1940, spurred in part by the Italian consulate's sponsorship of a Vancouver *fascio*. Nearly two hundred Italian-Vancouverites were exiled to Ontario for the better part of two years, a far cry from the Japanese internment and dispossession but, since most Italians and Japanese lived in the East End, these moves against suspected fifth columnists was also a move against East Vancouver.[136] In 1944 the

above: Lumberman's Arch in Stanley Park was an annual open-air venue for trade union, socialist, and communist speeches through the Cold War, 1950.
ARTRAY PHOTO, VANCOUVER PUBLIC LIBRARY VPL 81275-C

below: May Day March through the city centre, 1955.
VANCOUVER POLICE MUSEUM, 886

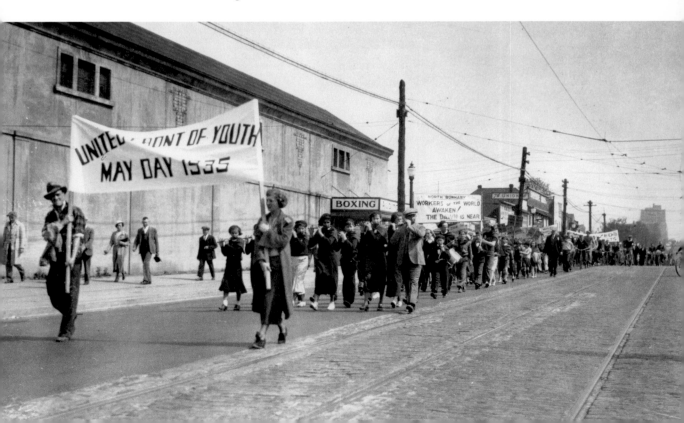

Ukrainian Hall—once the site of socialist support for the unemployed in the 1930s—was seized by a federal government terrified of Reds and, ironically, handed over to a right-wing Ukrainian-nationalist group.[137]

The Left was no mere bogeyman. It was real. Vancouver author Earle Birney's 1955 classic, *Down the Long Table*, describes secretive meetings in unlikely settings.[138] His accounts are based on actual experiences. And the Left didn't go away with the end of the Depression. In 1940, despite Canada's alliance with the Soviet Union in the war against Nazi Germany, the Communist Party of Canada was a banned organization. That didn't end it; it drove the Party underground. The New Age Bookstore, described by the Vancouver Police as "ostensibly a bona fide bookstore, but really the focal point of distribution of C. P. of C. literature," was raided by the VPD and the RCMP, some six thousand books and pamphlets confiscated, and the owner sentenced to a year in prison and fined $200.[139] Although the circumstances of the Communists improved somewhat while Stalin's Soviet Union was allied to Britain, Canada and the USA, it rapidly deteriorated again after the war. Organized labour turned sharply against the CPC, too. The national Canadian Congress of Labour, based in Ontario, joined the battle against communist-led trade unions on the west coast in the late 1940s. Purging the communist leadership of the Vancouver Labour Council in 1948 was one victory, but the CCL went on to move against the leaders of the International Woodworkers of America and International Mine, Mill and Smelter Workers' Union. Although some (perhaps most) of the hard-left leaders were Canadian-born or long-term residents, that didn't stop self-described agents-provocateur like reporter Jack Webster— himself a fresh-off-the-boat immigrant—from pitching in as red-baiters who painted the movement as one led by un-Canadian foreigners.[140] The local press described the situation in the Communist Party-controlled unions as unacceptable and their voice became only shriller as the Cold War, still in its early stages, gathered momentum.

Labour trouble erupted regularly in the second half of the Age of *Noir*, but it never again reached the violent pitch of the Depression years. In 1949, for example, a campaign was underway to break the Canadian Seamen's Union. On May 3, three freighters were trapped in Vancouver harbour by a strike on the part of the CSU. In the two months that followed, the VPD and the CSU exchanged occasional blows.[141] But this was a long way from thousands in the streets, charging mounted police,

Gatling guns, and tear gas attacks. Street battles between the VPD and the unemployed were not repeated later in the *Noir* period. Economic prosperity turned the heat down, as did the chill from the Cold War. The era ended with these confrontations burned into the memory of thousands upon thousands of Vancouverites.

That's not to say the City and its allies ceased their campaign against Vancouver's working class. Take, for example, City Hall's continuing assault on Central School. In addition to the rezoning that gutted the community, the City made other environmental changes to the neighbourhood in ways that would declaw a working-peoples' movement. The fate of the Cambie Street Grounds provides a powerful illustration.

A blockade of the Daily Province newspaper by strikers in 1946 gets interesting when a truck-load of the non-union-produced edition hits the streets. And catches fire.

CITY OF VANCOUVER ARCHIVES 1184-2560,
JACK LINDSAY

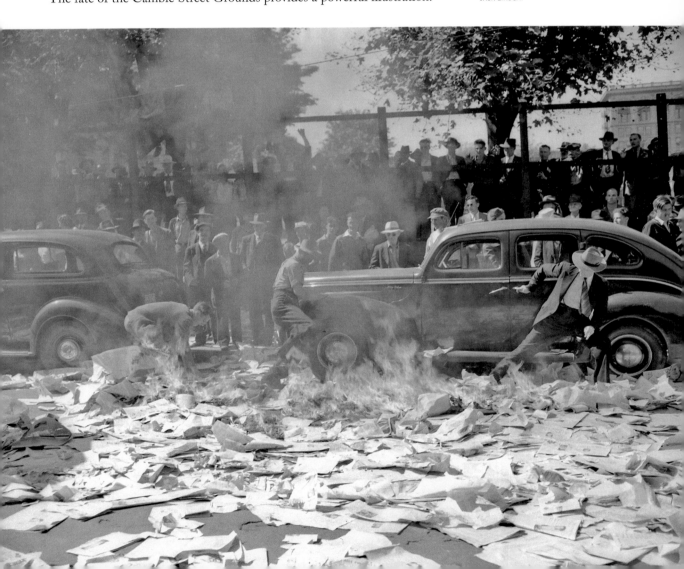

In 1942 *Vancouver Sun* reporter Larry Wood described the "Commons of the Pioneers" this way: "A plain, oblong of flat, grey earth, utilitarian but unpicturesque, unadorned by monument, unrelieved by verdure, never named, never ceremoniously opened; yet it has cost the city less and served it better than any of the other 98 parks Vancouver now possesses." The next year it was renamed Larwill Park for Alfred Larwill, a "genius of all sport" who had lived in a shack on the site. He stored sports equipment in his home, let teams change in his dining room, and for years coached youngsters, including Gerry McGeer. This was the principal playground and public gathering place in Central School. This vital, beating heart of Central School was, in 1947, taken away from the community and turned into the downtown bus depot; it was subsequently paved over. A similar fate befell Athletic Park, near Granville and Seventh on the south slope of False Creek. This was Vancouver's premier baseball diamond, a place where trade unions gathered for general meetings, their leadership

Smashed windows, Cracked skulls. Aftermath of the Post Office Sit-down and Riot, 1938.
PROVINCE NEWSPAPER, VANCOUVER PUBLIC LIBRARY VPL 1288

PROVINCE NEWSPAPER, VANCOUVER PUBLIC LIBRARY VPL 1289

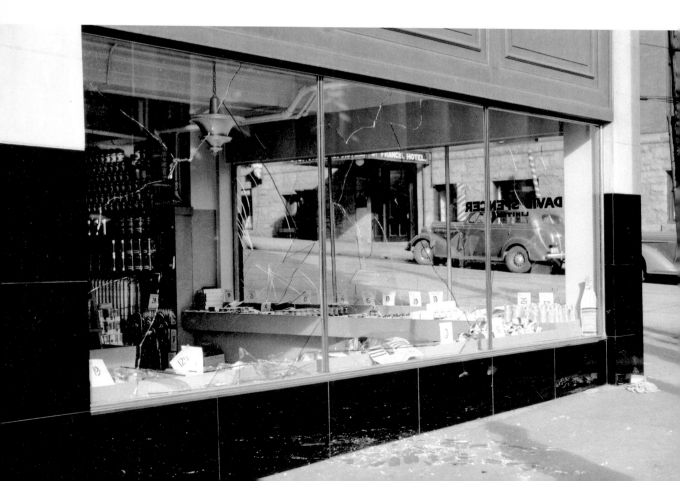

mustering with loudspeakers somewhere between home plate and the pitcher's mound. In 1945 it all burnt to the ground and the working-class neighbourhoods of Central School and False Creek Slopes lost their last public space for play and for rallying.[142] Other entertainments would come to be challenged as well.

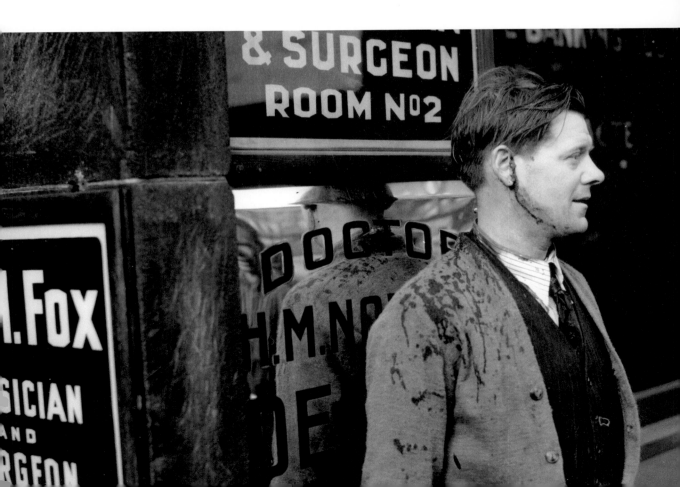

CHAPTER 3

LOTUS LAND: GLAMOUR AND VICE

above: Outside the Strand Cinema on Georgia Street, 1948.
CITY OF VANCOUVER ARCHIVES 1184-2595, JACK LINDSAY

left: Marie Moreau takes a stroll across the roof of the Hudson's Bay building, 1942.
CITY OF VANCOUVER ARCHIVES 1184-114, JACK LINDSAY

CHANGES IN PHOTO and print technology in the Golden Age of Hollywood gave rise to what came to be called "glamour." It combined an insouciant attitude with polished beauty, and it made a public spectacle of exclusive luxury, putting the material lives of the elite so close the masses could almost taste it.

Glamour and the *Noir* era are so intertwined it is difficult to separate the two. They might both be said to begin in earnest with the invention in 1927 of the "talkies": motion pictures with sound. The vicarious enjoyment in darkened theatres of the lives of others was a *Noir* experience in itself. It was also a means of spreading common perspectives on beauty, pleasure, and style. The photo magazine was another conduit of imagery that promoted a new ideal in black and white. Both film and print interpretations of glamour were sustained by the eye of the camera, specifically the camera of the day: speed graphic. It captured, emphasized, privileged, and promoted a certain look, one that would not survive other technologies. In the language of Hollywood, the camera loved some faces, others not so much.

In addition to their celebration of glamour, movies and magazines were engaged in the conversation about moral decay. Take the print media: because most of the magazines on Vancouver's newsstands either originated south of the 49th or emulated the style of American magazines, the agenda of writing on social and sexual decadence reflected the preoccupations of New Yorkers and Los Angelenos, thus further influencing Vancouverite sensibilities.

It might be argued, however, that Vancouverites didn't need much guidance. After all, this was the neon capital of North America, Granville Street was a greater and whiter way than anything west of New York's 42nd Street. It was also the seat of supper club sophistication, a city to which Hollywood beat a path. In the 1950s "the little port city had a nightlife with the swagger of a Jersey saloon singer and steakhouses

and lounges out of *L.A. Confidential*."[143] It had, as well, a thriving trade in sin. Bootlegging, illicit sex, and backroom gambling were trademark recreational activities in the Terminal City. With the exception of cross-border forays to the "liquor stores, congenial taverns, pinball arcades and … porn theatre" of nearby Point Roberts in the 1950s, Vancouverites were good at getting bad without any help from American peers in the age of *Noir*.[144]

We know a fair bit about the vices of *Noir* era Vancouverites because so many social sins were heavily regulated. They peppered the annual reports of the VPD and the front pages of local newspapers. And while the police and politicians railed against the sex trade, drinking, and

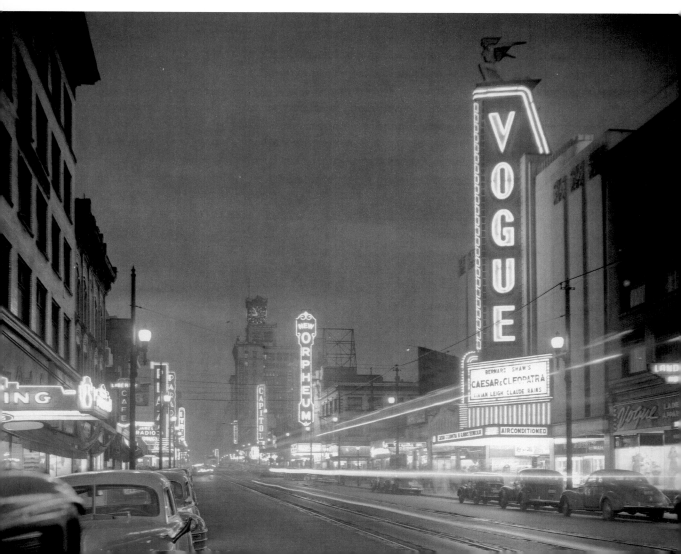

gambling—creating outrageous moral panics that anticipated the end of civilization—Vancouverites of all walks could point with pride to the city's outstanding nightclubbing and burlesque traditions. This chapter brings together those contradictory elements, surveying the glossy nightlife and the sleazy lowlife.

Swing City

Legal and quasi-legitimate entertainments in Vancouver ranged from high-end shows in the classiest hotels through Uptown's post-vaudeville supper clubs to the seedier establishments in the East End. From hip to square to jive, from respectable to irredeemable. The existence of variety is one measure of Vancouver's cultural vitality in these years; the extent to which this becomes a battlefield for moral high ground says something about the tensions of *Noir*.

The old Downtown had been, since the nineteenth century, the home of music, glitter, and performance. But as the 1930s opened, many of the best facilities were already long in the tooth, as was the kind of thing they served up. The Beacon on Hastings, for example, was vaudeville's last home in 1938. The old live theatres were switching rapidly to less expensive options: film, mostly, but titillation as well. The exemplar in the latter regard was the State Burlesque Theatre on East Hastings near Main, which opened in the first decade of the twentieth century as the Pantages (the first of two) and subsequently became the Royal and then the State, in which latter incarnation it served as the city's "first and only burlesque house."[145] Star performers like "Gypsy Rose Lee, Yvette Dare and her trained parrot, Faith Bacon and Sally Rand (both of whom claim to have invented the fan dance), and Evelyn "Hubba Hubba" West, with breasts insured by Lloyds of London for $50,000, performed at the six hundred-seat State Burlesque Theatre. They were … backed by local showgirls such as Nena Marlene, and co-billed with top-banana comedians, torch singers, magicians, accordion players, plate-twirlers, fire-eaters, tap dancers, and jugglers."[146] Vancouver's answer to New York's Minsky's, the State was raided in 1946 and again in 1952 and (transformed once more, this time into a "serious theatre" called the Avon) during a performance of *Tobacco Road* in 1953,[147] as clear a sign as any that the city's elite found raucous, ribald, and edgy entertainments on the Eastside to be less palatable than what was to be found Uptown.[148]

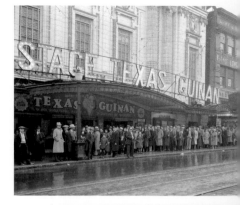

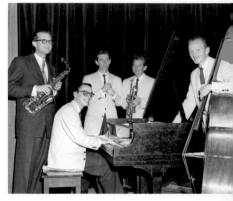

opposite/top: One of a handful of neon light producers in Vancouver, 1943.
CITY OF VANCOUVER ARCHIVES 1184-2733, JACK LINDSAY

opposite/bottom: The neon city in 1946.
CITY OF VANCOUVER ARCHIVES 1184-2733, JACK LINDSAY

top: "Hello, suckers!" Texas Guinan's storied career came to an end in Vancouver in 1933 when she contracted amoebic dysentery while touring with 'Too Hot for Paris.'
CITY OF VANCOUVER ARCHIVES 99-4563, STUART THOMSON

above: The house band at the Cave, led by jazz maestro Fraser McPherson, 1955.
VIC SPOONER PHOTO, VANCOUVER PUBLIC LIBRARY VPL 82806

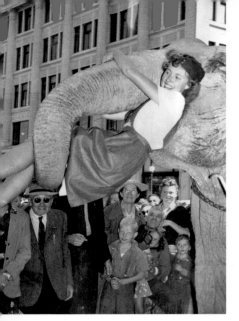

top: Glamour and circuses: an irresistible combination, ca. 1947.

CITY OF VANCOUVER ARCHIVES 388-68

centre: Songbird Lena Horne in Vancouver in her late 20s, somewhere between the Cotton Club and the House Committee on Un-American Activities, ca.1944.

CITY OF VANCOUVER ARCHIVES 1184-2327, JACK LINDSAY

And more and more of the city's distractions were on display along Granville Street. Entertainment—particularly the respectable kind— began a westward migration from Hastings and Main in the 1920s. The New Orpheum, which opened on Granville Street in 1927 as the largest vaudeville house in the country, was one mark of this shift. [149] But the Orpheum was dedicated, at least at the outset, to productions that were considered suitable for the whole family.[150] The Orpheum reveals the Old World, haute couture aspirations of the generation before the age of *Noir* and stands as a critique of the bawdy comedy of East End music hall, despite the big "vaudeville" sign on the original marquee.[151] It also signals the ascendency of middle-class family values, regardless of how far this vision was compromised by mid-century.

The Orpheum was not the only investment in Uptown as a centre of excitement and leisure: by the mid-1930s neon lights had spread from the Colonial Theatre at Dunsmuir along Granville to the Orpheum's doorstep.[152] In between the two, the Commodore Ballroom hosted private galas for debutantes and the new university's fraternities.[153]

Beginning in the late 1930s, Vancouver emerged as a centre for supper club entertainments. This was not exclusively contained to the Uptown area, but the Downtown versions were invariably and indisputably less swish. In the Uptown of Vancouver, the Cave and the Palomar led the way, the former dressed in plaster stalactites. Both clubs were "swanky and upmarket" and hosted big-name American acts like Harry Belafonte, Tony Bennett, Mitzi Gaynor, Duke Ellington, and Ella Fitzgerald. Middle-class Vancouverites—themselves dressed smartly in suits and gowns—were drawn to the "high-class acts, dancing to swing rhythms, and night-time razzle-dazzle." [154] These clubs—along with the Penthouse (opened in 1947) and Isy's Supper Club (1958)—were also the home of acceptable skin shows: striptease performances modelled on the traditions of burlesque, mostly featuring elaborate costumery, feathers, and fans, but stopping well short of completely bare breasts or bottoms. This was the kind of Vegas show that respectable folks could— and did—attend in large numbers, especially if a 1950s "girlie magazine" star like Lili St. Cyr was on the bill.[155] The Cave was licensed for six hundred but regularly crammed in nearly double that number.

The list of active ballrooms and nightclubs in *Noir* era Vancouver was a long one. The legendary bandleader Dal Richards recalled the White Rose ballroom on West Broadway near Granville, and could rattle

off "the Palomar, the Quadra Club, the Arctic Club, Isy's, the Embassy, Alexandra, White Rose, Howden, Trianon and Peter Pan ballrooms, the Alma Academy, the Commodore, the Harlem Nocturne, the Hot Jazz Club, the Mandarin Gardens, the WK Gardens [in Chinatown with its best days in the 1930s—and an orchestra and floor shows], the Smilin' Buddha, the Marco Polo, the Narrows Supper Club at the north end of the Second Narrows Bridge," as well as "coffee houses" "like the Bunkhouse, the Espresso, the Black Spot, the Attic, the Java Jive, the Inquisition, the Ark, the Club 5 and dozens more."[156] The Original Jazz Cellar was ground zero in Vancouver's "bebop scene in the '50s."[157] More than a few of the city's venues made outrageous claims to hipness in a highly competitive market. Oscar's, for example, was a restaurant in the same building as the Palomar, at Burrard and Georgia—it billed itself as the "Home of the Stars."[158] The Waldorf Hotel on East Hastings opened in 1947 and achieved instant hipness with a modernist flare; it trumped itself in the mid-1950s by adding a Polynesian theme. The result was an atomic era Tiki Bar that was more Bikini Atoll than Pacific Northwest. This might well have teased "the erotic fantasies of a middle class fascinated by the exotic and forbidden," but the Bayshore Hotel on Coal Harbour (famously the temporary home of Howard Hughes in the 1970s) would later do so in a far less edgy way on the west side of town.

The lively swing and jazz scene entered the comfortable middle-class mainstream in the Depression years. The Panorama Room atop the newest Hotel Vancouver dominated the downtown venues from the late 1930s. This was the entertainment home to the "Shaughnessy Set," the well-heeled upper middle-class from the city's southside. But it was not an exclusive venue—providing the client was white enough to get in the door.[159] Between this venue and the Palomar and the Cave, there was a steady stream of headliners and local talent. Local girl Peggy Middleton performed at both, first in the chorus line at the Palomar then, having moved from her day-job as an usher at the Orpheum to Hollywood fame, returned as headliner Yvonne DeCarlo. Her movie debut came in the early 1940s and De Carlo became the archetypal *femme fatale*, beginning with *Salome—Where She Danced* (1945) and graduating to a *film noir* role in *Criss Cross* (1949) and a brief stint as the girlfriend of multi-millionaire Howard Hughes.[160] Mandrake the Magician—better remembered by later generations as a comic-strip character—got his start in New Westminster in the late 1920s and was no stranger to the

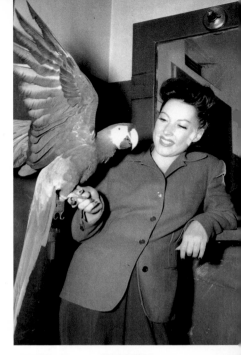

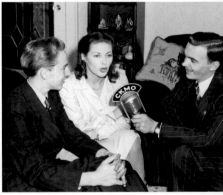

top: Yvette Dare and talented friend. Some parrots can talk; this one can take off a woman's clothes, 1943.
CITY OF VANCOUVER ARCHIVES 1184-118, JACK LINDSAY

bottom: Local girl Yvonne (Peggy Middleton) DeCarlo, a bona fide Hollywood star, 1945.
ART JONES PHOTO, VANCOUVER PUBLIC LIBRARY VPL 80459

opposite/bottom: Stripper Sally Rand confirms the legendary softness of Vancouver water in 1943.
CITY OF VANCOUVER ARCHIVES 1184-119, JACK LINDSAY

Vancouver stage. Dal Richards and his band were swinging at the top of the Hotel Vancouver from 1940-65, while on the other side of the West End respectable diners in the 1950s were shuffling their feet to the organ music in the Sylvia Hotel's rooftop "Dine in the Sky" restaurant.[161]

When the big venues closed for the evening, Vancouverites would move on to smaller, after-hour venues. The World, located on Granville near Robson, was Vancouver's "longest running after-hours club."[162] Bandleader Dal Richards remembers another on Seymour Street, known as "Nigger Jean's" and run by an Afro-Canadian woman who had achieved some notoriety as the titular character in Aunt Jemima TV adverts.[163] But the foremost of all the late-night hotspots was the Penthouse. It was opened in 1947 by two young Italian immigrant brothers, Joe Philliponi and Ross Fillipone (the different spellings tell a tale about immigration officer confusion). At first it was "an after-hours speakeasy" but it graduated to a legal cabaret in 1950. They ran it "for years" as a "bottle club" to which clients would bring their own booze. "In those years," recalled Ross Fillipone, "you had to brown-bag it." Police raids became a regular event, right from the outset. Soon after the Seymour Street booze can opened it was paid a visit by twenty or so constables from the VPD. Despite the fact that the one-hundred-and-twenty-seat club was unlicensed, the VPD came away with their biggest liquor seizure since the Depression. In 1950 the club finally got a license as a cabaret, but it still could not serve liquor. In this respect, the Penthouse was in good company. The Cave, the Palomar, the Commodore—they were all bottle clubs too, some with tablecloths that draped to the floor so as to discretely hide the clientele's liquor stashes, particularly in the case of a police raid, sometimes signalled by the house band breaking into *Roll Out The Barrel*.[164] But the Penthouse was an after-hours club, so it attracted the real nightowls and it was where the serious partying took place. Naturally, that's where the police

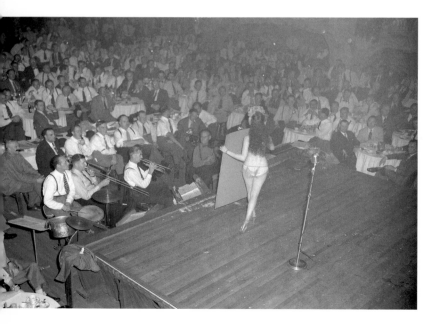

The Vancouver Board of Trade takes its Christmas lunch at the Cave in 1948.
CITY OF VANCOUVER ARCHIVES 1184-3471, JACK LINDSAY

concentrated their efforts. "The P remained a favourite target of the city dry squad in the 1950s," according to Fillipone. "The police would come in twenty or thirty strong two or three times a week." Patrons would be forewarned and bottles would disappear under the tables. The celebrity guest list (and sometime performers) included international stars of radio and screen like Bing Crosby, Bob Hope, Harry Belafonte, Frank Sinatra, Victor Borge, and Errol Flynn, who made an appearance the on the eve of his untimely death, seventeen-year-old girlfriend in tow. In the 1960s the club moved into the exotic dancers niche; Philliponi was murdered in 1983 during a robbery. The Penthouse never fully recovered its classy glamour-scene role.

Becki Ross, a UBC sociologist who has studied Vancouver's burlesque and striptease legacy, makes it clear that the Terminal City was linked in a north-south entertainments network. Vancouver was tied into *Noir* environments to the south from the 1930s if not earlier because that is where the entertainers mostly originated. These links, however, also supported the rise of local talent that could hop on the same "show business railway" as it headed back south. For American performers and their promoters, Vancouver offered good pay, low overheads, and fanatical crowds. As a result Vancouver eclipsed Montréal as Canada's capital of vaudeville and burlesque in the post-WWII era.[165] Another consequence was that the imagery of *Noir* came packaged with American acts fresh from engagements in Las Vegas or Portland, San Diego or

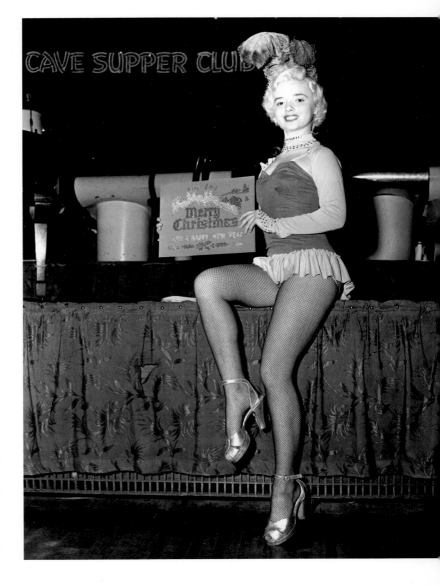

Chorister Joanne Barfett at the Cave Supper Club, 1952.

ART JONES PHOTO, VANCOUVER PUBLIC LIBRARY
VPL 82042

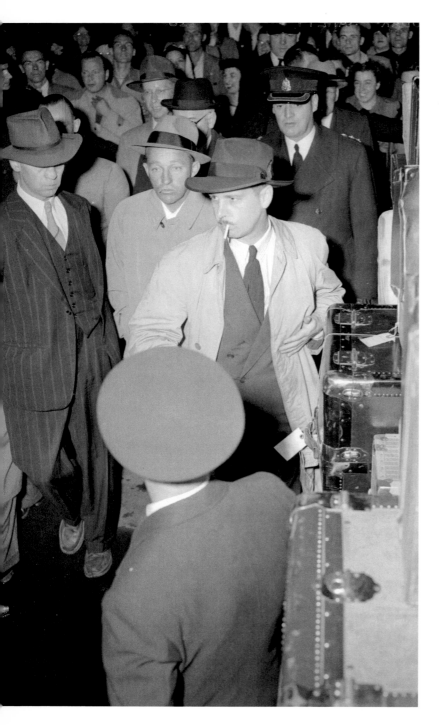

Seattle, Los Angeles or San Francisco. As well, these American acts carried plenty of moral baggage onto which local reformers could pounce: race, sex, and racy sex were favourite targets.

Despite offering a venue for Afro-American singers, the Uptown venues observed a careful colour line. Strippers were invariably white (with the noteworthy exception of the legendary Josephine Baker, who played the Cave in 1955). The Uptown hotels reinforced Vancouver's anti-black ethos, barring Lena Horne, Louis Armstrong, Sammy Davis Jr. and no doubt many others.[166] After the Hotel Vancouver refused to let Armstrong stay in their rooms it was famously boycotted by Frank Sinatra, who preferred the Georgia Hotel. And it was the Georgia that defied local sanctions when it hosted Nat King Cole in the '50s.[167] But the Georgia was the exception that proved the rule: this timidity and prejudice was deeply rooted in Vancouver, and was a reflection of the city's continuing struggle with its own diverse population. Beer parlours, for example, had their own peculiar colour bars. Aboriginal people were legally banned from the barrooms of British Columbia, although Asians and blacks were not. Black drinkers kept themselves to a handful of beer parlours that were, evidently, closely

watched by the authorities. And, although it was never codified in law, there were informal sanctions against men of colour drinking with white women.[168]

One other moral panic in these years merits mention, that associated with homosexuality. "The 1950s and the early 1960s were years of the social construction of homosexuality as a national, social, and sexual danger in Canada."[169] They were also years in which at least two Vancouver watering holes served gays and lesbians. The partitioning of BC's beer parlours had the unintended effect of creating one-sex spaces in which men could connect. In the few drinking establishments with Ladies Only sections, the possibilities for building lesbian relationships was obvious. The Castle on Granville Street catered mostly to men, but the New Fountain on Cordova Street was lesbian-friendly.

This is not to say that Vancouver was a safe-haven for homosexuals. Although the West End was already becoming a centre for the gay population, there was little in the way of an "out" community to offer mutual support and protection. Two murders in 1959—of Edward Beresford (fifty-nine years) and Robert White (forty-three years)—involved men who were waiters or bartenders who took advantage of their jobs to establish chance liaisons.

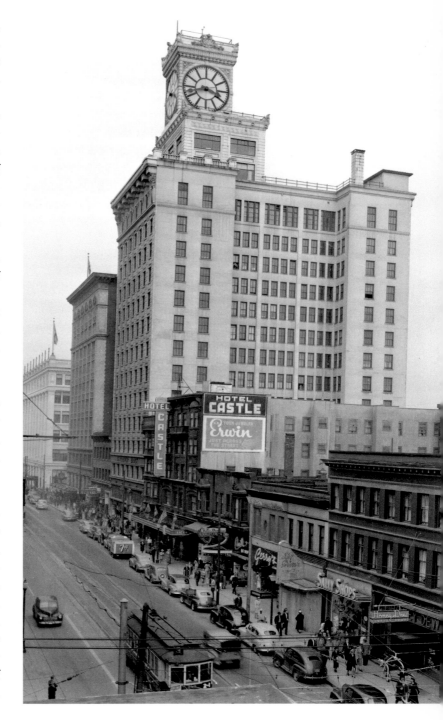

previous page/left: A large Vancouver crowd
turns out to greet American crooner Bing Crosby
at one of the city's railway stations, 1948.
VANCOUVER PUBLIC LIBRARY VPL 80676A

previous page/right: The Castle was Vancouver's
main hangout for homosexual men in the age
of *Noir*, 1949.
VANCOUVER PUBLIC LIBRARY VPL 83164A

The Hastings Park track was where Vancouverites
could get a legal gambling fix, 1942.
CITY OF VANCOUVER ARCHIVES 1184-315,
JACK LINDSAY

Lethal liaisons in these two instances.[170] Their killers were relentlessly pursued by the police, it has to be said, but the social environment that necessitated covert relationships also contributed to vulnerability and, clearly, tragedy.

"Deviant" sexual behaviour was dreaded as a sign of a degenerate society: this was a holdover from the salad days of the Social Darwinist creed that swept up much of the western world in the first half of the century. It didn't stop with the defeat of fascism, not least because it had strong roots in British Columbia. Homosexuality was perceived, bizarrely, as a habit that could be turned off or on. In this way, the "active homosexual" equates to the "practicing physician," someone who has the knowledge and skills but may or may not choose to employ them.[171] With the important distinction, of course, that homosexuality was viewed as deviant behaviour. Certainly no one in the Age of *Noir* is referred to as an "active heterosexual," and yet certain kinds of heterosexual activity were highly policed.

Sin City

British Columbia's sex ratio was badly out of balance in the early twentieth century. An economy built on logging, fishing, and mining inevitably attracted far more men than women. In Vancouver, especially during the winter months when logging camps up the coast closed down, there was always a large surplus of men, many of them with money to burn. In this context, it shouldn't be surprising that drinking was a major pastime and that the buying and selling of sex was a common practice and of enormous economic importance. And for that largely male community, sex-for-sale and a regular supply of booze constitutes an almost inalienable market right. This situation was an affront to twentieth century moral reform movements.

As the city's elite became more pious, more removed from the economic grit of the waterfront, and more concerned with civic image, change was imposed from above. Prostitution, gambling, and bootlegging were "behind the scenes" crimes, out of sight of most, so public interest had to be whipped up. Just as sin sells well, so too does newspaper coverage of vice. As well, it agitated more of the clergy (still vocal and influential in these decades), and it was thought to eat away at the fabric of the family—that fundamental bulwark against, first, fascism and, later, communism. As a consequence, drink, cards, and prostitution became

PURVEY • BELSHAW

not only criminalized in the 1930s but also vilified. No longer was it possible to say that these illegal businesses "did not *feel* criminal."[172] Driven further and further underground, they became shadier and more dangerous, attracting a different kind of practitioner and a more violent clientele. The brothels were banned and became recast in the discourse as "whorehouses." "Prostitution" and health panics associated with fear of venereal diseases (particularly their spread among the young, white male population) come to dominate the language. There is something agreeable about the word "brothel"; there is nothing but fear and contempt in "whore," not to mention "syph," "the clap," and a "dose" of v.d.

The same process can be seen in the regulation of liquor production prior to, during, and after North American experiments with prohibition. When the rules were lax, the making of home-brew was usually winked at; during Canadian prohibition it was actively and often violently discouraged by police action. Thereafter the monopolization of the tightly regulated industry criminalized even the small backyard and basement distilleries. If one wanted to buy a bottle of hooch it now had to come from an approved industrial-scale operation, not the neighbourhood Italian vintner who had been transformed into a "bootlegger" and, in all likelihood, a "gangster" or even *mafioso*. Increasingly marginalized, the business of bottling and selling modest quantities of liquor became an underground activity, precisely the sort of business that would create or attract a "racket" and "racketeers." Not surprisingly, as sex and drink and gambling all became more targeted, they became more attractive as combined operations, the trinity of sins in the city's East End.

Terminal City's "square mile of sin" enclosed Chinatown and Strathcona. Gambling operations in this area were so numerous that repeated VPD campaigns to eradicate the "dens" met with little success. Bootlegging and prostitution were also commonly practiced in this stretch of East Van, the former mainly along the "mile of vice" that

A gambling 'tour' in Chinatown stops at one of nearly two-dozen known establishments, 1950.
PROVINCE NEWSPAPER PHOTO, VANCOUVER PUBLIC LIBRARY VPL 41630

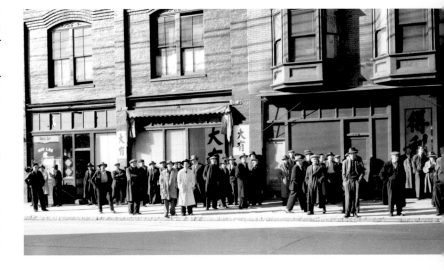

extended down Union Street from Main, and the latter liberally distributed around the Four Corners, particularly in the waterfront neighbourhoods along Alexander and Water Streets, down Cordova and Powell Street and the avenues running north and south.[173] Two sympathetic historians wrote in the 1970s that these activities "stemmed directly from a combination of poverty, self-reliance, and minimally available social welfare." They note, as well, that the brothel keepers, the bootleggers, and the gambling den managers made most of their money off the wealthier residents of the West End, whose moral probity disappeared somewhere near the middle of the old Georgia Viaduct.[174]

In the Roaring Twenties this arrangement was, with a few exceptions, acceptable. Long-time mayor, L.D. Taylor, endorsed the idea of a red light district in the Eastside and the brothels were, informally at least, permitted to carry on. For the most part, the police in the 1920s and early '30s took a similarly generous view of sin; they were more concerned with property crimes and violence. The political landscape changed as the *Noir* era opens, however, and vice came under attack.

Mayor Taylor's soft approach to "victimless crimes" meant that any politician (including a repackaged Taylor himself) could promise to "get tough" on vice.[175] The Chief Constable was called upon by a succession of mayors in the *Noir* era to purge the city of prostitution, gambling dens and one-armed bandits. As a consequence, the fight against vice became very public, yet another cause to rally Vancouverites behind, yet another reason to treat the East End as a problem.

In 1934-35 Mayor Gerry McGeer and Chief Constable Colonel W.W. Foster launched the first of many wars on vice. His Worship estimated that there were about five hundred slot machines in the city, three hundred of which were being run by one operator. The "one-armed bandits," along with pinball machines, were rounded up under Foster's watch, a move that McGeer claimed "saved the people something over a million dollars a year and eradicated a serious menace to both individual and public well-being." But that evidently did not do the job, at least not permanently.

In the summer of 1946, McGeer was back in office and his newly appointed Chief Constable, Walter Mulligan, reported that there were more than two hundred brothels, bookies, card houses, and Chinese gambling "joints" operating in Vancouver … right under the nose of the VPD. Off-track betting was widespread and well organized, and

Vancouver was known as a good place to find a serious poker game. At an appeals hearing Mulligan produced an extensive list with addresses and the names of operators. Three bookmakers in the old Orillia Apartments in the 600-block of Robson, for example, operated with complete disregard to both the police and discretion. Mulligan reported to *The Sun* that "at one place the crowd gathered outside was so large that the constable on the beat had to walk around it to get by."[176] Gambling was, as McGeer put it, carried on "openly and flagrantly in defiance of law and order."[177] The roll-call of bookies' operations included scores of gaming joints in Chinatown in the 1940s, eighteen of which "stood 'cheek by jowl'" on East Pender, according to Chief Constable Mulligan. Charlie Foy (*aka* Lai Foy) was the main operator, "a notorious Chinese gambler" who had been in business for years.[178] Gordon (Won) Cumyow, a Chinatown Notary Public, recalled in the 1970s that there were nearly a dozen Chinese lotteries running at any given time. Winning numbers would be announced—by a system of runners made up largely of elderly Chinese men—as many as four times a day.[179] Security at fan tan shops was sophisticated and included innovations like electric buzzers, false wall panels, "electric spring lock" doors, narrow hallways through which the police had to squeeze and which prevented the use of battering rams, and a complement of watchmen.[180] Competition between the gambling dens occasionally led to murders, although the Tong Wars of San Francisco's Chinatown were not reproduced in Vancouver. Like the opium dens of earlier decades, the City viewed gambling in Chinatown as problematic but not a first priority.

Official campaigns against the Chinese lotteries only began to bite in the 1940s, when jail sentences of thirty to ninety days were doled out for the first time.[181] Some $41,000 was seized from Wo Kee's Market Alley shop—allegedly a single week's takings—along with "approximately two tons of lottery tickets and paraphernalia seized on the premises;" much of these ill-gotten gains, however, were restored to Wo by the courts. Mulligan described the workings of the Chinatown gambling enterprises, saying that this was a nation-wide operation that depended, locally, on a squad of twenty-five to thirty-five "runners" who "left the rear of the premises every day on the odd hours between 11 a.m. and 11 p.m. to sell tickets." Lottery draws were held on even hours, so this clockwork activity was potentially easy to suppress.[182] The failure of the VPD to do so is what continued to dog the credibility of its leadership and the beatcop alike.

Gambling was, of course, not restricted to the Chinese. Respectable Eastside grocers discretely ran book from the back of the shop.[183] A former Japanese brothel keeper kept her hand in neighbourhood vice after WWII with a gambling club on Powell Street.[184] There were dice and card games galore in the little restaurants and blind pigs along Hogan's Alley, especially at Buddy's Beer Garden on Prior where West Side gamblers would "shoot two hundred up to a thousand bucks a shot, rolling dice."[185] Although the VPD would claim to have eradicated some types of games, bookmaking proved resilient. In 1960, at the end of our period, the police investigated twelve gaming establishments and arrested two hundred suspects.[186] The betting industry, clearly, was not being driven out of business by the law.

The Wages of Gin

The story of illegal drinking runs a similar course to that of illegal gambling. The economic collapse of the Depression shifted public morality but it created opportunities for crime even as it did so. As disposable wealth shrank, the incentive to buy cheap liquor from unsanctioned sources grew. Part of the infrastructure behind this was established during the 1920s but it expanded and evolved quickly.

Prohibition was dead and gone by the start of the age of *Noir*. But the tight regulation of drinking and saloons was entering a distinctly British Columbian phase. The "beer parlour" began to emerge in legislation in the late 1920s and became a widespread reality in the age of *Noir*. In 1927 a regulation was in place that effectively banned women from men's drinking spaces: operators began setting up separate rooms for their female customers and/or "Ladies & Escorts." In some bars four to five foot high partitions appeared, at least partially segregating the sexes. Men might join women in their section but women were technically forbidden from the men's side of the establishment. By the mid-1930s the no food, no music, no singing, no card games, no heterosexual couples' night out, sit-down-and-drink-your-beer facilities documented by Bob Campbell were part of the Downtown landscape, with a few outliers in the basements of swanky Uptown hotels like the Georgia. These were places where, in Campbell's telling phrase, "there was little to do except drink."[187]

In the *Noir* era, drinking was tightly regulated, but those rules were heavily enforced only in the East End. "The police dry squad and

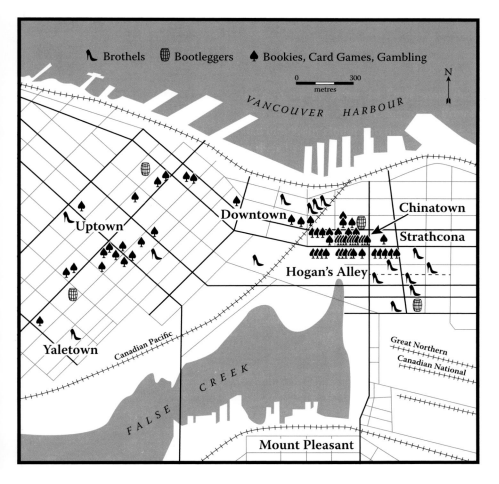

Brothels Bootleggers ♠ Bookies, Card Games, Gambling

VANCOUVER HARBOUR

Downtown

Chinatown

Strathcona

Uptown

Hogan's Alley

Yaletown

Canadian Pacific

Great Northern

Canadian National

FALSE CREEK

Mount Pleasant

gambling detail were the busiest sections of the force. In 1936, according to one source, thirty-three cabarets, restaurants and clubs lost their licences, and not one of them was west of Granville Street."[188] The City and the VPD certainly never crashed a party at the Vancouver Club. A further irony in the convoluted tale of observation and regulation of drinking arose in the 1950s, by which time the roughly two dozen beer parlours of the old Downtown were coming to be viewed as a greater problem than the beer they served. Calls increased for British-style public houses that would support "respectable" drinking by working people.[189] It would take another twenty years and then some before the "pub" movement in British Columbia would gain traction. In the meantime, the arrival of cocktail bars in 1954 made it possible for middle-class men and women to drink hard liquor in an environment free of partitions and lush with what passed at the time for sophisticated decor. Smart people drank martinis at the Sylvia or atop the Hotel Vancouver, while live bands played swing and jazz; riff-raff quaffed watered-down beer at

Map 2: Vancouver Vice, 1946.
ROSS NELSON, 2010

the Cobalt, the Ivanhoe or the Hotel Empress, women separated from men, everyone sullenly staring into their glasses, diligently getting drunk.

The second prong of liquor crime was bootlegging. The provincial government turned its sights on the illegal production and sale of liquor while, at the same time, making it easier for clubs—including servicemen's clubs and the exclusive businessmen's gathering places—to purchase, store, and serve alcohol. Society's concerns here covered both unauthorized production and fly-by-night distribution. The illegal distiller might be nothing more than a small Ma-and-Pa operation working out of a kitchen or garden shed, transforming anything from grapes to dandelion leaves into something that passed for wine. Or it could be a primitive industrial enterprise, capable of producing gallons of hard liquor of wildly uneven quality. Neither was easy to find nor to shut down. The bootlegging operations in the Eastside were often little more than small homebrew concerns. The Italians in particular turned their hand to making wine. Carl "Lungo" Marchi, sometimes referred to as the "Mayor" or "King" of Hogan's Alley, was a prominent bootlegger who hardly needed to leave his home to make a sale. One regular of the Alley recalled Lungo as "the big Italian, he was 310 pounds, six foot four inches. His house was in the middle of the alley, and they called him "The King." He made homebrew wine, you know. He'd make this wine and he would sell it for forty cents a quart, and the fella across the road from him, this West Indian guy, used to buy from him and sell it for ten cents a glass."[190] Cheap beer and homemade wine was available up and down the block, at Buddy's Beer Garden, the Scat Inn, and lesser joints. But even the well-known suppliers were small affairs. Mary Veljacic grew up in the Croatian and Italian neighbourhood in Strathcona and took the view that "where people who were lonely would come to the house and have a glass of wine, or two glasses, or three glasses, whatever… with their own people," it didn't count as bootlegging, it was just being social in the immigrant community. Even, it might be added, if they had to pay a small charge for the privilege of doing so.[191] Occasionally the police would show up and make the pretence of a raid, but it was more likely to collect a payoff than to make an arrest.[192] Having said that, a more aggressive approach was launched in 1938 under Chief Constable Foster, which involved padlocking bootleggers' homes, like the three at 209 and 272 Union Street, and 581 Hornby. In the case of the latter two homes, the Dry Squad actually padlocked the families

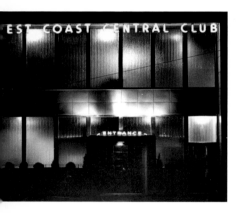

An Italian-Canadian cop who got his start fighting Italian bootleggers during prohibition decided, after retirement, to open a booze can with class, 1952.
VANCOUVER POLICE MUSEUM, RICCI 041

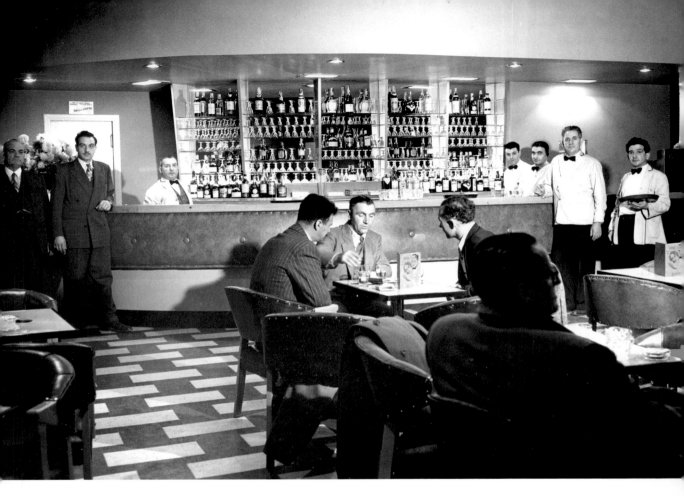

inside the houses.[193] Foster bragged in 1938 to have all but eliminated what he called "wholesale bootlegging," a claim at which his successors would have scoffed.[194]

The more lucrative and organized side of bootlegging was the "running" of liquor outside of the sanctioned saloons and beer parlours. Despite the establishment of at least two "owl" liquor stores—Liquor Control Board-run operations that ran late at night or even from midnight to 8 a.m.—the bootleggers continued to turn a profit through "convenient night delivery."[195] Hotels in the Downtown were particularly suspect in this regard. Providing their guests with a discrete bottle secured from the government outlet or from behind the hotel bar—a clandestine kind of room service—was a tidy little money-maker for the hotel staff and the subject of close police scrutiny. But there were also well-established "vendors" around the city centre—particularly in the 1100-block of Granville Street—who could provide a bottle on demand 'round the clock. There were other sources in the West End:

Of all the cheap gin-joints in the world....
Inside the West Coast Central Club, 1952.
VANCOUVER POLICE MUSEUM, RICCI 048

Joe (*aka* Paddy) Iaci and his brother Frank ran a well-known liquor supply business out of 1217 Howe Street at Davie, one to which the police turned a blind eye from the 1930s through most of the 1940s.[196] A similar business was conducted out of the home of Wally "Blondie" Wallace at 446 Union Street in Strathcona in the early 1940s. According to one source, "Wallace was a neighbourhood hero, dodging the cops in his bootlegging operation by night and teaching the local kids to box in the basement of his house during the day."[197]

The illegal sale of liquor could be a dangerous business. In 1943 and 1944 there were at least three prominent murders involving local blind pigs. One such operation, run out of 447 East Hastings by Giuseppi Esposito, a sixty-four-year-old career bootlegger, was trashed and looted by underworld rivals. Esposito sought police protection but, when his assailants returned, he defended himself with a rifle full of buckshot, killing Kevin Thompson.[198]

Bootleggers of this kind were not, generally, also in the business of producing liquor. They obtained it from illegal distillers but also from legal operations—though sometimes through illegal means. The latter process came to light in late October 1946, when it was discovered that United Distillers of 8900 Shaughnessy was fingered as part of a racket involving no less than a million cases of Vancouver-made liquor which was being sold in the United States in the face of wartime restrictions. A seventy-two-year-old former boxer with the colourful name of Robert "Soup" Bracken was arrested and charged.[199]

The city's blind pigs continued to thrive into the late 1950s. On a front page in 1955 *The Province* announced that no fewer than eighty-seven bootleggers had been identified in the city, twenty-seven of them running "drink-in" establishments and at least sixteen running bottle delivery services.[200] In the summer of 1959, the VPD mounted yet another campaign against bootleggers, rounding up twenty-six men and two women, all of them in the 1100-block of Granville.[201] One team of *Vancouver Sun* reporters went on the "Sledgehammer Beat" one December evening in 1959, moving from one bootlegging operation to the next between the hours of 2 and 4 a.m. What they found was three different kinds of establishments in three parts of town. In the West End, they described a "Charles Addams-type house" in a "prestige" neighbourhood, armed with a security "vestibule." "A face blotted the peep out of the peephole and then the door opened." There was a sterile waiting room,

followed by a "rumpus-room" with "a vast chrome and glass jukebox," a dancefloor, and a pretty Christmas tree in the corner. Beyond that was a lounge. "Nice, knotty pine walls. Smart sectional furniture and kidney-shaped tables. Heavy—very heavy—flowered drapes. Metal ducks winging across the wall. Mirrors. Floral pictures. Ceramic lamps as well as indirect lighting. Wall to wall carpeting. Just like home, but more so." At the smartly appointed bar an "agreeable" bartender poured Scotch at an "agreeable" 50 cents an-ounce shot, a bargain compared to the $1.25 martinis at the Cave. The regulars' behaviour was "fraternal but modulated," and the crowd was made up of a mix of early twenties, young women in black leotards, and beatniks debating the need to send out Christmas cards.

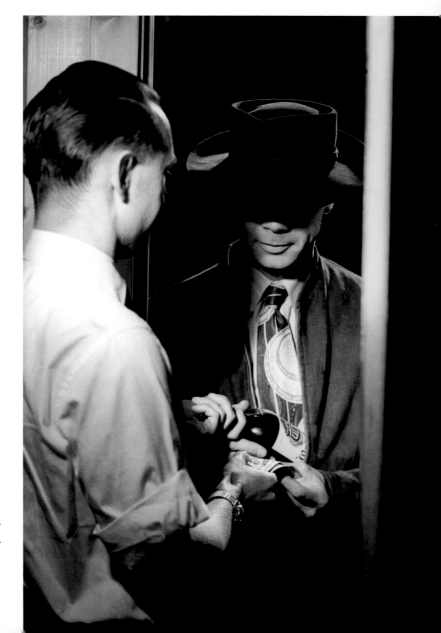

In case anyone couldn't imagine what one man buying liquor from another man in a doorway would look like, the VPD staged this shot, ca.1950.

VANCOUVER PUBLIC LIBRARY VPL 3849-C

The second blind pig on this survey was a dud, a "private party" in an "Uptown" neighbourhood behind a "very posh façade." Turned away by the man at the door—described as "a man in a tweed sports jacket, with the air of a revival meeting parson"—the journalists headed back to Granville at Helmcken. "Knock on any door," the cabbie instructs them, the neighbourhood being so thick with blind pigs. But the police had got there first: "a black maria was in front of a shattered grey door. Full and getting fuller." Minutes later, "the female van pulls up. It is for the ladies—but it actually looks feminine, slimmer, sleeker, prettier. In go the ladies." The door to the joint has been hammered down and the police are leaving with bottles of evidence, as well as every stick of

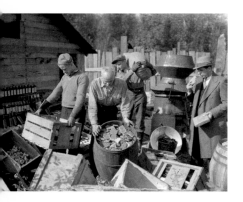

Police confiscate illegally produced liquor, 1932.
CITY OF VANCOUVER ARCHIVES 99-4266,
STUART THOMSON

furniture they can carry. *The Sun* team never gets inside, but they learn one detail from a plainclothes constable, "Never seen such a hard door to knock down."[202]

The province's system of liquor regulations was slow to liberalize. Not least, this was due to conflicting interests. In 1933 Gerry McGeer accused his Liberal Party leader, T.D. Pattullo, of "being in the clutches of the 'liquor interests' in Vancouver," by which he meant mainly his former law partner and his own running mate in the two-seat riding of Vancouver-Burrard, Gordon Wismer.[203] Four years later, in his new capacity as Attorney-General, Wismer wanted to make it easier for exclusive bastions of business like the Vancouver Club and the Terminal City Club to serve hard liquor. Wismer's political bedmates (other than McGeer) were said to include "the liquor ring that dominated Vancouver Centre" and he was known for his "liquor connections."[204] Depression-era piety competed with echoes of Roaring Twenties abandon. Civic politicians who had responsibility for cleaning up the streets and dealing with criminal producers of hooch found themselves at odds with a provincial government that was quickly growing drunk on liquor revenues. In the 1940s, after the War, there were still other contrary forces at work: some pushing for a more easy-going approach that included the introduction of cocktail bars, others resisting that trend and crying out for greater restrictions. A string of Coalition governments in Victoria couldn't muster the numbers nor the nerve to challenge the status quo. Conservative members of the Coalition cabinet included a brewer and a vintner, and even the notoriously tee-totaller W.A.C. Bennett—the Okanagan hardware merchant who would become Premier from 1952 to 1972—had a substantial finger in the Calona Winery pie.[205] Regulation of liquor production made money for the province and corporate, licensed brewers and distillers. It was a significant source of support for all of the right-of-centre political parties as well.

There were, in all likelihood, as many small-scale domestic distillers and homely little drink-ins in Vancouver at the end of the *Noir* years as there were at the start. Some had grown a bit bigger; some had become a little more sophisticated. If any trend can be seen, the illegal trade in liquor was becoming more of a racket than it had been in the past. Regulation—fed by the ideal of a moral society—was indisputably creating conditions in which illegality could thrive.

There was also, of course, an illegal trade in drugs in this period, but nothing like the industry that would emerge after 1960. As a local recalled years later, remembering the rough-and-tumble twenty-four-hour party scene that was Hogan's Alley, "maybe out of a thousand you'd see one dope-fiend in those days, that's how few they were."[206] Annual police reports only begin to draw attention to the illegal narcotics trade in the early 1950s and marijuana gets what may be its first official mention in 1951. Nevertheless, the VPD's leadership concluded that, "Despite the apprehension felt in some quarters regarding juveniles becoming addicted to the use of drugs … so far there has been no reason to believe such a problem exists in this City." This is not to say there wasn't *some* drug trade throughout the *Noir* era: there are patchy newspaper reports about incidental drug-related crimes like possession and small-scale sales.[207] Besides, when it came to illicit drugs the focus in the 1930s was still on opium. One raid in the spring of that year seized nearly seventy-seven tins of opium with a street value reckoned at about $8,000. The goods arrived on the Canadian Pacific steamer, the *Empress of Russia*, and were being sold out of the Grand Hotel on Water Street.[208] The declining size of the Chinese-Vancouverite population and the interruptions of trade with China effected by the war between China and Japan, the Second World War in the Pacific, and finally by Mao's Chinese Revolution in 1949 (which clamped down hard on the opium trade), removed Vancouver from the centre of Canada's drug trade.[209] The bad news was that this meant the competition was more cutthroat (literally) and that, when heroin started arriving in the mid-1940s from the Middle East via Eastern Canada and the USA, there was an organized-crime-vacuum that would fill…with violence.

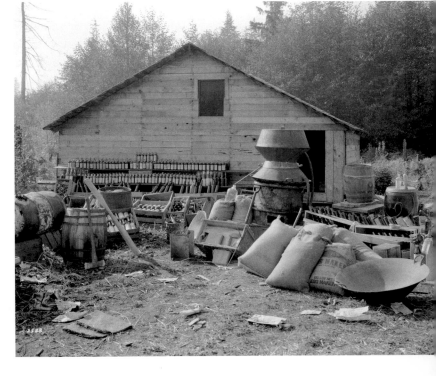

Some illegal production of liquor went beyond the Ma-and-Pa operations. A still discovered on the Musqueam Reserve in 1932.

CITY OF VANCOUVER ARCHIVES 99-4264
STUART THOMSON

In 1954 a narcotics "ring" was identified and described by the Chief Constable as "part of a plot to obtain control of the narcotic distribution in this City." Around the same time, *The Sun* ran the headline, "City Exposed as Stronghold of World Narcotic Ring."[210] The drug cartel might have made more headway had they not opted to kill off a rival dealer, Danny Brent. Subsequently William Seminick narrowly escaped assassination in Stanley Park by members of the emergent drug monopoly. Defying the old adage that there's no honour among thieves (and ignoring his multiple bullet wounds), "Silent Bill" refused to identify his assailants.[211] The attacks escalated into what was described in 1956 by the incoming Chief Constable as a "drug war." One casualty was Jacob Leonhardt (aka Jack Stone), whose car was wired with dynamite by rivals. Leonhardt's back was broken and he lost a leg when the bomb went off in the driveway of his 5693 Heather Street home in comfortable Oakridge.[212] Fully thirty-two individuals were arrested and charged in connection with the narcotics trade in 1955 alone. Hefty sentences ranging from ten to fourteen years were handed out the next year, the highest going to Daniel "Red" Place, the alleged "king-pin" in local drug traffic.[213]

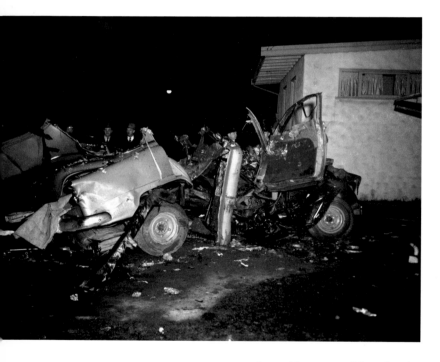

Jacob (Jack Stone) Leonhardt was fortunate to survive the bomb blast that tore apart his car outside his home in August 1955.

ROSS J. KENWARD PHOTO, VANCOUVER PUBLIC LIBRARY VPL 44196

By the end of the *Noir* period, the golden age of bootlegging was eclipsed by rising rates of drug peddling. In 1960 the VPD seized nearly six thousand bottles of beer, about thirteen hundred bottles of liquor, and close to eight hundred bottles of wine; and yet only eighty-two arrests were made. By contrast, in the same year 567 arrests were made under the Opium and Narcotic Drugs Act. The Chief Commissioner complained that the drug trade and its clientele had now moved well beyond any single neighbourhood, making it more difficult to keep an eye on probable suspects.[214]

Skin City

The conflict between rising middle-class ambitions and long-established values was probably made most clear in the moral panic over prostitution. Vancouver is a port town; inevitably it has attracted its share of brothels and "houses of ill-repute." The Strathcona brothels probably still numbered over a hundred in the 1930s, although few were as grand as the old establishments had been. They closed down one by one, leaving only a handful—including an ostentatious example on Alexander Street by the mill—to struggle into the 1940s.[215] Madams like Dominique DeSoto were regarded locally as professional, smart, and classy.[216] Others, including Chinese prostitutes, carried on their trade in the Empress Hotel at the Four Corners. The East End moral crusader, the Reverend Andrew Roddan himself was an unwitting brothel keeper, having rented out one of First United's Strathcona houses to a group of prostitutes.[217] Another Japanese brothel keeper leased the upstairs of 35 West Hastings. She ran a dozen women from the rooms, keeping thirty per cent of the take for herself. Her white women would fetch $2 but Japanese women commanded a higher price: $3 to $5. The police were regular visitors and they got their service for free. In exchange, the operation was not raided. When an acquaintance from Kamloops became a high-ranking member of the VPD, this madam's operation was gold-plated, despite pronouncements of a crackdown on the sex trade. And the more the other brothels suffered, the better her business did.[218] Annual Police Commission Reports tell a tale of ineffectual efforts on the part of the Vice Squad, as more than four hundred charges were laid each year in the category of "Keeper of a Disorderly House" or "Section 228 (Bawdy House)", plus a handful more against "Inmates of Disorderly Houses" and sex traders sometimes captured under "Vagrancy."[219]

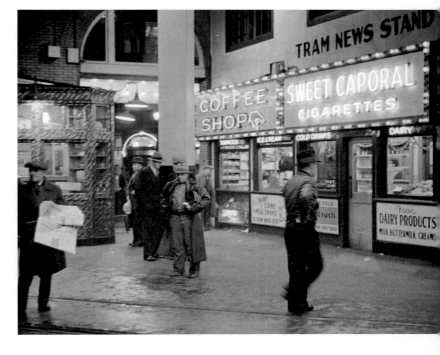

The Tram News Stand and Coffee Shop illuminated at night in the B.C. Electric Building at 425 Carrall Street, 1937.

CITY OF VANCOUVER ARCHIVES 260-778, PHOTO BY JAMES CROOKALL

This campaign has all the markings of a routine intended to give the appearance of policing. By the mid-1930s it was not enough.

The Mary Shaw murder of 1931, in addition to being a tragedy in its own right, set the stage for a sexualized and racialized confrontation over prostitution on the Eastside. Shaw was a white waitress in a Chinatown restaurant. The story goes that she had caught the eye of Lee Dick who, probably out of jealousy, shot and killed Shaw in the middle of the East Pender eatery and then, standing over her lifeless body, turned the gun on himself.[220] Chinese restaurants thereafter became the subject of a crackdown on the use of white waitresses and in 1935 Chief Constable Foster launched a crusade against the practice. As Foster put it, "The restaurants affected by the ban are ... patronized exclusively by Chinese with the possible exception of a few low type whites."[221] The target may have been prostitution, not Chinatown waitresses, but increasingly middle-class reformers could not make this sort of distinction. In their

Dancers at the Palomar, ca. 1950.

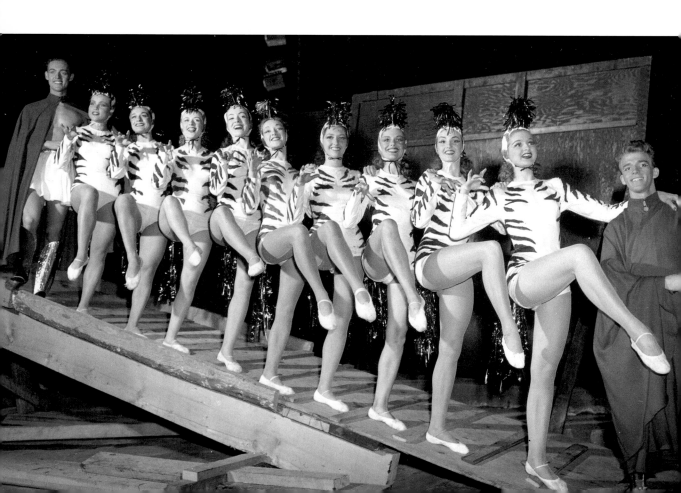

failure, McGeer and Foster not only reinforced the prejudicial image of vice-ridden Chinatown and morally bankrupt, sexually predacious Chinese males, they effectively mined and paraded the *Noir* image of the woman of dubious morals.[222] The Yellow Peril was invoked, not for the first time in Vancouver's history: white women were prey to the cold-blooded sexual appetites of the Asians. Inter-racial sex—long a source of visceral fear in a white community weaned on Social Darwinism, eugenics, and straight-ahead racism—resonated with the locals. When Foster found his efforts frustrated by the courts, he turned to the City's Licence Inspector, H.A. Urquhart, a like-minded bureaucrat who could close down offending restaurants. And offence came cheap: "loose conduct" included "a white waitress sitting down with a Chinese," which was thought to be a sure sign that the sale of sex was being negotiated. Mayor George Miller, not the worst of a bad lot, proclaimed that he was "out to clean up Chinatown."[223]

Out of this campaign we might single out Mah Chee. He rounded out a list of men charged in 1937 with living off the avails of prostitution. While most of his peers received six months to two years in jail, and although one William Larsen got a stiffer sentence of five years, Mah not only tied for second longest stretch in jail at three years, but he was the only man so charged who was whipped—Mah got nine lashes.[224]

For their part, the restaurant women were appalled not only by their sudden loss of jobs and incomes but also by the taint of immorality that now stuck to them. According to one of the waitresses, the councilmen who mounted the crackdown were "a bunch of fussy old bridge-playing gossips who are self-appointed directors of morals for the girls in Chinatown."[225] During a protest march to City Hall in September 1937, another said, "We must live and heaven knows if a girl is inclined to go wrong, she can do it just as readily on Granville Street as she can down here."[226] By forcing the waitresses onto the streets, city officials and do-gooders almost certainly propelled a few of the women into genuine prostitution.[227]

The attack on the Chinese restaurants was part of a larger vice clampdown by McGeer. In a 1935 radio broadcast to the citizens of Vancouver, he maintained that there were easily one hundred "brothels and drug dives" and at least two-dozen pimps at the start of the year; the crusade under Foster (for which McGeer claimed overall credit) led to seventeen convictions for living off the avails of prostitution for a total of

more than ninety years jail time. Be that as it may, McGeer's assurance that this would surely "put an end to that reprehensible traffic in our City forever" was foolish at best. His claim that he had made Vancouver "crimeless as far as the commercialization of vice and evil is concerned" was simply ludicrous.[228]

Another purported embargo on sin got under way around 1938 but the evidence of success has to be taken with a shot of whisky. Foster boasted that year that "commercialized vice has been eliminated," a remarkable achievement based (it would seem) on fewer arrests, charges, and successful prosecutions than in previous years. Even the Chief Constable couldn't sustain the charade. While there was no more commercialized vice, there were still thirty-three bawdy houses in operation, though this may have hidden a major decline. (According to a later police probe into vice, "bawdy houses ran wide open from 1920 to 1938."[229]) Streetwalking, in the meantime, had been "practically eliminated" before the Second World War.[230]

What was called "the big drive against vice" (as if it was the first) got underway after social democrat Dr. Lyle Telford became mayor in 1939. It was under the good doctor's regime that the discourse on prostitution

The Palomar, like its competitors the Cave and Isy's, served up style, 1951.

ART JONES PHOTO, VANCOUVER PUBLIC LIBRARY
VPL 81618

shifted its focus somewhat to venereal diseases. Women "on the game" were regarded as the principal conduits for syphilis and gonorrhea, rather than the men who made use of their services.[231] Prostitutes were now increasingly depicted not so much as fallen women but predatory and potentially destructive, infectious *femmes fatale*. According to the provincial Minister of Health, Vancouver was itself a diseased city. He claimed that the city had the worst v.d. levels in the province; and it was almost a given that the province had the worst record in the country.[232] Feeding anxieties that these conditions were safeguarded rather than fought by the police, one

brothel keeper was quoted in the *Vancouver Province* in 1939: "Vancouver is the easiest spot on the continent, and … we have nothing to fear from the police here."[233] Overall, the evidence points in one direction only: vice continued unabated. In the aftermath of the war there were at least sixty brothels operating in the city and gambling operations were still going strong.

New measures that were introduced in the 1940s and '50s, included sexual segregation in beer parlours. This step was meant in part to keep the prostitutes separate from the casual male drinker. So powerful was the moral panic around venereal disease in the 1930s—and it only worsened during wartime—that the segregation policy was rationalized by arguing that "the use of non-sterile drinking glasses" was spreading syphilis; somehow the sexual segregation at the door would be extended to the washing-up sink in the back. Arguing to a 1939 gathering of Rotarians at the Hotel Vancouver, the Director of the Division of Venereal Disease Control claimed his unit knew where the brothels were, knew who the highly infected sex trade workers were ("they leave a trail" of disease "wherever they go"), and he recommended busting the brothels and keeping the prostitutes on the move, making them harder for clients to find. But, of course, also making it harder for police and medical officers to track.[234] Much of the traffic moved to the beer parlours. In 1942, nineteen Vancouver beer parlours were identified as posing a threat to the Canadian war effort, so great was the traffic in sex and the likelihood of infection. Crackdowns on the sex trade during the war intensified and by 1945 the brothels had effectively closed; street prostitution took their place and the action shifted to less salubrious accommodations like the Main Hotel or the London Hotel.[235]

Since the beer parlours were concentrated overwhelmingly in the Downtown Eastside, it was hardly a surprise to find that beer parlour prostitutes were equated with Skid Row. From the Lotus through the Roger, the Main, and probably every other beer parlour in between and beyond, the sex trade came to where the business was: the beer parlours where loggers, dockworkers, miners, and other hard-working males with money in their pockets could be found. In 1947, the West Hotel banned from its premises no fewer than seventeen women thought to be sex trade workers. As historian Bob Campbell happily points out, their number included "Shanghai Lil,'" "Big Betty," and "Irene, the Logger's Queen."[236]

Inside a 1940s beer parlour.
CITY OF VANCOUVER ARCHIVES 1184-1018, JACK LINDSAY

As the *Noir* era closes, police report a new phenomenon: call girls. In 1960 a major operation on the part of the VPD closed the noose on an "organized ring" working out of a West End apartment building. Instead of targeting those who were "living off the avails of prostitution"—which would have netted only a few of the ring's top players—the VPD built their investigation systematically so as to charge as many as possible with "Conspiracy to live off the Avails of Prostitution." Four detectives were assigned to the case, a "system of code words was developed, with references to all hotels, the names of the girls involved and other pertinent information." The plainclothes detectives repeatedly followed the women from "the office" in the West End to assignations in hotels across the city centre. On November 10th, 1960, search warrants were obtained and ten arrest warrants as well. Perhaps it is a measure of the extent to which the VPD had become more professional: the cloak-and-dagger approach was not blown and all the parties arrested pleaded guilty to charges.[237]

Despite successive "wars on vice," Vancouver ends the *Noir* years much as it began: a haven for gamblers and drinkers and individuals interested in the buying and selling of sex in a wide variety of forms. Skid Row is often described as "seedy" but Vancouver as a whole in these years verged on the sleazy. It was a drizzly Vegas, strewn with neon lights, illicit thrills, liquor, gambling, sex, glamour, and swing beats. When legalized gambling took off in Nevada in the 1950s and when the British Columbian economy was strong enough to pay for vacations to slick American gambling palaces, and when the process of suburbanization had combined at last with the rise of television, Vancouver's old dens of iniquity began to shrivel up. Policing the situation hadn't really done much; the opportunity to consume liquor, shoot craps, and watch showgirls without fear of persecution, or to stay home and watch the TV was a far more effective impediment to sin in the city.

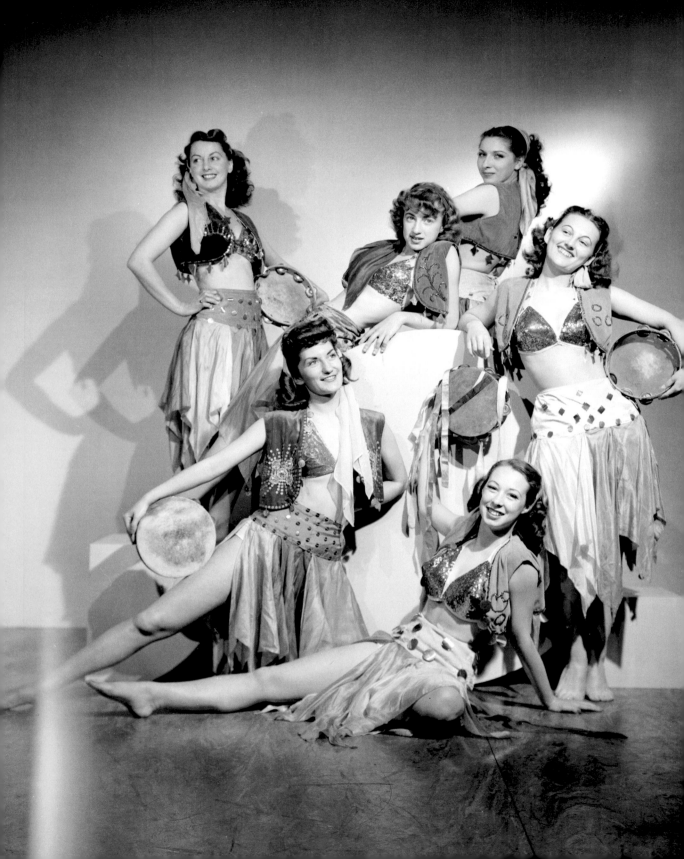

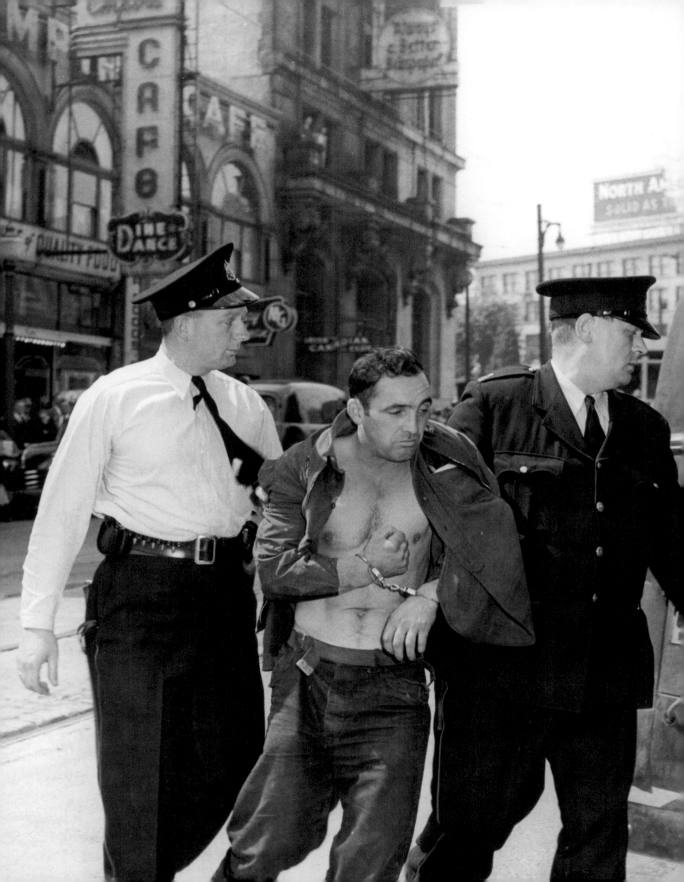

BY SEA AND LAND WE PROSPER : CRIME

"On April 8, 1949, at about 10:30 a.m. a stolen maroon Mercury sedan pulled to the side of the Canadian Bank of Commerce, 1st Avenue and Commercial Drive, Vancouver. The driver, later identified as Robert George Harrison, made his way to the entrance hall and put on a handkerchief mask. A 9 mm Browning in his hand, he then entered the bank shielded by an elderly woman. He shouted something not clearly heard by the employees, and fired one shot into the ceiling. The bank accountant, working on the books halfway along the south wall, attempted to run to the Manager's office. Harrison fired at him, striking him low in the right shoulder. He continued firing, following the accountant in his flight. One bullet struck the east wall of the Manager's office, two bullets passed through the glass door of the office and two more ploughed through the north wall west of the door. The accountant fell to the floor of the office. One bullet … struck the manager causing a flesh wound in the left leg near the hip. Not realizing he had been injured, the manager entered the bank proper where Harrison demanded he go to the No. 1 teller's cage and give him the money and the bank gun. The gunman was still using the woman customer as a shield. Two of the staff were flat on the floor. After receiving the bank gun and the money, which he stuffed into his pockets, the holdup man backed to the door taking the elderly woman with him.

During this time Constable Paul of the Traffic Division of this Department was cruising along Commercial Drive on his motorcycle towards 1st Avenue and Commercial Drive, when his attention was drawn to the Canadian Bank of Commerce by a large crowd shouting and waving towards the bank. As he reached the centre of the intersection he observed a masked man, carrying a gun in his right hand, leaving the bank. As the bandit came out on a landing leading to the steps, he fired a shot at a man crouched beside a parked car. Noticing Paul advancing towards him, he raced down the bank steps and attempted to grab a young lady to use as a shield. She fought him off and he then grabbed up a small

boy and advanced, holding the boy in front of him. He fired a shot in the direction of the officer. Paul fired a warning shot and as Harrison did not drop his gun, he fired a second shot which struck the bandit on the forehead. Harrison dropped to the roadway—dead."[238]

WHATEVER ELSE WALTER MULLIGAN might have been—a crusader against or a beneficiary of vice, a tyrannical leader, corrupt top-cop, effective or morally suspect—he was a formidable writer. The passage above comes from the Chief Constable's Annual Report for 1950 and it screams out *Noir*. Desperation, gunplay, a trio of human shields. Bullets don't hit a wall, they "plough" into it. And the policeman's response to being shot at is a "warning shot." One can imagine the Sam Spade-esque dialogue:

"I fired a warning shot."

"After he shot at you, you fired a 'warning' shot?"

"I figure any shot that misses is a warning shot."

These were years in which banks were for robbing, safes were for cracking, widows were for bilking, and comic books were for burning. Gangs wearing zootsuits and criminals with trademark nicknames like "The Flea" or the "Scar-Nosed Slugger" decorated the front pages of Vancouver's newspapers. It was also the era that witnessed the debut of "prowler cars" and a "police lab."

Noir era crime took many forms but there were four in particular that gave fear of the criminal its particular shadowy shape in these years: hold-ups, safe cracking, fraud, and juvenile gangs. This chapter unmasks the bandits and throws a spotlight onto the criminal class lurking in the shadows of *Noir*.

Watching the Detectives

One effect of the Wall Street Crash of 1929 was an immediate spike in criminal activity. The headlines on the 7th January 1930 cried out, "Crime Wave Sweeps Vancouver." Sub-headers included "7 Outrages Over Night" and "Many Burglaries & Petty Thefts." Hospital nurses were held up at gunpoint; seventeen "bandits" were hard at work. The Chief of Police, W.J. Bingham, denied the existence of a "criminal class" but he acknowledged that the city was experiencing crime like it never had in recent memory. Bingham placed the blame on the unemployed, particularly "a certain section of the unemployed, the troublesome,

disgruntled element which entered Vancouver" in the autumn of 1929. There were many in Vancouver who agreed with Bingham that "idleness leads to an inevitable increase of crime."[239] Certainly, destitution drove more than a few to rob banks, hold up taxis, and take a gun into a coffee shop. The newspapers played this to the hilt, with lurid, cascading headlines like these from the front page of *The Sun* on December 5, 1932: "Bandits Stage Crime Orgy;" "Pepper Thrown in Woman's Eyes;" "Prison Terms, Lashes Given Pair;" "Terminal City Club Held Up, Thrilling Chase." On December 15, 1932, there were five hold-ups in the city in one night. Two weeks later, a woman wearing two rings of considerable value was abducted by four men and a woman as she left an East Hastings Street pre-New Year's Eve party at 1 a.m.; she was taken to Stanley Park, and was severely beaten and robbed. The same night two gunmen hit a social club at 50 Dunlevy Street, taking away $40 in cash.[240] Not a bad haul in the Depression, since high rates of joblessness meant that the weed of crime often bore very meagre fruit. In another case from the early '30s, a pair of men were robbed by three "youths, one armed with an old revolver," losing a total of fifty cents in change and a packet of cigarettes.[241] No one was safe as crime evidently ran rampant.

"Just the facts, ma'am." A detective calls, ca.1940.

One local church minister in 1931 appealed to the public to act in some way to support the unemployed and the desperate: "Don't let the underworld win by default."[242] It's safe to say, however, that the organized "underworld" wasn't likely to be behind the 2,700-plus burglaries (or "B&Es") that were recorded each year until 1940. Thefts, too, were steady at between 7,300 to 7,700 per year until the outbreak of the Second World War. The value of property stolen was also fairly stable, fluctuating within a range of $240,000 to $313,000. Perhaps the high number of robberies can be explained by the poor returns. One mugging that ended in the elderly victim's death involved two juveniles who briefly escaped with the grand sum of $1.25 and a pocket knife. When the takings are that poor, there's nothing else to do but try again. Certainly crime rates dipped as the world plunged once more into conflict and joblessness disappeared almost overnight: thefts, for example, fell by about ten percent between 1938 and 1940. But once the new reality took hold—near full employment, rationing, changes in policing, wartime laws dealing with crime and mobility—the rates rose sharply again. The incidence of theft was higher in 1943 than at any time previously, extending to more than 8,000 victims for the first time. And evidently there was more and better stuff to steal. The value of stolen property in 1940 was reckoned at $212,000; in 1944 it was more than $430,000.[243] As the war drew to a close, the litany of crimes that plagued the city seems to have intensified. The number of guns involved very definitely increased, as does the occurrence in police and court reports of the phrase "army deserter." In 1944 alone, the Chief Constable's report highlighted eight homicides, a bank robbing spree on the part of an RCAF member, the kidnapping and robbery of a drugstore owner, the hold-up at gunpoint of the West Hastings Moose Club, and the arrest of two men who were running a cross-town robbery campaign against confectionaries. What distinguished this year from others was reports of serial crimes: bandits who hit several targets, murderers who killed more than one victim. Following a late '40s lull that convinced senior officials that crime was in retreat, rates in 1954 and 1955 shot up once more. Seven murders were recorded in 1954, robbery with violence jumped by seventy-one cases (an increase of nearly fifty per cent over 1953) and B&Es went up by nearly fifteen per cent. Crime rates were high and, despite some fluctuations, kept growing with the population.

A vengeful gang singles out a suburban mayor as their target in 1933. In this case, 'XXX' is not kisses.

CITY OF VANCOUVER ARCHIVES 99-2756, STUART THOMSON

Vancouver's Finest

To be fair to the VPD, they had their work cut out for them. Early in the Depression the parades and protests mounted by the unemployed and the Left meant "much valuable time which would otherwise be devoted to investigation and suppression of crime was taken up in curbing street demonstrations and maintaining 'the Peace.'" Not that there was much to work with anyway: in 1935, when the city's population was still less than 250,000, there were only 336 police on the force and their wages had been cut in both 1932 and 1933.[244] Ten years later—by which time more than 60,000 had been added to the city proper (not to mention the suburbs)—the VPD's "authorized strength" was barely more than four hundred.[245] The passing of still another decade saw the number of Vancouverites reach four hundred thousand, with the VPD now at 735 members. Proportionally, this was significant growth for the Police force; nevertheless, there were still fewer than two employees of the VPD for every thousand citizens.

Given the lack of training received by the City's force, it's no surprise that the business of controlling crime seemed so hopeless. From year to year the newspapers of the period report a new "crime wave." In 1947, hard on the heels of the murder of two police constables by a trio of foiled bank robbers, newly sworn in Chief Constable Walter Mulligan declared the "gloves were off" in what one newspaper stated was a "war against crime." And yet, in the two days after the fateful shooting of Constables Ledingham and Boyes, *The Sun* reported that "Vancouver has had seven burglaries, two holdups, one of them armed, two attempted robberies and nineteen thefts."[246]

Throughout the age of *Noir* there is a campaign to modernize the war on crime, to take it from a cottage industry of physically large but untrained beat cops to a corps of professionals supported by an array of technological advantages.[247] As the era opens the Police Commission is solicited by Colonel Charles Edgar Edgett for car radios in order to "combat the high speed and efficiency with which criminals now do their infamous work."[248] "Doc" Edgett was also, in the same year, in the market for another marvel of modernity, the teletype machine. According to one account, Edgett "put additional officers on the street, increased the number of patrol cars, and acquired more high-powered firearms."[249] Practices and procedures also changed, as identification "Line-ups" become a more common tool early on.[250] "Prowler cars" were also introduced. The VPD's

The VPD was eager to show the public that crime investigation consisted of more than roughing up suspects, 1930s.

IMAGE B-06230 COURTESY OF ROYAL BC MUSEUM, BC ARCHIVES.

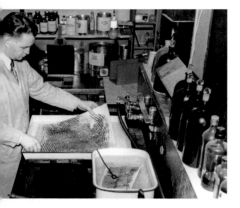

above: The VPD Bureau of Science shows off its equipment and its labcoat, 1940s.
VANCOUVER POLICE MUSEUM, 048

below: An early breathalyzer, called a 'Drinkometer,' shown off in a staged photo, 1953.
VANCOUVER POLICE MUSEUM, 3095

"Bureau of Science Division" was created in November 1932 and in its first month of operation conducted fifty-seven investigations which included "the identification of blood and human blood stains, seminal fluid, explosives, implement and human impressions and measurements, identification and classification of body and implement matter, cloth fabric, gravel, earth, rock, stains, film and oxidation deposits left at the scene of the crime, or which had become attached and found adhering to exhibits, or to the person and clothing of accused persons."[251] The work of the Bureau, moreover, was publicized like no other part of the VPD, as successive modernizers tried to convince the public that the progressive Vancouver Police Department was at the cutting edge of crime-fighting. A display of crime lab equipment was put together for the Vancouver Exhibition Association fair (later known as the PNE) and was subsequently on show at the main streetcar terminus downturn.[252] News of every fresh innovation was breathlessly released to the public. Staged photographs from Mulligan's early years as Commissioner show labcoat-wearing police technicians and coroners launching a scientific campaign against crime. Something similar occurred when the VPD

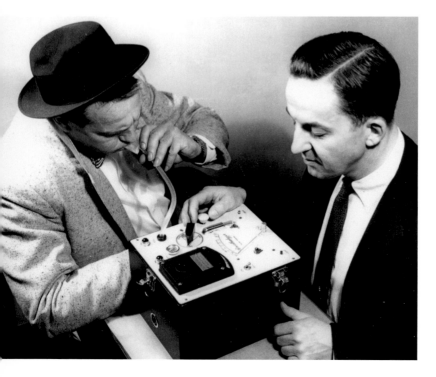

acquired scuba gear (still in 1955 referred to awkwardly as "underwater breathing apparatus").[253] In the mid-1950s another piece of technology made its debut: the Breathalyzer. Described as a machine that "measures the amount of alcoholic influence in a subject," it was at first a huge and cumbersome machine; in 1957 it was rendered sufficiently portable that it could, for the first time, be taken to a crime scene.[254] The VPD's lab even played a minor role in a 1958 scandal involving a Provincial Cabinet Minister who was suspected of fudging his accounts; the Science Unit restored ledger entries that had been "chemically erased."[255]

All the new technology and forensic gear aside, the VPD was

still—even as late as 1957—mostly made up of men who, in the words of no less an authority on the subject than the Chief Constable, had "received little or no training."[256] Certainly there was little in the way of "police training," but much of the force in the 1930s, '40s, and '50s cut its teeth in battlefield situations abroad during two world wars. Both Edgett and Foster were unmistakeably military men, and they looked for military discipline from the constables in their service—something that became especially clear during the 1930s waterfront wars. But armed and mounted confrontation with organized and disorganized labour constitutes only a small part of the work of the VPD; battling crime was another matter.

Crime Wave

Was there a reciprocal relationship between the Hollywood version of *Noir* and the reality? The workaday lingo of the bad guys suggests there was. A 1930s mugger was quoted in *The Sun* as using these lines: "Stick 'em up, buddy. I want your money. Reach up with those lunch hooks."[257] One bank robber in 1958 passed a note to the teller in the 4095 Main Street branch of the Royal Bank: "This is a hold-up, hand over the big bills." He pulled his coat open to reveal a gun and said, "Hurry up—in about two minutes you'll get this."[258] Do these not read like B-movie scripts?

And it wasn't just the villains who were employing *Noir* dialogue. The police adopted new terms, for example, describing robberies in 1931 for the first time as "so called 'Hold-ups.'" [259] The press, for their part, applied new images. In both cases, they were seemingly mining the rich veins of pulp fiction: hard-bitten, tough, dramatic, and a touch sleazy. It smells of stale cigarette smoke in cheap hotel rooms, whisky in a lipstick-stained tumbler, and a

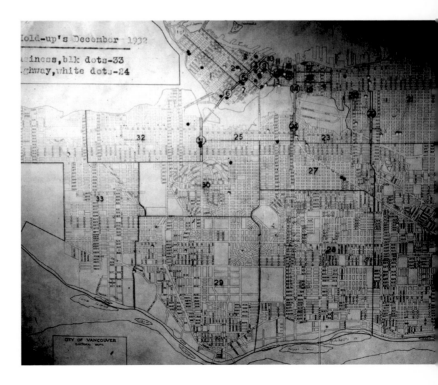

A VPD map showing thefts and other crimes, heavily concentrated in the old Downtown, 1932.
VANCOUVER POLICE MUSEUM, 3627

roll of marked ten-dollar bills. So much so, you'd think there was a different class of criminal in the *Noir* era.

A rash of violent robberies in early 1930 provoked colourful coverage by reporters at *The Sun* in particular. The "Shoeless Bandit" struck a home at 2490 West 1st Avenue, pistol-whipping a woman and tying her to her bed. A motorcycle cop on the scene gave chase, putting a bullet into one of four villains: the "Scar-Nosed Slugger," a thief who had coshed a local woman on West Tenth the day before. The round-up that day pulled in just one fish: George "Squint-Eye" Imbree.[260] A few months later an opium smuggling ring was broken up and John Bishop, alias "One-Armed Casey," was brought to book.[261]

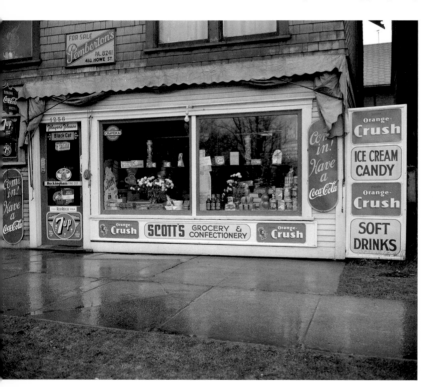

Typical of the dozens and dozens of neighbourhood stores across the city, Scott's might have been a target for thieves or a front for gambling, 1940s.

CITY OF VANCOUVER ARCHIVES 1184-3185,
JACK LINDSAY

Through the summer of 1935 the city's small groceries were being plagued by a team of robbers. These hoods were known as the "Silk Stocking Gang" for the masks they wore over their heads, and also as the "Blue Sedan Bandits" for the cars they stole and used in the commission of their crimes. One of the four gang members, still wearing his mask, was captured after a gun-blazing high-speed car chase down Broadway and its side streets, a chase that involved no less a figure than the Chief Constable himself. Two of the remaining three were captured shortly thereafter and the teenaged gang leader, Elmer Almquist, confessed to more than two dozen armed robberies.[262]

One other brief criminal career-of-the-year deserves mention: the case of the "Southern Gentleman Bandit." On February 9th, 1944, the Stanley Theatre on South Granville was hit by a good looking, well dressed, young man described as wielding a sawed-off revolver, wearing a bandage over his chin, and having a pronounced Southern accent. Escaping with $200, the Southerner moved onto New Westminster, where

he kidnapped the manager of a large hardware store at his home, took him to his place of business and forced him to empty the safe of some $700. According to VPD reports, the police detectives' response was to target the local dancehalls, reckoning that a handsome young robber would be in a hurry to spend his loot. And indeed he was. Two weeks after the brazen New Westminster crime, Calvin William Bailey was arrested at a dancehall. The only mystery that remained was the question of the bandage on the chin: it hid a distinctive scar.[263]

Other celebrated—if somewhat more anonymous—robberies blazed across the headlines. In 1940, in the small hours of December 1st, the Night Steward at the posh Terminal City Club found himself looking down the barrel of a large black revolver as two hold-up men cleaned out the Club's cash holdings.[264] Six

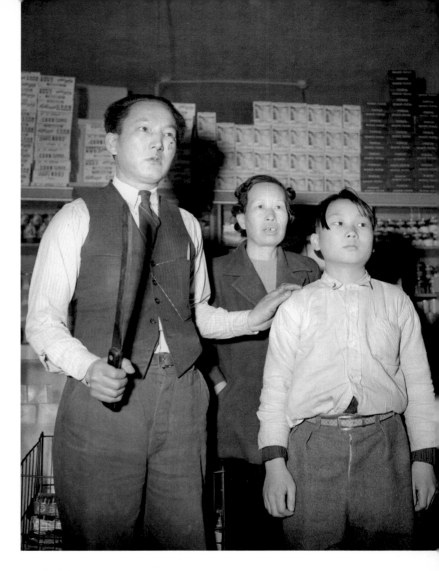

Wong's Grocery, 500 East Pender Street, storekeepers who routed robber, 1950.
ARTRAY PHOTO, VANCOUVER PUBLIC LIBRARY VPL 81131

years later a gang of three young men, aged eighteen to twenty years, hit a series of small stores across the city, including the Honest Way Grocery at 1101 Nelson, the Irish Steam Baths at 1233 West Broadway, the Whiteway Cleaners at 1523 East Thirteenth, Goe Lee's Chinese Laundry at 3268 Main, and Carrie's Dress Shop at 3096 Granville.[265] (Like several of their peers in the young criminal fraternity, they were not merely jailed: they were whipped, too.)

In November 1948, another gang of armed men began a spree of robberies targeting theatres, banks and small stores. They hit the Orpheum Theatre and a Chinese laundry three blocks away on Homer Street on the same day. One month and several hold-ups later the first of the robbers, William Coxon, was in police custody. Daniel Munroe was in the hands of the VPD two weeks after that, having botched the

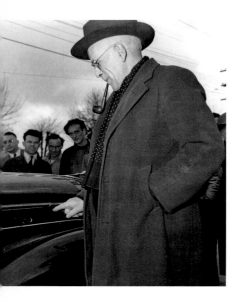

The Vancouver Coroner obligingly points out a bullet hole after the shootout at the Commercial Drive Bank of Commerce while a crowd watches, 1949.

robbery of an Imperial Bank branch at Granville and Dunsmuir. Ernest Dorey's arrest followed three days later, and he admitted to robbing three theatres as well as a small store. This, as the Chief Commissioner boasted, "brought to a successful conclusion this 'wave' of holdups" that had kept police running hard for six weeks.[266] After a very quiet year in 1952, the incidences of hold-ups resumed, peaking five years later.[267] In 1957 there was a particularly wild crime wave involving nearly a hundred violent robberies. Nearly three dozen small grocery stores—the sort of family-run operations that dotted the city—were held up.[268]

There were other criminals at work, breaking and entering across the city. Over a three-year period one man launched a bizarre nighttime charm offensive, breaking into the bedrooms of women who lived alone, kissing them in their sleep, but otherwise not assaulting them. The police chased the chaste "Love Bandit," as the newspapers called him, until he was captured—by citizens who summarily beat him senseless. (His otherwise successful kiss-and-run career might be explained by the fact he was an ex-cop.)[269]

The "Love Bandit" wasn't the only crook so dramatically named. A more dangerous peer was "The Point Grey Molester," who stalked the west side between December 1957 and February 1959. Out in the leafy suburbs near UBC, young Barry McLintock was prowling from bedroom to bedroom in a tight four-block radius, terrifying young women night after night. His *modus operandi* was to find his way into the victim's bedroom while she was asleep, and wake her with a flashlight blazing into her eyes and a knife pressed against her throat or some other part of the her body. The victim was commanded to strip, and typically she was "mauled and, in some cases, forced to submit to indecent acts." None of McLintock's victims were, however, raped. Indeed, one of his targets described him, acidly, as "young and inexperienced." Be that as it may, he eluded the police for more than a year and did so despite being interviewed early on and, remarkably, being stopped by police in January 1959 as he was, in his own words, on his way to the University of British Columbia to "prowl women's dormitories." The fact that he was carrying both a sheath knife and a flashlight did not, evidently, set off alarm bells. Had McLintock not decided to hold up a bus one night in March 1959, he might have remained on the loose for considerably longer.[270]

Honest citizens could rightly be afraid. Random robberies of small (in some cases, very small) neighbourhood stores brought crime

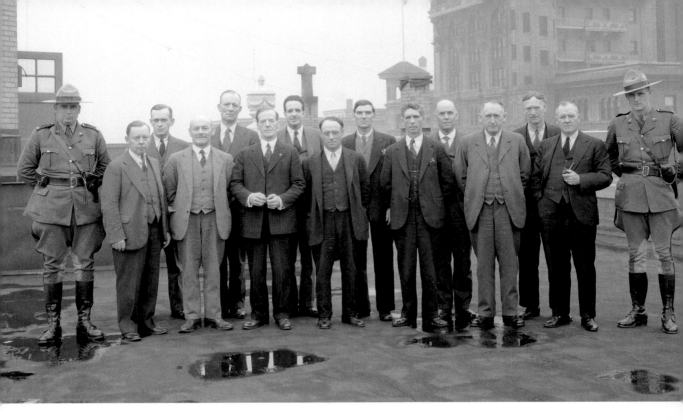

into almost every part of the city. Gunplay was remarkably common. For example, in February of 1947 a man was begging at a Granville Street café, troubling the cashier for seven cents. Police showed up and the suspect scarpered. The police on the scene fired two "warning shots" after the man as he fled up the busy sidewalk, winging a sixty-seven-year-old woman, Mrs. Annie Campbell, who was waiting for a streetcar, tearing through her left leg."[271] Bullets flew wildly through the windows of residents at home, as well, on three separate occasions in 1947 alone.[272] Because "Police officers and bandits 'took to their guns'" so frequently, and because a "fusillade of shots" might be followed by five more "snapped" off while another constable "peppered prowlers," the risk of a chance injury was not insignificant.[273] And the poverty of the 1930s combined with the instability of the war years provided motivation to a greater and greater number of Vancouver's potential thieves. This latter group included C.H. Cahan, Jr., a fifty-one-year-old Vancouver barrister who held up the Canadian Bank of Commerce in west side Dunbar in 1938. He came away with $69 and a sentence that included seven years behind bars.[274] This sort of crime occurred often enough but it was not what Vancouver became well-known for. That distinction belonged to a different category of thief.

The murder of Dominion Constable Francis Gisbourne in 1934 led to the conviction of four brothers from First Nations reserves in the Interior. An all-white jury takes a break while considering their appeal.

A Safe Job

Although there were better ways to make a crooked buck, safe-cracking was a *Noir* speciality in Vancouver. Safecrackers regarded Vancouver's many safes as easy pickings. They hit everything from the massive and complex vaults in banks to the smallest of church safes, like that of First Baptist at Nelson and Burrard (which rendered up $140 in April 1930). And, thanks to the nature of the BC resource economy, there was plenty of dynamite lying about, waiting to be misused. In March 1930 thieves stole forty sticks of dynamite from a road crew, "enough to blow up every safe in Vancouver," according to one source.[275]

From 1934 through 1937 there were nearly one hundred and fifty safe jobs pulled by "cracksmen" in the city, with a total take of more than $36,000.[276] The same number of safes were blown in one particularly busy year: 1958.[277] In 1943 alone, safecrackers struck at the LaSalle Bowling Alley on Granville, the Guernsey Breeders Dairy on West Broadway, the offices of McLennan McFeely & Prior at 556 Seymour, and Clark & Stewart Ltd. next door, and the Grand Union Market at the corner of Abbott and Hastings Street. In each case, the safecrackers or "yeggs" were apprehended, possibly not least because cracking safes is noisy work. And in one case, the cracksmen on the Dairy job walked away with one hundred and forty dollars—in American coppers, a heavy and bulky and obvious swag of loot.[278] Better dividends were paid out the same year to safecrackers who hit the Cave Cabaret, taking War Bonds and cash valued at nearly three thousand dollars. Other yeggs didn't do so well in the following year, 1944: attempts to rob the Creamland Crescent Dairy on Howe Street, McGavin's Baker on West Broadway, the Eldridge Drug Store, a men's clothing store on West Georgia, Orange Crush in the 3600 block of West 4th, and Suzette Sportswear at 639 Howe Street led to several arrests and long stretches in jail.[279] Likewise in 1946, when two "oldtime safecrackers" returned to the Grand Union Market, this time taking $400 and drugs reckoned worth a thousand dollars street-value, they had an hour to enjoy their takings before being rounded up by the VPD.[280]

A better record was logged by the three-man safe-cracking team that hit the Pacific Meat Company at 8950 Shaughnessy Street on the south side early in the morning of October 16, 1945. They blew two large safes and made off with nearly $3,000 in cash, $5,650 in bearer bonds, and $15,000 in other registered bonds. The bonds would show up

Yeggs strike again, this time at Rosses Restaurant, 1950.

VANCOUVER PUBLIC LIBRARY VPL 5490

from time to time as women and a man connected with an address near Davie and Granville tried to cash them at local banks. Try as they might, the police had no luck in pinning the crime to anyone.

Using the slang of the day The *Vancouver News-Herald* trumpeted the continuing plague of safecrackers in 1947 with headlines that included "Yeggs Strike Again" and "Girl Held as Yegg Suspect."[281] Indeed, "expert yeggmen" hit New Westminster's Queen's Park Arena after a New West—Seattle hockey game in 1947. Hiding themselves in the equipment room after the crowd had gone, they gained access to the office, "knocked off the safe dial, inserted the right amount of nitro-glycerine and blew the door partly off. [S]o expertly was the job done that nothing in the office except the safe was disturbed."[282] The safecrackers made off with an estimated $2,500 in cash, the entire "take" from the game (which, to make matters worse, was lost by the New Westminster squad).

These robberies tended to be the work of organized and well-equipped gangs. In December 1940 a chance interrogation of three men "known to police" revealed the basic kit of the professional safe-cracker: "Soap, fuse, fuse caps, a radio, … a quantity of nitro-glycerine, percussion caps, detonator caps, 900 blasting caps and a quantity of wiring…."[283]

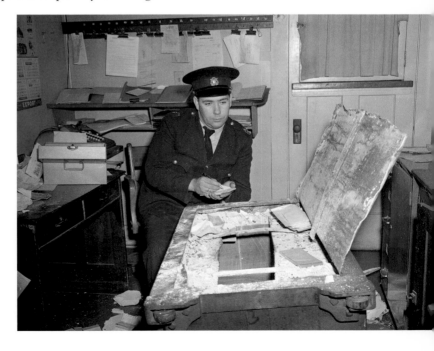

A burned safe belonging to a waterfront trade union in New Westminster, 1957.
NEW WESTMINSTER MUSEUM AND ARCHIVES, PHOTOGRAPH 3861001

The city's safecrackers were noticeably arming themselves with more and better explosives. And they got grudging respect from the press, which admired their efficiency and generally violence-free approach. One *Sun* account goes so far as to describe a gang as "hard-working yeggs."[284] Some of them were, indeed, criminal professionals. For example, the arrest and imprisonment in the spring of 1946 of Robert Davidson, Peter Swischook, Raymond McLeod, and Thomas Siddall put an end to safe-blowing in the city for a brief while. It was reckoned by police that this one team was behind "a large number" of explosive robberies.[285] In

November 1947 the career of thirty-four-year-old cracksman William Munavish, too, came to an end as he won the dubious distinction of being convicted as Canada's first "Habitual Criminal"—a career expert at blowing vaults.[286] In 1953 better luck and better planning was the trademark of the gang that cleaned a thousand dollars out the safe at the Sterling Laundry at 1460 West Seventh: they successfully gambled that the sound of the explosion would be mistaken for work on the new Granville Bridge.[287] In the mid-1950s another gang made up of "four Chinese and one white man" hit safes at the Grand Union Beer Parlour and H.Y. Louie Food Wholesale. In 1954 "a group of Montréal crooks were in Vancouver" with an eye to "burning" safes. By this time, police reports had developed a greater array of verbs to describe the business of cracking a safe: burning and blowing were joined by peeling and punching.[288]

Why so many hits on safes? American bank robber "Slick Willy" Sutton (allegedly) said it best: "that's where the money is." But there were other factors. Opening hours at the city's banks were limited to as little as five hours a day, meaning that most small businesses had to keep substantial sums of cash on-site. And this was a "paper" economy, in which cheques were easily cashed, credit cards were non-existent, and hard currency was everywhere. It might, however, be easier and cleaner to have people willingly hand you the money. To borrow a phrase attributed to another American entrepreneur, Texas Guinan, "Hello, suckers!".

Fraud Squad

Vancouver was a hotbed of unregulated gambling, backroom betting, and a legitimate resource-extraction sector that depended on wildcat speculating on mines and other dubious stock. This was a rich soil for growing a fraud industry. Throughout the *Noir* era the police reports are thick with accounts of fraudsters, cardsharps, and confidence men. In 1930 alone, forty-nine con men were arrested, many of them deported or simply "told to leave town."[289] Between 1929 and 1936 it was reckoned that "bunco" artists or con men fleeced Vancouverites for more than $700,000. At that time, Vancouver "was reputed to be one of the three worst places for that type of crime on the continent."[290]

A tabulation of fraud cases in Vancouver in 1946 points to the variety of cons at work in the Terminal City. In addition to the garden variety swindles, embezzlements, and thefts, there were seventy-one cases of

real estate, insurance, and business frauds, and 111 cases involving fraud associated with sales of magazines, hearing aids, and photographic equipment. What's more, one ethnic minority had its very own entry on this list of infamy: "Gypsies" associated with fortune telling and pocket-picking were responsible for sixteen entries on the '46 list.[291] In 1947 the Fraud Bureau was turning its attention to what it called: "Medical and Religious Quackery."[292] Of the latter it can be said this was a North America-wide phenomenon built on the foundation of pseudo-Eastern religions that appeared in the interwar years. The most unique of the Vancouver crop was the Canadian Temple Cathedral of the

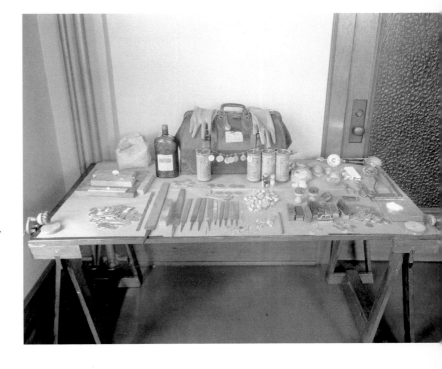

The arrest of a counterfeiting ring netted this equipment in 1932.
CITY OF VANCOUVER ARCHIVES 99-4248, STUART THOMSON

Universal Apostolic Church of the More Abundant Life, which in 1954 set up shop in Ceperley House in Burnaby under the leadership of William Franklin Wolsey (aka Archbishop John I).[293] Counterfeiting was another speciality and in September 1949 the VPD clapped the cuffs on a pair of men who were circulating a large number of bogus ten-dollar bills at the PNE.[294]

One 1940 case was typical of the kind of bunco operations favoured in Vancouver. A small gang of con men placed adverts in the local newspapers, fishing for locals with a few hundred dollars to invest as "partners" in what were described as "established concerns." Usually the business opportunity was presented as something in the insecticide or veterinary supply business, sometimes in a movie-making opportunity, or (almost inevitably) in a mining prospect. The real sting began when the supplies purchased by the target were provided by one member of the gang (presenting himself as an independent third party) "at exorbitant prices." Then the mark would be shown how difficult it was to sell the supplies and/or product, and would be encouraged to offload the remainder at a discount, usually to another member of the gang. The victim would

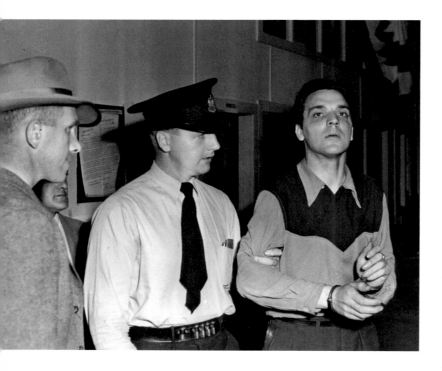

The PNE attracted more than its share of fraudsters, including this counterfeiter, 1949.

VANCOUVER PUBLIC LIBRARY VPL 3424

be provided with a promissory note which was, of course, worthless. The whole cycle could take as little time to complete as a few hours from the point of contact. The Graham Gang cleared $16,000 in these lightning bunco frauds, which involved nearly forty victims.[295]

Another fraud preyed upon the victim's greed coupled to their sense of guilt. A bank clerk would be contacted by one of the Gerrard Brothers Gang about a slightly dodgy horse racing opportunity. The clerk would put up his money, perhaps a few times, until he started to count his losses. At that point, he'd be told that one of the consortium had been arrested, "and that the resultant publicity would probably cost the bank employee his job." Perhaps, he'd be told, the police might take an interest, too. At that stage, two of the gang members would present themselves at the home of the victim, masquerading as "detectives." They'd interview the mark until his nerves were frayed and then would extort more money from him. In one case, the victim was taken for $1300 of savings.[296]

A nursing homes fraud case cast a long shadow across the city in 1938. Eighty-two-year-old Eva Huntington was admitted to a nursing home operated by Violet Collins and her common-law husband, Andrew Goulding. The "home" was, in fact, a typical Kitsilano residence, one that was being run by the cold-blooded couple who systematically separated Huntington from her savings and "valuable jewelry, socks, wardrobe, household effects, and a valuable collection of silverware." When a cheque drawn on the Huntington account bounced, the local bank raised the alarm, mainly because they knew she was dead. In the four months after her admission to the Collins-Goulding operation some $2000 had been withdrawn from the elderly woman's accounts. The fact that a deceased woman was still writing cheques aroused the suspicion of the

VPD. Police caught a lucky break when an eighteen-year-old "nurse" in the home was caught trying to pawn a $300 diamond ring. The teen was, in all likelihood, another one of Mrs. Collins' clients, as the couple was also in the business of running a home for unmarried mothers and running an illegal adoption business as well. Both Goulding and Collins were apprehended, charged, and sentenced to four years in prison.[297]

Just as the war was getting underway, a "Big Science" wrinkle was added to Vancouver's bunco landscape. A con artist with some electrical knowledge faked up an electricity-generating invention that, on the face of it, involved a "radio-active fluid." It was all smoke and mirrors, but a subtle one that preyed on ignorance of the emerging super-scientific age.[298]

Mostly, however, fraudsters relied on the old dependable methods of separating suckers from their money. Take one last example: in 1946 alone there were thirty-one cases of bigamy. One of the biggest fraud busts of the year was the case of the serial groom, Armand J. LaRocque (status: married), who wedded *at least* three Vancouver women in an effort to get at their money.[299] A year later the Chief Constable (himself, ironically, a married man with a mistress in the East End) was complaining of "'Romeos' who obtain money from women by promises of marriage, which they cannot fulfil, as they are already married." This was, he observed, "a crime that was practically unknown here before the war." The golden age of bigamy in Vancouver even included a man who had three wives, two of whom were themselves bigamists![300]

Teenage Rampage

Juvenile delinquency was a concern throughout this period, increasingly during the 1950s. These were years in which free secondary education through twelfth grade was being gradually extended to more and more of the population. There's no point in talking about "Grade 10 dropouts" in the 1930s when the option of continuing into Grade 11 was as good as closed to the majority of adolescents. So, by the age of sixteen, a great many young Vancouverites were moving out of the institutional settings of high school and into the workforce or unemployment, into law-abiding citizenship or into criminality.

There were plenty of neighbourhood gangs in these days to hone criminal skills and toughness. Local teens associated with a few city blocks or a single street kept outsiders at its boundaries. They gravitated to the nearest coffee shop where they could hang out and look threaten-

ing as needs be. After the Depression, the gangs developed a different style. The Home Apple Gang was a Princess Avenue pack that graduated into flashy clothing in the 1940s but kept the Home Apple Pie Café as their base of operations.[301] The Home Apple Gang was part of the Zoot Suit movement that was renowned for their baggy "strides," tapered "tight at the ankle but measured as much as sixty centimetres across at the knee," topped with dress jackets that completed the wild angles with dramatically wide padded shoulders. The Zoots tended to be young, generally no older than eighteen, which is why they were still civilians and not part of the war effort.[302] In the absence of older males to rein them in, the Zoot Suit Armies prowled the streets at leisure, finding trouble with enlisted men and merchant sailors. And they were all pretty much fearless. In the summer of 1944, a body of US Marines (accompanied by a small marching band and armed with easily concealed blackjacks and billy clubs) descended on Strathcona with an eye to smashing in a few heads on account of some insult (real or imagined) in the name of moral uplift; they were met by an alliance of East End street gangs with greater resolve and larger bats.[303] As July turned into August, "zoot suit riots" continued through the downtown and along Granville Street.[304]

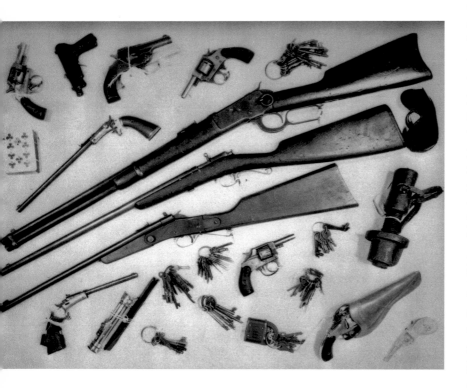

In the late 1920s and early 1930s teen gangs were armed with more than slingshots and BB guns.

VANCOUVER PUBLIC LIBRARY VPL 9109

The end of the War pretty much ended the Zoot Suit "menace," but that doesn't mean gangs disappeared. They re-formed into auto-theft rings and even hold-up gangs. In 1947, however, there occurred the first of several "turf wars" between East End and Kerrisdale rivals. Gang activity picked up in Point Grey as well, the corner of Alma and Broadway becoming a gathering point for the local "hooligans" and a

focus for conflict with raiding mobs. Switchblades made their first serious appearance in Vancouver and vandalism became a new trademark of teen crime. In 1949 the Mayor struck a "hoodlumism committee" as Zoot Suiters reappeared, the "Alma Dukes" and the "Vic Gang" confirmed their turf in the west- and eastsides respectively, and—in the early '50s—guns found their way into the hands of gang members.[305]

No surprise, then, that we find large numbers of mid/late-teens in the sights of the VPD and other agencies concerned with degeneration, depravity, and general non-conformity. Youth violence was a source of concern to the police, one that the annual reports and newspaper accounts suggest was constantly worsening. After the war, however, there's a change in the tenor of reporting of youth crimes and behaviours in general. The word "juvenile" is progressively replaced in the vocabulary by "teenager." Vandalism and immorality (that is, mainly pre-marital sexual promiscuity) were the chief concerns of the VPD, which in 1950 had identified fully five hundred "boys and girls whose conduct indicated anti-social tendencies," and whose names the police made available "to the committees and organizations conducting research into this social problem."[306] (Clearly, this took place long before "protection of privacy" was much of a concern.) Merchants and residents along Victoria Drive near Kingsway complained in 1950 of being terrorized by young gangs and called for stern treatment by the VPD: "What the police should do is come out in force and give these hoodlums a good battering with clubs to teach them a lesson," one store owner was quoted as saying. In the same year *The Sun* ran a special series of articles on teen hooliganism, dubbing one pint-sized but particularly noxious gang leader "The Flea," whose influence extended to more than one hundred gang members.[307] Local author and poet Peter Trower, who wasted his suburbanite youth around Skid Row, claimed that the spread of teen gangs in the mid-1940s had much to do with the popularity of the novel, *The Amboy Dukes*. He describes encounters with The Flea, Zoot Harry, and Jimmy Norton's Broadway and Main Gang, characters who may well have been part of relatively well-organized theft rings and who, in all likelihood, spent their Friday nights menacing other youths in particular.[308] Chief Constable Mulligan felt that the problem was being overblown: he cautioned that the arrest and conviction rate reflected accelerated efforts on the part of the "Youth Guidance Detail," at least as much as it did teenage immorality.[309] In 1953 he reported that youth crime was well

down and that a rash of south side thefts could be attributed to a single gang of six teenagers whose arrest brought the crime wave to a sudden end.[310] Nevertheless, beginning with rampages in 1949, the police and the community as a whole held its collective breath each year through the 1950s as Hallowe'en rolled around and property damage rates leapt upwards.[311] In 1958 the province as a whole had the worst rates of juvenile delinquency in Canada, no doubt a further product of BC's exceptionally large Baby Boom.

Large public events were increasingly viewed as opportunities for misbehaviour by young people. This was noted in the context of the 1955 Grey Cup final, played in Vancouver that November. Fights, violence in general, and vandalism broke out as the city played host to the Edmonton Eskimos and the Montréal Alouettes (the Eskies won, 34-19). Chief Constable G.J. Archer was less sanguine than his predecessor on the subject of juvenile misbehaviour. He described the steps taken to control what he called "the activities of the near moronic minority of the younger portion of our population." What Archer was fighting in 1955 was not so much teens, however, but what he called "near adolescents."[312] That is to say, the youth that troubled the VPD in 1955 was the same cohort that had beleaguered Mulligan in 1951, just four years older.

The Vancouver response to the moral panic over teenage criminality took three prominent forms. The first was the creation (and, indeed, building) of "community centres" in which the energies and interests of youth might be channelled. This was supported by cooperation between the VPD and school Principals drawn from all the public and private schools in the city. The second was an intensified courtroom campaign against young criminals, one which involved stiffer sentences, more flogging, and hard time in prison, rather than the juvenile centres. The Boys' Industrial School in Coquitlam (known locally as BISCO) figures prominently in police and newspaper reports from the 1920s through the 1950s, as does the Provincial Industrial School for Girls on the city's northeastern limits. Breakouts from both of these facilities were a growing part of the police department's brief: in 1952 alone there were three dozen escapes from BISCO, mostly by fourteen-year-olds.[313] By the late 1950s, partly in an effort to get "tougher" on juvenile crime, more and more young offenders were being sent to Oakalla Prison. This was a much harder sentence, not least because the Burnaby prison was mostly populated by adults and had both a gallows and a

device for flogging, the latter of which got plenty of use.

Third, there was a very public debate on the allegedly malicious and baleful influence of popular culture on teens. As David Hadju describes in *The Ten-Cent Plague*, comic books were targeted in the United States from the 1940s but with increasing rhetorical vitriol in the 1950s. In the early 1950s their content—which shifted from year to year as fads and trends in the marketplace changed—became increasingly violent and gory. There was a movement in the youth magazine industry away from costumed superheroes and anthropomorphized animals toward crime and horror comics, along with the "true love" variant (which could be surprisingly racy). As Hadju observes, "While many of the actions to curtail comics were attempts to protect the young, they were also efforts to protect the culture at large *from* the young." Canadian legislators had the same motives but they had the added advantage of being able to point to comic books as an American (that is, foreign) source of menace. E. Davie Fulton, an establishment lawyer and the Conservative Member of Parliament for Kamloops, led the charge in Canada against crime comics as early as 1949.[314] By the mid-1950s, community, school, and church leaders across Vancouver were organizing mass comic book bonfires in an effort to purge the city of their reputedly malevolent influence. On 12 December 1954, Alderman Syd Bowman presided at a comic

Oakalla prison was where most of Vancouver's criminals were sent after sentencing, 1950s.
CITY OF VANCOUVER ARCHIVES 1184-2268, JACK LINDSAY

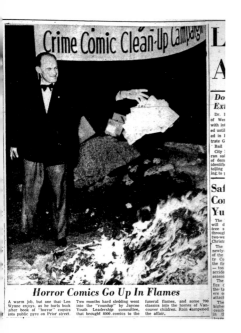

Horror Comics Go Up In Flames

above: One of many comic book pyres across North America in the 1950s.

VANCOUVER HERALD, 13 DECEMBER 1954.

right: The Hastings Sport Centre, a popular hang-out for off-duty policemen, n.d.

VANCOUVER POLICE MUSEUM, 4292

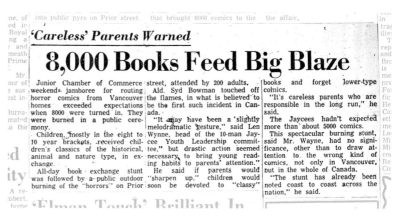

'Careless' Parents Warned
8,000 Books Feed Big Blaze

Junior Chamber of Commerce weekend jamboree for routing horror comics from Vancouver homes exceeded expectations when 8000 were turned in. They were burned in a public ceremony.

Children, mostly in the eight to 10 year brackets, received children's classics of the historical, animal and nature type, in exchange.

All-day book exchange stunt was followed by a public outdoor burning of the "horrors" on Prior street, attended by 200 adults. Ald. Syd Bowman touched off the flames, in what is believed to be the first such incident in Canada.

"It may have been a 'slightly melodramatic 'gesture," said Len Wynne, head of the 10-man Jaycee Youth Leadership committee," but drastic action seemed necessary to bring young reading habits to parents' attention."

He said if parents would "sharpen up," children would soon be devoted to "classy" books and forget lower-type comics.

"It's careless parents who are responsible in the long run," he said.

The Jaycees hadn't expected more than about 5000 comics.

This spectacular burning stunt, said Mr. Wayne, had no significance, other than to draw attention to the wrong kind of comics, not only in Vancouver, but in the whole of Canada.

"The stunt has already been noted coast to coast across the nation," he said.

book burning on Prior Street organized by the Jaycee Youth Leadership under Len Wynne; an estimated two hundred adults attended as some eight thousand "horrors" were consigned to the flames.[315] No significant improvement in juvenile behaviour was observed.

The *Noir* era starts with a crime wave that was outstanding for its violence. But overall, regardless of the rise in property crimes in the early 1930s, general crime rates fell during the Depression. This includes vice crimes that, of course, were a lightning rod for moral panic.[316] Just the same, contradictory reports and public exclamations on rising and falling crime rates in these decades disguise the overall trend: things were not getting better. Just as the period begins with a wave of violent crime, it closes in much the same way. Thieves developed greater sophistication in some areas of crime while they became more brutal in others.

The authorities clearly played a role in weaving the fabric of crime and justice in these years. The city's response to crime was, typically, either more and better policing or heightened courtroom drama. It isn't until the late 1950s that a Chief Commissioner begins to draw attention to the underlying causes of crime. Despite repeated efforts to set it on a modernizing path, the VPD was not a trusted institution and its members were shockingly undertrained. Nevertheless, the force was instrumental in both defining deviance and patrolling its boundaries, which they did with conspicuous unevenness. This track record drew attention to the force itself, leading to allegations of bribery, graft, and corruption.

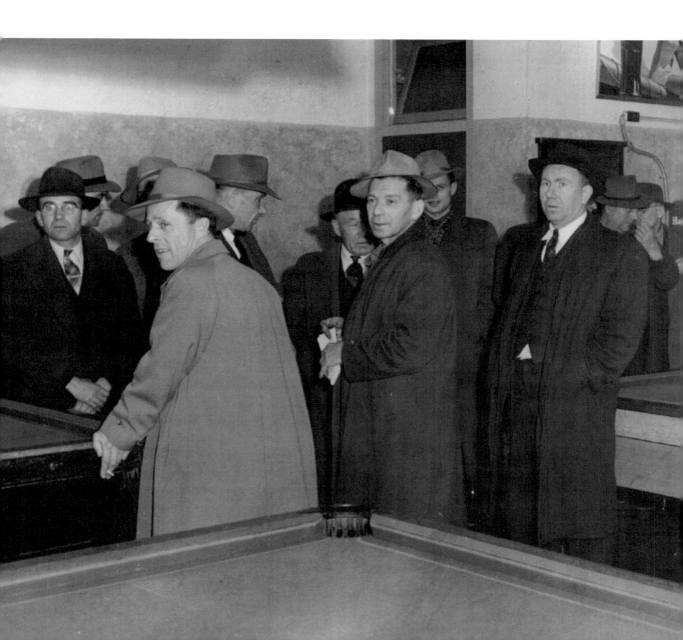

THE BIG SMOKE: CORRUPTION

ON THE 15TH OF SEPTEMBER, 1935, Mayor Gerry McGeer went on Radio CKWX to lecture Vancouverites about the festering underbelly of their city. Quoting his Chief Constable, Colonel W.W. Foster, he said "To such an extent has the system of protection for white slavery, bootlegging, gambling, dope and confidence rackets developed that Vancouver has become the international headquarters of a revolting type of vice and the natural refuge for criminals of dangerous character." Not only was crime and criminality on the rise, but the police were in on it. McGeer opened his thirty-minute speech by taking a shot at the cynicism of the age: "There is a deep and abiding conviction prevalent among men that all human actions, particularly of public men, are promoted by unworthy, selfish, and mercenary motives." The materialism of the early twentieth century, he maintained, spawned the most heinous crimes, but it also turned cops into criminals. McGeer enumerated the devastating effects on society of slot machines, Chinese gambling, bookmaking, "white slavery," bunco rackets, and pinball tables, none of which could survive without the support of a corrupted police force and judiciary. His Worship had begun his political career in the role of the "new broom," the last honest man, a profile he cultivated throughout his career; he modestly entitled his speech, "Mayor McGeer's Fight Against Crime in Vancouver."[317]

And this is where Joe Celona comes in. Joe Celona (born Giuseppe Fiorenza) was the closest thing that Vancouver had to a kingpin of crime. He was prominently involved in bootlegging and the sex trade, but as an overlord of the underworld, he cut a disappointing figure. Especially in 1933, when his wife caught him in bed with another woman and put a bullet in his hip. In truth, it may not have been his hip; a less decorous account placed the entry wound in his buttock. Either way, it was, for the erstwhile mobster, a lucky break: Josie Celona had made her entrance to the room wielding an axe, so things could have turned out much worse for Vancouver's Vice Czar.[318]

Despite being based in the East End, the VPD
sometimes got the feeling they weren't welcome
in the neighbourhood. A local woman "razzes
the police" in 1935.

This case of domestic gunplay drew unwanted attention to Joe Celona's continued involvement in criminal activities. He had survived and thrived under Mayor L.D. Taylor's tolerant regime but in 1934 he was a big enough fish to serve as a target in Mayor Gerry McGeer's campaign to clean up the city. The police picked him up on charges of "white slavery," living off the avails of prostitution, and running a bawdy house. He went to jail for nearly a decade.

When Celona was released from prison in 1944, Vancouver was being described by its own leaders as "the worst city in Canada as far as major crime is concerned."[319] Vice crimes were the main focus of concern, as allegations flew across the front pages that the city's Police Department wasn't just turning a blind eye—cops were on the take. In 1947 the new Chief Constable, Walter Mulligan, launched a shakeup of the force, cleaning out the bad apples, making a stand for integrity. As for Celona, he quickly found his old niche: he went back to bootlegging and kept a low profile, until he surfaced again in the mid-1950s to testify in a corruption investigation that once more turned the VPD inside out.[320] This time it was Mulligan himself who was feeling the heat, although the whole VPD was on the grill.

In Celona and Mulligan we have two stock *Noir* characters: the gangster and the bent copper, either of whom might tell you that morality is a game for chumps. Although it is important to have a villain, a bad guy in the story, *Noir* really revolves around the ambiguity and cynicism of the ostensible hero. The trick of *Noir* literature and film is to find the grey areas between the black and white. And no character is as central to the *Noir* storyline as the detective. Vancouver cooperated, producing not only a generation of crooks, but thirty years of crooked top cops. The era opens with a police corruption trial and it closes with another. Hollywood images of the tough cop were potent, but deference to the authority of the VPD—especially when it was in the throes of another inquest—was negotiable. Corruption, too, infested City Hall, so authority in the Terminal City, as a whole, was regarded with a jaded eye. This chapter rounds up the usual suspects among the bad guys, the good guys, and the bad good guys, from City Hall through Hogan's Alley to Police Headquarters.

You Can't Fight City Hall

As described in Chapter 1, L.D. Taylor's near-lock on the mayoralty started to crumble in 1928 when, despite continued support from the Eastside, he lost office in what was largely a law-and-order election.[321] William Malkin's successful campaign, endorsed by the Christian Vigilance League and run under the banner "New Town, Not Blue Town," lost its appeal when the economy collapsed in 1929. Unemployment and the largely unsympathetic posture of the aristocratic Malkin allowed Taylor to get back into office in 1931. During these Taylor years the old Downtown witnessed a return to laissez-faire morality and an easing of pressure from the VPD. "Anything went. And Mayor Taylor used to come down [to Hogan's Alley] and drink if he went to Buddy's [on Prior] or Dode's, or Mother Alexander's for chicken and steak."[322]

Rushing to a riot, 1938.
PROVINCE NEWSPAPER PHOTO, VANCOUVER PUBLIC LIBRARY VPL 1294

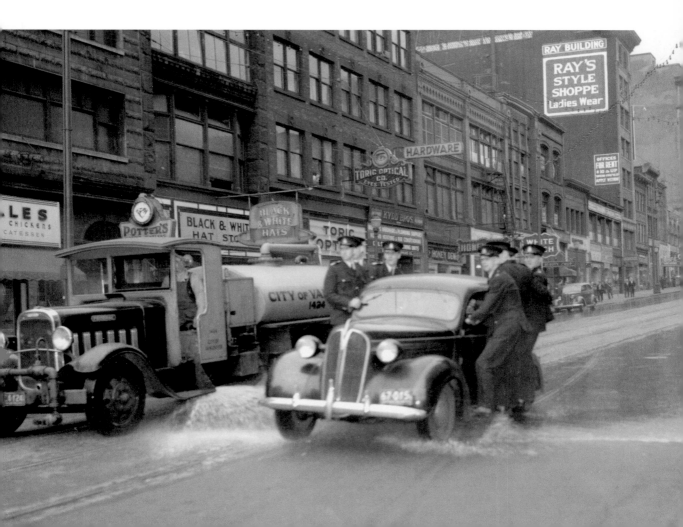

Taylor was replaced late in 1934 by Gerald Gratton McGeer, another populist but one from the West Side with strong links to the world of Liberal and Conservative Party bosses. The contrast between the two mayoralty favourites' positions and behaviours as regards vice could not have been stronger.

Originally an East Vancouver boy who had made good (and married well—to a Spencer heiress), McGeer was a strident opponent of Eastside crime and grime, not to mention left-wing agitators.[323] Starting with the 1928 Lennie Commission enquiry into crime in Vancouver, McGeer whipped up public fear of gangsterism, rampant police corruption, and an epidemic of vice, despite the fact that such issues had not before registered significantly on the local political radar. In 1933 the Chief of Police, Col. C.E. "Doc" Edgett, was sacked by Mayor Taylor for inefficiency but a subsequent inquest fuelled suspicion of corruption among high-ranking officers. This wouldn't be the last time that a gamekeeper was accused of turning poacher. Doc Edgett's fate was an ironic one: he himself had played the law and order card to the fullest, attacking both property crime and the radical left. He fell afoul, as so many of his peers seemed prone to, to charges of corruption and links to crime figures.[324] This renewed McGeer's zeal in his quest to clean out the rot in the city's streets and in the VPD. In the 1934 civic elections, he campaigned on the claim that "crime must be stamped out," alleging widespread bribe-taking from brothels by city police. As soon as he was in office McGeer sacked not only twelve beat cops but three inspectors and he got rid of Police Chief John Cameron as well.[325] The Police Department staggered from one regime to the next. One account claims that Vancouver became known as "the graveyard of police chiefs because of its high turnover rate in chief constables."[326]

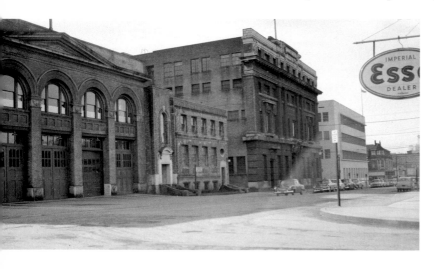

The Vancouver Coroner's Office (now the Police Museum) wedged between VPD Headquarters and the Vancouver Fire Department, 1956.

CITY OF VANCOUVER ARCHIVES A21601, WALTER E. FROST

Chief Constables of Vancouver, 1929–1962

NAME	DATES OF APPOINTMENT
W.J. Bingham	1929-1931
C.E. 'Doc' Edgett	1931-1933
John Cameron	1933-1934
Col. W.W. Foster	1935-1939
D. MacKay	1939-1945
A.G. McNeill	1945-1947
Walter H. Mulligan	1947-1955
G.J. Archer	1956-1962

Gerry Gratton McGeer, ca.1946.
CITY OF VANCOUVER ARCHIVES 136242

In his role as the "new broom," McGeer said he would also sweep clean corruption in City Hall. Several departments had earned dismal reputations. Early in 1930, the civic official responsible for unemployment relief, G.D. Ireland, "was exposed as accepting a rake-off on meal tickets."[327] This was the issue more than any other that cost Malkin the mayor's chain of office. But the rot was far from cleared away. In 1934, Ireland's successor in the fated Relief Office, W.R. Bone, faced a trio of enquiries in one year over his department's role as a source of patronage posts. One involved an Alderman who busied himself by playing private eye, riding around the city in a relief bread truck trying to get direct evidence of welfare fraud on the part of the unemployed, the cafes and restaurants accepting scrip, and anyone else who caught his attention. Soon, McGeer himself was getting a lesson regarding the throwing of stones and living in glass houses. In 1936 a relatively new face on City Council, the social gospeller Lyle Telford, thought there was something rotten in the state of the Pacific National Exhibition's books. He accused McGeer of "condoning and even attempting to conceal" suspicious practices. Telford brought in Wilfred Tucker, an investigator who had been deployed in previous civic scandals, to run an impromptu inquiry.[328] Later the same year a separate investigation—the Barrett-Leonard "Report on the Reorganization of the Civic Administration of the City of Vancouver"—described petty corruption and extensive patronage in City Hall.[329] McGeer, referencing earlier investigations, dismissed the Barrett-Leonard report, saying it "out-Tuckers Tucker."[330]

McGeer did much to set the tone for the *Noir* era in Vancouver, but he wore the Mayor's Chain for only two years in the '30s. He took a break from civic politics to pursue federal office and returned to his modernist

City Hall on the hill in 1947. Revealing a predictable *modus operandi*, one of his first steps was to replace Chief Constable A.G. McNeill. This was accomplished with yet another inquiry into the VPD, this time headed up by Lieutenant-Colonel Cecil Hill. Reporting out on the last day of February 1947, only two days after the shooting deaths of Detectives Ledingham and Boyes (described in Chapter 6), Hill observed that the segregation of the various vice departments into—respectively—gambling, morality, and liquor squads produced "an abounding lack of law enforcement," which resulted in "an enormous influx of underworld characters" into Vancouver.[331] What clearly turned his head most was the testimony of Acting Chief Constable Walter Mulligan, who called for the dismissal of McNeill, Deputy Chief Norman Corbett, two Inspectors, and fifteen Detectives.[332] Most of the men were demoted to lower ranks; Mulligan was promoted to the top job.

This is where the careers of McGeer, Celona, and Mulligan really intersect. It was Celona's criminal reputation in 1928 which launched the civic political career of the young aspirant lawyer, McGeer. The fact that Mayor Taylor had some connection with Celona—evidently he bought his cigars from Celona's store—contributed to Taylor's defeat at the hands of William Malkin.[333] But Celona stayed out of jail in 1928, meaning that he was available as a scapegoat during McGeer's successful 1934 campaign. This time, Celona was charged and convicted. Celona's return to the streets in the mid-'40s restored to McGeer a familiar target, an arch-villain he could use to once more arouse voters' fear of vice and corruption. So it was Celona, then, who indirectly helped get Mulligan the top cop job spot. Surely no other scoundrel in Vancouver's history has proven so useful.

The Man About Town

In 1934, Joe Celona was a successful businessman. He left Italy in 1913 and arrived in Vancouver around 1919, at which time he started living off the avails of prostitution. His first home at 272 Union Street was a well-known "disorderly house" and he augmented this with businesses operating from a variety of Downtown addresses, including at least one legitimate undertaking—the cigar store at 600 Main Street, about a block south of the old City Hall and thus convenient for stogie-chomping L.D. Taylor. Despite run-ins with the police, he turned his modest sex trade and bootlegging enterprises into a tidy pile of money. The 1928

Lennie Commission made it clear that Celona was a player in the vice industry, but there was nothing to clinch allegations of corrupting officials. Celona stayed at large and, as the Depression got underway, he moved from his Strathcona home/brothel to a mansion at 4973 Angus Drive.[334] Nevertheless, the local kingpin of crime was essentially a thirty-seven-year-old small-scale brothel keeper when, in 1934, he started to attract special attention from the law.[335] But he was also, perhaps, a petty hood with anti-social attitudes. Looking back on the "glory days" of Hogan's Alley, long-time resident troubadour Austin Phillips said of Celona, "The only good thing that [Mayor McGeer] done … was when he put Joe Celona in jail. That's a guy you couldn't even be decent with—the guys he was paying off to, the cops he was paying off to. And he was just a young man but let go long enough he'd of become another Al Capone."[336] Conjecture, of course, but Phillips' fears were shared by others. In March 1935 Joe Celona, described by *The Sun* as "hotelkeeper and man-about-town," was standing in a court room charged with two counts of procuring girls to become prostitutes in what quickly became "the most frequently discussed white slavery case in Vancouver history."[337]

Racketeer Joe Celona, happy to be giving evidence against a cop, for a change, 1955.
THE VANCOUVER SUN

Working with Clarence Bancroft, a thirty-two-year-old want-to-be pimp, and Bancroft's "blonde common-law wife"—thirty-five-year-old Ellen (*aka* "Marcelle") Joyce—Celona was allegedly connected to a white slavery system that preyed on teenaged girls. Bancroft and Joyce hired young women to work as domestics in their 3334 Point Grey Road home. Despite the chi-chi west side address, the house was described by the Crown Prosecutor as "a dive." At the very least it was a honeypot of champagne parties, with plenty of food, nights on the town, and promises of nice new clothes for the girls. This was all designed to attract young women into the sex trade. Lubricated at drunken parties, the women were egged on by Bancroft to "get wise to yourself and make some money." They were then relocated to rooms at 513 Main Street where they met "the landlady of the premises, one Bea, and girls named Jerry, Toots, and Mae."[338] This was a "sporting house," a brothel, but not their last stop. Shortly thereafter they were moved to the Windsor Hotel at 52 East Hastings where they serviced "Orientals" and then on to Celona's Maple Hotel at 177 East Hastings, which he admitted freely was home to a gambling and bookmaking operation. Celona claimed to live in the front rooms of the hotel's fourth floor and in complete ignorance of the brothel literally at his back—the women, it was alleged, were working in

other rooms on the same floor. It took the jury all of six minutes to return a verdict of "Guilty" and hardly twenty minutes more for the judge to pass a twenty-two-year jail sentence (reduced subsequently to eleven years).

What clearly upset the court (and excited the press) most was the allegation that the women who were led into a life of "degradation" by the Celona-Bancroft-Joyce trio were specifically recruited so that they could serve the sexual needs of Asian men: Chinese, Japanese, and Filipinos. As Prosecutor Dugald Donaghy, K.C., growled at the jury, "Only the youngest and prettiest girls were submitted to these China-men. It is most preposterous to think that this should take place in a Christian community. Prostituting themselves to these despicable Orientals."[339] But Donaghy didn't stop there. He described the Maple Hotel as a place where "little children under sixteen years of age were fed to Chinamen." His xenophobia reached a crescendo as he concluded his emotional summing up to the jury: "Are you going to turn a foreigner from Europe loose on the maidenhood of this fair city to make a living off their bodies?"[340] The establishment's unvarnished terror of the Yellow Peril is there, plus a generalized nativist fear of anyone who wasn't a White Anglo-Saxon Protestant. This was the stuff that newspapermen's dreams were made of.

Two weeks after the Battle of Ballantyne Pier, Chief Constable Col. W.W. Foster looks like he never saw a cavalry charge he didn't like.

The Sun and *The Province* could barely get enough of Celona. The language they used in coverage of the 1935 trial reveals a barely disguised love for Celona as a suave villain. *The Sun* described him as "urbane, bespectacled, and dressed in expensive blue tweed" or in a "heavy black ulster."[341] *The Province* said he was "nattily dressed, confident, voluble."[342] Occasionally in the course of the trial he would "smile quietly as if enjoying a secret joke." The press wasn't so generous with his allies. Turning public opinion against Ellen Joyce, she went from being "blonde" to "peroxide-

haired" to "a faded blonde with stringy hair, apparently dyed." "Marcelle" certainly comes off in these accounts as the requisite *femme fatale*: "There was talk of Chinamen, but Ellen Joyce laughingly assured [the women] that Chinese were nicer men than whites."[343] Bancroft fared even worse: he was at best a "nightlife habitué," at worst "pasty-faced, sleek-haired and frowning."

Not surprisingly, the voice of the defence attorney, Stuart Henderson, was almost lost in the courtroom circus. But in his summing up he attempted to contextualize the Celona affair, suggesting that there was more to it than met the eye. For starters, no one had demonstrated that Celona had actually received a penny from his supposed prostitutes. Henderson made the additional observation that Celona and Mayor McGeer had "crossed swords" back in 1928 during the Lennie Commission inquest into civic corruption. He suggested that "somebody is behind all this thing, somebody is out to get Celona." Henderson said that the day after the mayoralty election, "everybody got busy" chasing up dirt on Celona. The cop on the beat "knew what happened in 1928"— that is, bent coppers were purged from the force—so "every policeman got busy to save his job."[344]

Could there be any truth to these allegations? Absolutely. McGeer's tagline during his successful 1934 election campaign was "We're going to Barcelona."[345] And he did. He got Celona off the streets, then he eliminated VPD leaders who couldn't be counted on as loyal servants of his agenda. Within two weeks of Celona's conviction, the leadership of the VPD was itself on trial. Former Chief John Cameron and six other constables were charged with conspiracy, the main thrust of which was that Cameron had Celona as a visitor to his home and also that the Chief had taken two night voyages up Howe Sound on the Police Boat *William McRae*; liquor was, of course, involved—presumably provided by the bootlegger. According to Detective Robert Tisdale (sporting an eye blackened in a riot a couple of nights earlier), Cameron told his men to "go easy" on Celona's establishments.[346] Did the rot reach all the way to the desk of the Chief Constable? If McGeer didn't trust Cameron, what better way to deal with him than dismissal on suspicion of receiving a bottle of whisky from a convicted bootlegger and procurer? Jailing Celona settled the score from 1928 and it also set up Cameron for a fall.[347] Col. Foster—indisputably a McGeer ally—took over the VPD.

Ten years later the pieces were all in place for a repeat engagement. McGeer was back in civic politics and, in September 1947, the now fifty-year-old ex-con was back in business—or, as a prosecuting attorney put it, "Mostly monkey business." Joe Celona and his wife, Josie, were allegedly serving illegal liquor from their premises at 373 East Hastings. This figured, in a small way, into another inquest. For a spell, Walter Mulligan would be the beneficiary, but not for long.

Detective Sergeant Len Cuthbert, with lawyer Perry Miller at Tupper Commission, 1955.

PROVINCE NEWSPAPER PHOTO, VANCOUVER PUBLIC LIBRARY VPL 43012

Mulligan Stew

Described in one account as a "230-pound Irishman," Walter Mulligan was more than a hulking beat cop who caught a lucky break.[348] Mulligan was committed to bringing the VPD into the modern age, introducing more training and better forensic equipment.[349] More than that, he publicly announced a campaign in 1947 to clean up the city, and the VPD.

There had long been complaints that the VPD was rotten from the inside out and, despite the efforts of McGeer and Foster in the late 1930s, not much had changed by the end of the Second World War. There were still too many connections between the cops and the city's many gambling and bootlegging operations. The gambling squad's alleged protection schemes were Mulligan's main target for reform. He had been pulling together the files while he was Superintendent of the Criminal Investigations Branch of the VPD and was rewarded with the Chief Constable's job.

The lynchpin of the gambling and bookmaking network in the city was named Ab Forshaw, who was headquartered at the Martinique Smoke Shop at 1184 Granville.[350] One of his competitors came forward in the mid-1940s, complaining of police rake-offs in the hope that his

operation could get the same semi-legal status accorded two "charter" clubs: the Pacific Athletic and the Arctic. The operator in question, Harry Tisman, along with his brother Louis, had been charged with trying to bribe a police officer. Harry launched a counter-attack on the force, calling for the firing of the entire Gambling Squad. This was music to the ears of one crime-fighting mayoralty candidate—the returning Gerry McGeer. (A delightful detail of Tisman's testimony at an appeals hearing is his comment that "I would have to be a Madame Lazonga" to predict that Gerry McGeer would be back in the mayor's office in 1946. This was an allusion to the 1941 film, *Six Lessons from Madame La Zonga*, a *Noir*-ish road movie that tied together swing and rhumba, con artists on the lam, and a sexy Havana music hall hostess with the gift of second sight.)[351]

Mulligan waits with police officer Stan Laycock as deliberations continue, 1955.

So, in 1947, and with the un-expected help of peevish bookies like the Tismans, Mulligan was in a position to go after more than a dozen cops he believed weren't do-ing their job. Mulligan announced a "gloves off" approach to reorganizing a VPD that seemed badly out-per-formed and compromised by "the underworld." The public was meant to be reassured. Mulligan's colleagues on the VPD evidently weren't and by the early 1950s, although the gloves were off, the knives were out.

Resentment and an appetite for revenge bubbled to the surface late in 1954. The Mulligan Case was a comprehensive disaster for the VPD. As one journalist recollected, "every cigar store was a bookie shop. Every so-called private club was

Photographer Ray Munro at the wrong end of a camera during the Tupper hearings, 1955.

CITY OF VANCOUVER ARCHIVES 371-435, BOB OLSEN

illegally selling drinks to the public. The place was full of blind pigs. If a policeman gave you a ticket, deliver a couple of bottles the next day and the ticket vanished."[352] Corruption connected to the vice business had not gone away. What's worse, it appeared to have spread all the way to the top. A Toronto rag called the *Flash Weekly* had just picked up Ray Munro, a frustrated crusading reporter and photojournalist who had left *The Province* when its editor refused to publish his stories on VPD corruption. The *Flash* ran the sensationalized story under the headline "Rape Of Vancouver! Munro Tears Mask From Crooked Law In Gangland Eden" and sold more than 10,000 copies within a day.[353] Mulligan was accused of taking kick-backs from gambling dens and brothels; his new-and-improved Gambling Squad was at the dead centre of the alleged corruption scandal. Almost literally, in fact. As the press started to sink its teeth into the latest hints of graft at the top, Detective Sergeant Len Cuthbert tried to blast himself in the chest with his own service revolver while sitting at his desk in the VPD Gambling Squad's office. Cuthbert, one of the police casualties of the Battle of Ballantyne Pier in 1935, had gone to the Police Commission as early as 1949 with his concerns about graft in the force. When nothing came of it, he later decided to become part of the problem. Once Munro's article fingered him as a key player, his room for manoeuvre narrowed. His own involvement in the kickbacks racket would come out, not helped by the fact that he had recently purchased an East Van house from Rose Capello, a seventy-six-year-old whom Cuthbert knew to be a bootlegger.[354] Cuthbert survived his botched suicide attempt and took the stand against Mulligan, implicating most of the men on his force, including his Chief. The Mulligan Case spawned a Commission of Inquiry under Reginald H. Tupper, QC, that got underway in the summer.[355] It had such a demoralizing effect on the VPD that the criminal element seemed to take it as a cue to go on a rampage. Criminal books were balanced, in some cases with executions, a hail of bullets, and a car-bomb.

The Tupper Inquiry focussed entirely on moral lapses, but the context was the Chief's annual salary. A victim of Depression-era cutbacks, the Chief Constable's pay fell from the late 1930s to the mid-1940s and did not recover. Whereas McGeer and Celona lived in luxury in, respectively, Point Grey and Shaughnessy, the Chief Constable could only afford a small bungalow on the southside of town.[356] Mulligan's response

154

was to garnishee the wages of crime. Ironically, Mulligan had flagged the temptations of graft as early as 1947 when he reported, insightfully, that "the end of easy-money" which came with the conclusion of the war meant that "war gratuities and war savings" were being used up quickly, bringing lean times to brokers, agencies, and lenders. In his own words and prophetically, he said "a period of greater stringency always brings its run of defalcations and embezzlements, of which we may expect many in the near future."[357] Faced with exposure and no hope of getting a fair shake in the newspapers, Mulligan resigned midway through the Inquiry and skipped town, taking up temporary residence in Los Angeles.

As theatre, the Mulligan Inquiry could not be topped. Detective-Sergeant Bob Leatherdale opened testimony with a cool recital of the bootleggers who were expected to pay graft, some of whom needed regular squeezing by the police: Al Nugent, Peto Nino, Wally "Blondie" Wallace, Jack Craig, Hans Burquist, Joe Celona, and one "Mrs. Emily."[358] Old beat cops and detectives knew the risks and suffered sudden-onset amnesia. The same was true of gamblers and bootleggers who benefitted from selective police blindness on a daily basis. To be sure, there were grudges galore. Mulligan's 1946-47 campaign against vice had left a few bootleggers and bookies still smarting, as well as vice cops who resented Mulligan's dismissal of some of their comrades at the outset of his term as Chief Constable. Everyone who took the stand at the Inquiry was evasive and duplicitous. Even Joe Celona—by now a fifty-eight-year-old spectre of earlier times—testified.

In the midst of it all, the Inquiry was rocked by tragedy. Superintendent Harry Whelan committed suicide—using the same technique as his colleague Len Cuthbert, but more effectively. Whelan's brother Jack (a former detective who had gone on to a career as a gambling promoter and small-fry bookie) had provided evidence that senior police had overseen the dividing of the city's gambling operations into east and west territories. Harry Whelan was burdened by his brother's recklessness but more so by the prospect that his own reputation might soon be in tatters if the Inquiry was looking for a fall guy. Rather than take the witness stand again and hoping to spare his family the shame, Whelan killed himself.[359]

But the crowning touch was the appearance in court of Helen Douglas, Mulligan's Strathcona mistress, the "mysterious brunette in a veil." Douglas kept house in East Vancouver, in an apartment on East Georgia Street. From 1944 to 1949, at the very least, she had been Mulligan's woman on the side. While the top cop was battling vice, he was also providing his mistress with expensive jewellery, trips south of the border, and even a "love nest" in bucolic Langley. There wasn't much in her testimony that was likely to convict, but this was an Inquiry, not a trial. When asked where the money came from, she replied: "I had the impression it didn't come from his salary."[360] A Pandora's box of moral ambiguities had been opened, and Mulligan was probably smart to flee to the City of Angels.

The Mulligan scandal turned over a rock and showed the city what crawled around underneath. The only man with a conscience tries to take his own life, the top cop has a mistress, everyone seems bent. Against this, a career criminal like Joe Celona must have been a relief: at least he was what he seemed to be.

Mulligan wasn't the only British Columbian caught in the spotlight as the era of *Noir* came to a close: Robert Sommers, the Minister of Forests in British Columbia, stumbled through five years of allegations of corruption, culminating in a trial—held in Vancouver—in which he was convicted of accepting bribes: he served jail time. The Sommers Scandal, as it was known in 1958, threatened to bring down the Provincial Government and was another blow to authority in a city whose leadership had, for decades, failed to practice what they preached. When the *Noir* era began, there was laxity on a number of fronts and cynicism all 'round. By the time it ended, there were widespread demands for greater accountability and integrity.

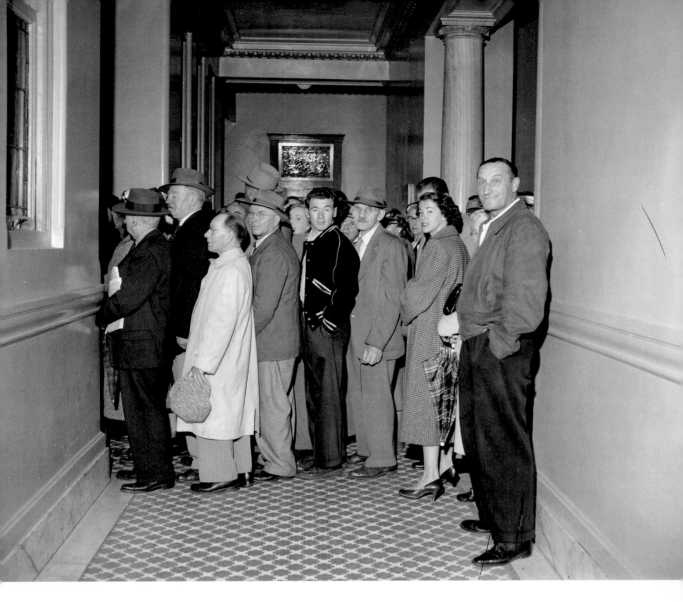

How Vancouverites got to that point, however, was via a series of scandals at City Hall and in the VPD. And what drove these crises forward, more than anything else, was the feeling that the fight to reform society was being lost to an underworld of gamblers and prostitutes, bootleggers and hoodlums. With each successive inquest and commission, the reputation of the VPD suffered another plunge. The people who were meant to protect and fight for "normal" were themselves aberrant. In the meantime, and while vice crimes dominated the headlines, there was still murder to deal with.

The 1955 Tupper Commission was such a popular public event that the gallery was the scene of shoving and fighting for seats.

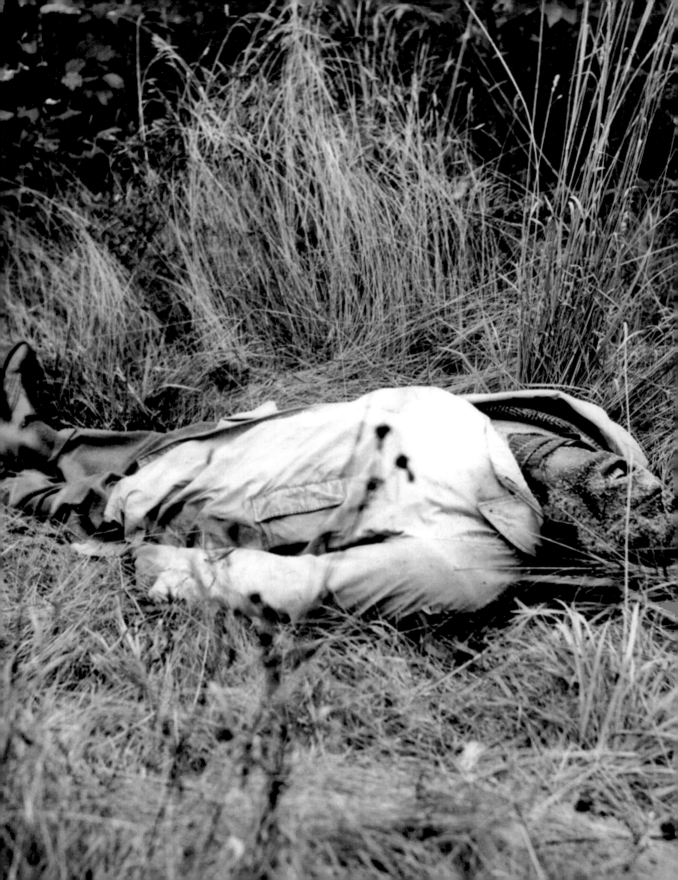

TERMINAL CITY: MURDER

"On April 11th, 1939, at 4:55 p.m., Woo Dack, a well-known figure in Vancouver's Chinatown, was found dead in his room at an obscure hotel on East Hastings Street. Examination indicated that he had been dead some 12 hours. After preliminary investigations, officers detailed to the case decided that the victim had been murdered while lying on the bed in his room. Possible motives appeared to be robbery, revenge, or woman trouble, as Woo Dack was a large-scale operator in the cannery field, was connected with an important restaurant business, and was known to be partial to women of low morals who catered to Chinese, to whom he was generous with his gifts. [...] After intensive investigation of the many complex factors in the case, officers concentrated on the woman angle. It was thought that some woman well known to Woo Dack might have been admitted to his room without question and later have brought others into the room. Following some weeks of painstaking work, these deductions proved correct and the "woman in the case," Dolores Brooks, alias Linda Wilson, 19-year-old underworld frequenter, and two young men, Harry McMillan and Arthur Rennie, were arrested.... Dolores Brooks and McMillan were tried by jury and found guilty of manslaughter. Arthur Rennie was tried, found guilty of murder and sentenced to be hanged...."[361]

A COLD BODY. A large-scale operator with a taste for fast women. Chinatown. A hotel with a bad reputation. Concentrate on the woman angle. The underworld. A *femme fatale* with an alias. Deathrow.... Are there *any* classic *film noir* elements missing from this account? Although it reads like James M. Cain it actually comes word-for-word from the Police Department's annual report in 1939.

Vancouver was by no means the murder capital of Canada, although it's difficult to know what the national rankings really were. Homicide statistics weren't uniformly compiled until 1962 and what was reported

Police discover a badly decomposed body, 1942.
VANCOUVER POLICE MUSEUM, 4128

159

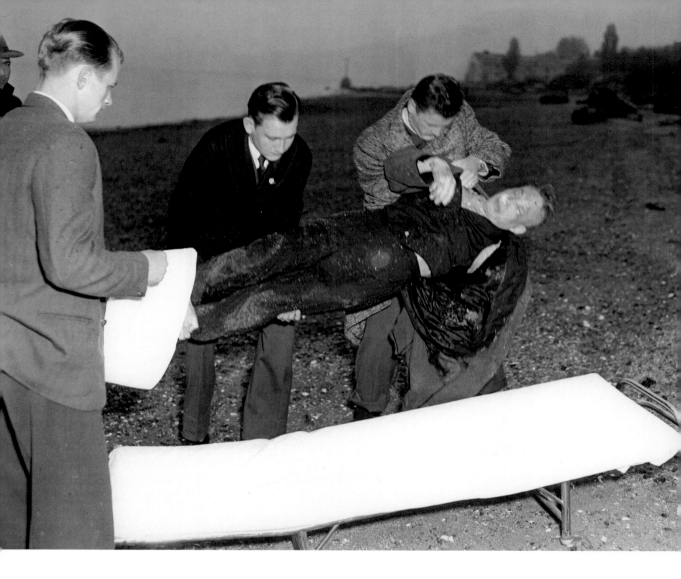

English Bay, Burrard Inlet, and the Fraser River furnished watery graves for a dozen or more each year, including this one, pulled out near Beach Avenue, 1948.

inevitably ran aground on the distinctions between murder and manslaughter, not to mention "death by misadventure." And where does one put the discovery of human remains when it is clear that foul play was involved? In the year they were found or in the year the coroner thinks they likely came to a sticky end? Nevertheless, trying to compare like-with-like, the *Noir* period appears to have seen a lull in homicides in Vancouver (as was the case also—remarkably—in Los Angeles).[362] Murders doubled between 1929 and 1931, jumping from six to twelve as the city reeled from the impact of the Wall Street Crash. But this rate, paralleled by the suicide rate, plunged through the rest of the decade until 1939 when it rebounded to eight homicides.[363] Although the peak year came at the end of this period of unrelenting crackdowns on crime, the

PURVEY • BELSHAW

rate was, on a per capita basis, falling sharply.[364] Even though incidents of homicide were relatively few, Vancouverites perceived an increase—fuelled by gruesome newspaper reports and photos.

Photographs of murder scenes are no less elusive than the stats. Many exist but some cannot be displayed, due to consideration of the right to privacy of the victim, the accused killer(s), and generations descended from either. The few that we've found are, of course, disturbing. And the documentation of murder scenes is different from photos of alleged "slum" neighbourhoods: the qualities of a streetscape might be subjective but there's no getting around the fact that there's a headless corpse captured on film. Likewise, one might take the position of Mayor L.D. Taylor that Vancouver's no "Sunday School town" and that vice is going to occur, regardless, so better to focus on violent crimes and property crimes, or one could counter (à la McGeer and Foster) that vice is a disease that tears at the very fabric of society, one which must be eradicated. But there's not much debateable about the "deviance" of murder. It lies outside of the acceptable.

In this chapter, then, we don't argue that fear of homicide in Vancouver in the age of *Noir* was contrived in the same way that fear of vice or juveniles or corruption became stalking horses for reform. Instead, we look at a small number of homicides to see what the language—the discourse—around these murders reveals about the values of Vancouver's "mainstream." What's more, there were several genuine murder mysteries, some of which have never been solved. These events continue to haunt the imagination of many in the Terminal City.

Cold-Blooded City

The crime waves of the 1930s provided plenty of grist for the newspaper mill, murders even more so. Dramatic events could be spun into gold by a good reporter. An excellent example of the style of the day was the case of two bandits on the run after killing William H. Hobbs, the manager of the Victoria and Powell Street branch of the Canadian Bank of Commerce. George Lawson (thirty-five years) and Jack Hyslop (twenty years) were one half of the bandit gang involved in the messy hold-up. Their partners were already cooling their heels in the Vancouver jail and Lawson and Hyslop were rapidly running out of places to hide. It took eight sleepless days for the VPD to track them to the Oak Rooms Rooming House (now the Woodbine Hotel at 786 East Hastings), barely

a mile from the scene of the crime. As they holed up in a room reportedly rented "by a slim blonde woman," the police noose around Lawson and Hyslop drew tighter and tighter. With the building surrounded and the hallways bursting with "more than two score detectives," Hyslop and Lawson turned their guns on themselves rather than be captured. Reportage covering these events was classic *Noir*:

> *"There's something wrong in that room," said a startled lodger, sticking his head out of the doorway of his room and pointing to room 40, at the end and on the left side of the corridor.*
>
> *Without hesitation the officer hurled his bulk against the door of room 40. The flimsy lock gave way and he entered. Acrid fumes of recently discharged gunpowder met his nostrils and he saw two bodies on the floor."*[365]

The assault on the Oak Rooms was led by Superintendent Herbert Darling but the case was very much in the hands of Chief Constable Col. Foster, who moved a cot into his office for quick rests in a round-the-clock search for the murderers. The Chief used the publicity surrounding the siege to call on the public for support in his other campaign: for better police resources. First, he whipped up fear of the criminal element: "The underworld openly challenged our police administration and threatened to bring about old conditions to overthrow the administration of law and order." Then he opened up his hands, palms up: "Our citizens should now be ready to respond to our call for necessary funds to equip the force with the needed modern equipment. This equipment includes a two-way radio system, better police cars and an extended record system." If Hyslop and Lawson were cold-blooded in their banditry, Foster was hardly less so in cynically using William H. Hobb's death as an opportunity to modernize the VPD.

Banks were often scenes of violence but so, too, was Vancouver's waterfront and its beaches. The photographic record shows bodies being recovered from the water and the sand; the newspapers of the day support the sense that foul play along English Bay was not uncommon.

Women, generally, were targets for violence, though not always because they were easy victims. The spike in crime in 1930 began in its very first week, the worst of which was a robbery that went badly awry. Roderick Perrin, fifty-two, and his forty-eight-year-old wife, Belle, were returning to their home in the 400 block of East 23rd, just after midnight on the 5th of January. A lone gunman, his face hidden by a burlap mask, confronted them in the alley behind their home, demanding their money.

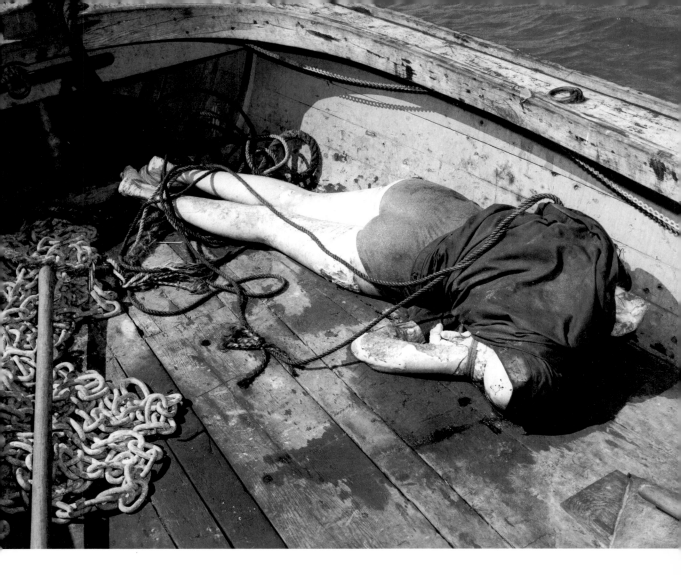

An anonymous victim of suspicious circumstances recovered from Coal Harbour, n.d.
VANCOUVER PUBLIC LIBRARY VPL 1104

Belle Perrin in particular put up an impressive resistance but was felled by a bullet that pierced her abdomen, lodging in her kidney. She died two weeks later in Vancouver General Hospital, but Roderick survived, despite a bullet wound to his spine. Belle Perrin received a hero's treatment in the newspapers, which was unusual. More often than not, female murder victims were made anonymous while their killer took the spotlight. Examples abound.

In 1945, only weeks before the end of the war, a Vancouverite soldier due to be sent out on duty marked the occasion by consuming a prodigious quantity of liquor. Before going out on the tiles, twenty-eight-year-old William Hainen hit the bottle at home then began a tour of the city's beer parlours with his sister and a group of friends. Hainen's own lawyer,

hoping to convince the jury that his client was of "diminished capacity," tallied up the drinks as at least thirteen ounces of rye and perhaps as many as forty-five glasses of beer consumed between noon and 2 a.m. the next day. Given his drunken state, it's hardly surprising Hainen was rebuffed by twenty-three-year-old Olga Hawryluk, a waitress at the all-night Empire Cafe who made the mistake of stopping into the Good Eats Cafe at 906 Granville in the early hours on her way home. A short time later, Hawryluk was unsuccessfully screaming for her life on the beach at English Bay as Hainen smashed in her skull with a piece of driftwood. Playing before a full gallery at the Vancouver Courthouse, Hainen got the attention he had been seeking. And he got a date at last: with the hangman.[366]

Sometimes homicide reports and murder trials presented the media and judges with an opportunity to hold forth on the guilt of the accused and the moral failings of the victim, if not society as a whole. In 1946, on September 3rd, a VPD Constable on the beat was called to the Cascade Rooms at 134 Powell Street, where he found the cooling corpse of Lillian Lee, the lone tenant of Room 22. The circumstances of her discovery bear repeating: The door was bolted on the inside, there was no sign of a struggle apart from "a sugar bowl lying broken on the floor, and a man's walking stick in its usual position in the room, but having about four inches broken off the lower end, and the rubber ferrule then replaced." The room, as well, contained several empty wine bottles.

Lee had been beaten and strangled during the dinner hour two days earlier. Her killer had evidently made his escape through the window and down the fire escape. He left behind a bloody thumbprint on the heel of the woman's shoe. The police were frustrated in their detection efforts by the fact that Lee had a succession of male companions in the twenty-four hours before her death. It is clear that the VPD were also morally critical of Lee. She was described in police accounts as "a woman of loose morals and known to be a heavy drinker"; her sometimes-companion Ole Johnson, might have served as a witness were it not for the fact that "just prior to her death… [Lee] asked him to absent himself from the room for a short time while she entertained a white male acquaintance." They focused their efforts, eventually, on Lee's last known visitor, "a coloured soldier in United States Army uniform." He was described "as a very large man, well over six feet tall, about 230 lbs., dressed in a tunic with three stripes and a "T" (Technical Sergeant) and peaked cap. He is alleged to

be fairly good looking for a Negro, not very dark coloured and somewhat resembling the pictures of Joe Louis, the fighter, in features."[367] Despite this vivid description and the "magnificent co-operation" of American authorities, the killer eluded custody.

Similarly, the 1947 trial of Malcolm Woolridge for the murder of his wife, Viola, provided an opportunity for authorities to present their ideals of womanhood. In the midst of a noisy argument in their rooming house apartment at 625 Hornby, Malcolm pulled a gun and put three bullets into Viola, then picked up the phone, called the police, and confessed his guilt.

During the Woolridge trial, Malcolm was portrayed as a childlike man who was manipulated by his domineering and physically large wife. Viola was accused of being a bad wife and mother, by neglecting to have supper on the table when her husband returned home after work, and for "nagging" Malcolm. Viola and expectations of early Cold War womanhood were on trial, not Malcolm. At one point in the trial the judge (and former Attorney-General), Alexander Malcolm Manson, stopped the proceedings to ask the accused where he got the gun. Found it in a paper bag on Broadway, he said. That satisfied Judge Manson, who acquitted Woolridge saying the poor man had suffered enough. Had Viola suffered enough? She certainly wasn't going to suffer any more.

Public attention was certainly drawn to "morality play" murders. This was most clearly the situation when charges were laid and the accused came before a judge and jury. The values of mid-century Vancouver society could be spelled out in the courtroom or in the pages of the local newspapers. There's something casually theatrical about even the most tragic of these events. Take, for example, the murder of Archie Johnson. A fifty-two-year-old commission agent, "sporting man," "family man," and "square-shooter," was shot dead in his office in the Iris Apartments, a repurposed turn-of-the-century boarding house at 813 Hornby Street at midday in February 1930. The press called it a mystery but offered up three possible motives:

That a disgruntled client shot him out of revenge.

That it was a quarrel over a woman.

That it was an attempt at robbery, Johnson being reputedly wealthy.

The story became progressively more colourful, wending its way through allegations of extortion, a betting ring's involvement, and the possibility that this was a gambling debt hit, until, eventually, the press

FREE on seven years' probation is Malcolm Woolridge, 20, who shot his wife to death, March 1. He received a suspended sentence Friday on a charge of manslaughter after a jury pleaded for "utmost clemency."

VANCOUVER NEWS HERALD, 28 JUNE 1947

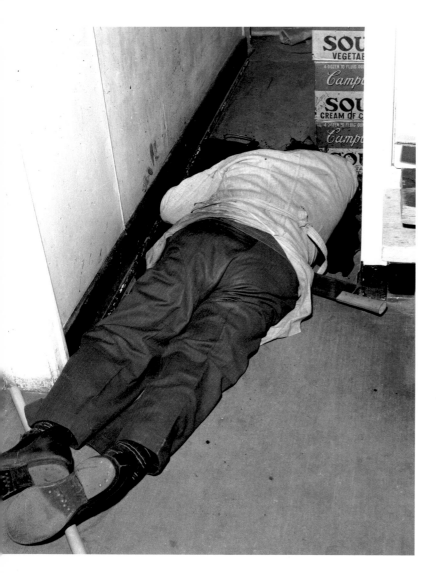

Lo Yung Sam, one of many shopkeepers whose small businesses were targetted by vicious criminals, 1960.

VANCOUVER POLICE MUSEUM, L0001

finally wound up back where it started: a robbery gone bad. Johnson, a square-jawed former Medicine Hat police chief, was described by neighbours as having "taken a few racing bets just to pass the time," so he was likely to have a little cash on hand. The gunman, for his part, was portrayed by witnesses as "a man with soft hands, unmarked by signs of outdoor toil, and dressed in a blue chinchilla overcoat and a grey cap," and "a guy who looked like a respectable working stiff."[368] He didn't strike any of the parties directly involved as a mob hit man cleaning up a debt.[369] None of the players are big time crooks, no one seems especially competent, and the shooter—closely witnessed by Johnson's neighbours—escapes easily by running down an alley.

Canadians are used to the idea that gunplay is the exception, not the rule. Yet Hobbs, Perrin, Woolridge and Johnson were all shot by their killers. In the *Noir* years, guns show up regularly. This meant that even small-time crime came with additional risks. Petty holdups of corner stores were regularly conducted at gunpoint and bandits showed little fear of firing off a round or six. Neither did the police. There seemed to be no shortage of firepower in Vancouver in the early 1930s and by the late 1940s the streets were lousy with guns.[370] Plenty of demobilized servicemen brought home their weapons, so much so their presence was taken for granted.

This put corner grocery owners at a tremendous disadvantage, since honest folks (apart from bankers) didn't carry side arms. The

proliferation of small shops, corner stores, confectionaries, cigarette and magazine stands, and little coffee shops provided Vancouverites with plenty of shopping convenience. But they were also attractive to hold-up artists. Chinese-Canadian shopkeepers—of whom there were many in Vancouver—inevitably came up against gunmen. Low Gum Chew, sixty, was murdered while defending his shop at 2711 West Fourth in 1956. Lo Yung Sam's documented fear of hoodlums was vindicated the next year when his shop at 5931 Victoria was held up.[371] In 1960, Lit Fat Tom, a shopkeeper born at the turn of the century, surprised some small-time thieves in his small grocery store. A "furious struggle" broke out, but the shopkeeper came off the worst for it. One of his attackers held him while the other beat him savagely and drove a knife, repeatedly, deep into the man's body. Lit Fat Tom's life was bought cheaply: the burglars panicked and made off with only a quantity of cigarette cartons, leaving behind a large amount of cash.[372] In the heat of the summer in 1941, there was a rash of gunpoint robberies targeting drugstores. Despite the "large black revolver" that figured prominently in identifying the spree as the work of one man, no one had been hurt until, on September 18th, Fred Fawcett—the owner-operator of Fawcett's Drug Store in the 3700 block Oak Street—was shot in the back with a .45 revolver. Inter-city police work pointed to a bandit who had stolen cars and held up drugstores in Winnipeg and Calgary. George S. Young, an Army deserter who had bolted before he could be shipped out to Europe, was tracked to Prince Rupert, brought to justice in Vancouver and sentenced to seventeen years: fifteen for the robberies, two for assaulting a cop as he tried to make another break for it, and zero for the murder of Fawcett, for which he was, remarkably, acquitted.[373] Images from these years of frustrated shopkeepers wielding machetes or cleavers speak to their desperation and fear.

Performance Art

The Vancouver Courthouse—now the Vancouver Art Gallery—provided theatre for the public and fodder for journalists. Lawyers and columnists mingled at the Georgia Coffee Garden and the reportage of the day gave the sort of play to criminal trials now reserved for the sports section.[374] Trials were opportunities for the public to see the underclass on stage and justice delivered. Well-heeled crowds gathered in sizeable numbers outside the Courthouse to hear verdicts minutes after they were delivered.

Witnesses and suspects at the Boland Trial, 1944.
CITY OF VANCOUVER ARCHIVES 1184-246,
JACK LINDSAY

One such event aroused emotions across the city. This was the Robert Hughes case of 1942-43. In January '42, Hughes and three of his pals got a gun and some bullets (partly through the efforts of a sixteen-year-old female accomplice), stole a car, and set out to hold up a couple of Kitsilano stores. The nineteen-year-old mastermind's plan went badly awry when the second shopkeeper put up a struggle and their son—twenty-seven-year-old Yoshiyuki Uno—was hit in the hand by a stray bullet, then took another in the shoulder and a lethal third in the head.[375] This was just months after Pearl Harbor and public sentiment was divided between those who sympathized with the grieving family of the victim, and those whose hostility towards Japanese Canadians was aflame. "These boys' sentences," wrote one reader of *The Province*, "should be handled by giving them a chance to kill many more Japs."[376] This was not the opinion of the teenage seductress in the tale, Rosella Gorovenko. When the police crashed their "flophouse" hideout, they found Gorovenko in bed with Hughes and one of his accomplices. Gorovenko, described in a "true crime" magazine as an "attractive, dark-eyed little damsel," turned on her chums in court, giving testimony that would, for the time being, send them to the gallows. In her opinion, "these Japanese had as much right to live as anyone else."[377] An appeals court extended this logic to the Hughes gang, reducing their convictions to manslaughter and a ten-year term in the BC Pen for the killer.[378]

The Hughes trial took place before a courtroom crowded to the rafters. The same was true in the case of the 1944 murder of Francis Andrew Boland, a twenty-seven-year-old connected to the city's robust bootlegging business. In the small hours of December 13th, 1943, the police were called to 1431 Howe Street, a suspected illegal liquor outlet run by Bert Woods. Boland was found lying in the hallway, his body riddled with bullet holes. Although he was rushed off to Vancouver

General Hospital, Boland never regained consciousness and was unable to provide any clue as to his murderer's identity. Nonetheless, it was looking bad from the outset for Fred Mayer, a twenty-five-year-old associate, who was found in the same building with blood on his face, likely from a punch-up with Boland. A search of the house, however, turned up two revolvers (including a .38 calibre Ivor Johnson which had recently discharged five bullets), and two green masks. A fourth resident of the house, Charles Hawken, who was known to police as "an associate" of Bert Woods, testified that he had been held up the previous evening by two gun-wielding masked bandits outside the bootlegging operation. It would seem that Hawken, having made some extra money through some means other than selling Woods' liquor, was robbed by his erstwhile allies, including the fated Boland. Hawken's subsequent trial was a local *cause celebre*, but the young gunman was found not guilty and walked. Mayer, on the other hand, received nine months for robbery with violence.[379]

Probably more than any other judge in Vancouver's age of *Noir*, Alex Manson played a key role on the bench. Despite his performance in the Woolridge trial (described above), Manson generally took deep personal offence when it came to crimes against women—especially rape—and in the course of his career he sent fourteen killers to the gallows for a variety of reasons. His verdict in the case of Walter Pavlukoff, earned him the sobriquet of "Hanging Judge" Manson, although some may have used the term before that trial. Pavlukoff, described in the press as a "Doukhobor ex-convict," at a time when "Sons of Freedom" was itself a shorthand signal of "differentness" and "Russian" meant "communist threat." The Doukhobor religious colonies on the Prairies and in south-eastern BC were a sensational news item in *Noir* Vancouver. Engaged in a protest campaign of public nudity and arson—targeted at their own property— they were regularly rounded up by police when their protests came to Vancouver. Pavlukoff's situation may have arisen from Doukhobor colony conditions but he had surely moved on; by the Second World War he was a career criminal who specialized in holdups at gunpoint. In 1941 he went to jail for three years after robbing a West End gas station owner of $80.00.[380] Six years later, on the morning of August 25th, 1947, Pavlukoff, by this stage thirty-four years old, "stepped out of the Rancho Rooms at 119 East Cordova Street with a Luger automatic pistol in his pocket" and bank robbery on his mind. The branch manager of the

Canadian Bank of Commerce on West Broadway in Kitsilano, Sidney Sinclair Petrie, wound up looking down the wrong end of Pavlukoff's Luger.[381] A gun-blazing chase followed, moving from Kitsilano to the woods and swamps of Surrey, but Pavlukoff eluded capture. With the murder of Petrie, Pavlukoff graduated from run-of-the-mill hold-up bandit to dubious distinction as Canada's Second-Most Wanted Man by 1953. In that year he was finally arrested in Toronto—after nearly a half-dozen years on the run—and charged. Shipped back to Vancouver, he came up against Judge Manson. Shouting from the prisoner's dock as the trial opened, Pavlukoff audaciously accused Manson of wanting to see him executed even before the trial began. Manson, happy to accommodate, soon sent him to the gallows. Pavlukoff, not so happy to accommodate, filed a spoon handle into a primitive blade and, driving it into his own heart, committed suicide while awaiting execution at Oakalla Prison.

The Burrard Bridge Monster

Despite Pavlukoff's efforts to lighten his load, Oakalla's executioner—the pseudonymous "Arthur Ellis"—was kept busy enough. In not every case did the punishment suit the neck in the noose.

In November 1949 the body of Blanche Fisher was discovered, floating in the waters just below the Burrard Street Bridge. Fisher was a clerk in the women's "foundations" section of Woodward's, a forty-five-year-old single woman who cared for her older siblings in their "well-regulated home at 1051 East Twelfth." Tuesday and Saturday evenings, she would head off to the Rio Cinema on Broadway at Commercial. It was after one of these movie nights that she failed to return home. At first, the VPD—led in this case by Detective Sergeant George Monger, described by *The Sun* as "tall and lean"—reckoned it to be a suicide, assuming that Fisher had jumped from the False Creek railway trestle, but her family wouldn't buy it.[382] They pressed the police to continue with the investigation. Shortly thereafter, a mentally unstable flasher named Frederick "Red" Ducharme (*aka*: Frederick Graham Farnsworth) was picked up in Kitsilano; an inspection of his car and his rundown float house on False Creek turned up Fisher's wristwatch, umbrella, and rubber boots. Ducharme came clean, admitted he'd raped Fisher and tossed her still-living body into the saltchuck, but denied that he actually murdered her. The distinction was so fine that no one took much notice.

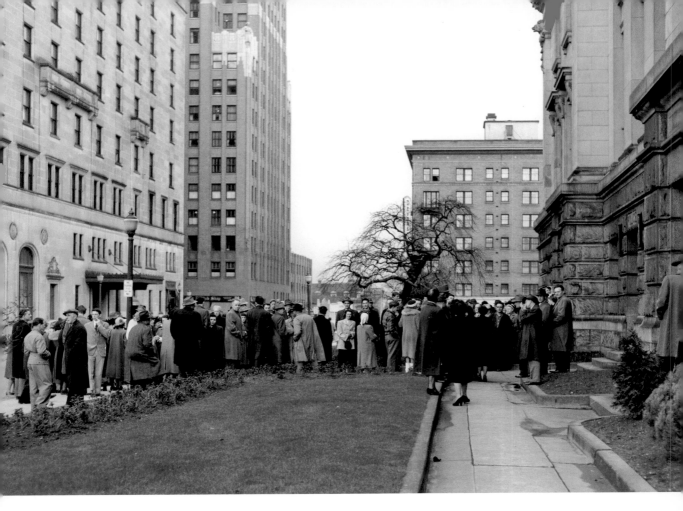

Ducharme's ordeal in court was described in the press as a "smash hit murder trial."[383] It drew a huge amount of public attention, fed by lurid newspaper reports. The crowds in the stolid Georgia Street courthouse engaged in "an undignified scramble to get possession of the front seats." Others simply could not be accommodated: over the course of a two-week trial, hundreds of spectators were turned away. False Creek's float house society made a rare public appearance, which included bizarre witness testimony from Ducharme's neighbour Joseph "Little Joe" Holmgren. The float house resident testified that at two in the morning he let Ducharme use his rowboat to dump "outa piece" in the saltchuck, what Holmgren himself suspected was a corpse; Holmgren was so blasé about the whole episode he asked Ducharme if he'd gone through the pockets. Perhaps reflecting the priorities of the shanty towners, Holmgren was more concerned that what he was told was a suicide's corpse should be taken far enough away "so the blue beetles [i.e.: police] would not be

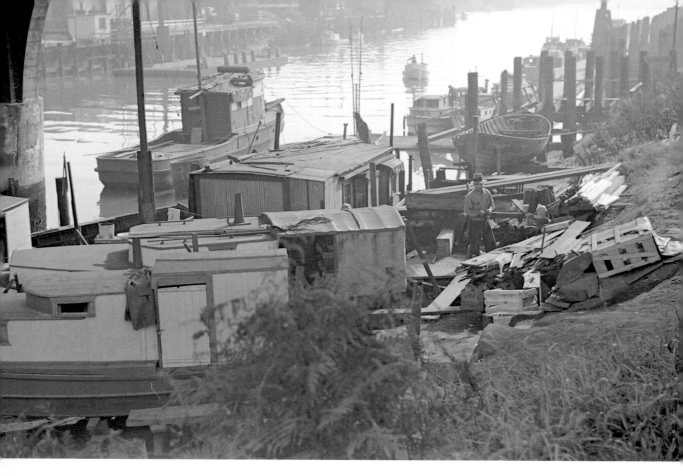

The floathouse community described as "a nest
of perverts on False Creek," 1949.

CITY OF VANCOUVER ARCHIVES 1184-1893,
JACK LINDSAY

prowling around. That seemed fair enough to me, so I didn't give no other thought to it."[384] In the witness stand, Holmgren testified that he told Ducharme that he'd "rather have live corpses than dead ones because they are a lot more sociable."[385] A further colourful wrinkle in a grim case was the disappearance of a key witness: Joe "Half-a-Rock" Derewenko. There was, too, a subtext to the trial: while Fisher was described as coming from a good family, living in a nice neighbourhood, and being the "salt of the earth," Ducharme was identified as an orphan and "a fool, living in a nest of perverts on False Creek."[386]

Despite Ducharme's plausible defence that he had not actually killed Fisher, and despite the fact that he was clearly suffering from some kind of mental illness—described in the trial as "a psychopathic personality subject to shameless sex offences"—he was found guilty of murder.[387] After seventeen days of trial, a crowd gathered outside the courthouse to hear the verdict. Judge Manson came through with another assignment for the Oakalla hangman. Appeals failed and Ducharme was executed at the crack of dawn on the 14th of July 1950.

There are two footnotes to the tragic events surrounding the death of Blanche Fisher. First, the circumstances and scene of her murder would echo in debates about the float house and shanty town pockets along the Vancouver waterfronts. Fisher's killing no doubt hardened public opinion in favour of the demolition and removal of the shanties and their occupants. More lasting, in some respects, was the myth of the "Burrard Bridge Monster." Ducharme earned this epithet partly for the murder of Fisher but perhaps even more for his physical distinctions. He had a penis that was described as "fourteen inches flaccid," which he liked to tie up under his chin with bootlaces strapped across his chest.[388] When he was arrested he was wearing a fisherman's oilskin coat and not a lot more. Evidently, he especially liked "walking the dog" in public view, on and around the bridge. Small wonder that Ducharme's attorney took the view that the killer was not mentally fit to stand trial.

Cop Killers

There were only a few cases during the *Noir* era where police constables were killed but in each instance justice was served up and was seen to be done. The December 1955 murder of Constable Gordon Sinclair by career heist-man Joe Gordon saw the killer off to the gallows after one of the city's longest trials. During a marathon summing up, the public spectators refused to budge from their seats for fear of losing them before the jury returned with a verdict.[389] As compelling as the Gordon case was to the police force and the public, no homicide in this period remains as profoundly emblazoned in the collective memory of the VPD as the killings of Constables Charles Boyes and Oliver Ledingham on 26 February 1947. After months of trying to break an East Van gang made up mostly of young teens, an anonymous tip led to a police stakeout of the Royal Bank of Canada at First and Renfrew.[390] When a stolen automobile pulled up, its occupants noticed the police presence and raced off. A multi-police car pursuit followed. About a half-mile from the bank, the suspects jumped from their car and ditched the police tail. Three schoolboys observed the suspicious behaviour of the fleeing men and flagged down a prowler car, one of the boys joining the police in the subsequent pursuit to the Great Northern Railway tracks and the roundhouse. It was there that Detective P.A. Hoare, along with Boyes and Ledingham confronted the thieves and ordered them into the waiting police car. Hoare noticed a gun sticking out the pants of one of

left: Constable Oliver Ledingham, 1947.
right: Constable Charles Boyes, 1947.

VANCOUVER POLICE MUSEUM, 040
VANCOUVER POLICE MUSEUM, 046

the suspects and made a grab for it. The three robbers tried to run, but one of them, Harry Medos, twenty-two, pulled out a hidden revolver, spun, and fired at Boyes, hitting him squarely. Another, Douglas Carter, nineteen, got off six rounds of heavy 44-40 bullets, most of which hit Ledingham, one of which caught Hoare in the hip. Medos put a second bullet into Hoare's shoulder and then finished off Ledingham. The badly wounded Hoare, remarkably, found his own aim. He clipped Medos in the backside and brought down Carter with a deadly shower of bullets. Other police, arriving on the scene, picked up the trail of the wounded Medos and the third man, William Henderson, seventeen, who were found not far away, hiding in the basement of a house on East Sixth. The suspects were found to be armed with spare ammunition, a change of clothing for their getaway, and masks made from "Ladies stockings."[391]

Medos and Henderson were both convicted and sentenced to death. Although Medos went to the gallows, Henderson's sentence was

commuted to life in prison, given his age and the fact he was the one culprit who voluntarily disarmed himself prior to the shootout; Henderson was later acquitted.[392] As for Ledingham and Boyes, their funeral parade was one of the largest public events in Vancouver history. It was reckoned that 100,000 people lined the streets to watch the procession, this in a city of fewer than 400,000.[393] This public display of grief and solidarity with the VPD was by any measure, exceptional. The closing of major city roadways for the procession and the fact that this sense of civic loss was so great only two years after the end of a war in which thousands of Canadians died recalled the kind of city Vancouver was before the Depression. The Boyes-Ledingham murders humbled the city, however briefly. It was not matched by anything like it for more than a generation.

Murder Mysteries

Murder mysteries routinely populated the pages of the local newspapers. An early example occurred in 1939. Despite the services of the Bureau of Science, the VPD's Criminal Investigation Branch was stymied by the George Gray murder. Gray, a seventy-year-old bachelor living alone on East First, was found in his blood-spattered house, brutally battered to death. When the cleaning lady arrived for her weekly tour of duty she found the back door locked, but the key still in the lock from the outside. What's more, "a considerable sum of money was found on the person of the victim," indicating that theft was not the motive. The most powerful image coming out of this case, however, was the fact that Gray's pipe was still clutched in his right hand, despite the vicious beating to which he was subjected.[394] Gray's killer was never found.

Despite the modernization of the VPD in these years, killers often eluded capture. In 1949 alone, on Walter Mulligan's watch, there were three unsolved murders: twenty-five-year-old Joyce Monasterski disappeared on her way home from work at the Stanley Park Pavilion and her lifeless body washed up across the First Narrows near Lighthouse Park; William "Crosshaul" Kelly, a retired logger who made his home in the 1500-block of Powell Street, came out at the worse end of an assault involving an axe; a resident of the run-down float house village in Coal Harbour, seventy-one-year-old William Bent, was found murdered in his home; elderly William McIntosh of 2158 Turner picked the wrong night to go for an evening constitutional—he was beaten by person or persons unknown and his body left in an alleyway. Stanley Butkus met

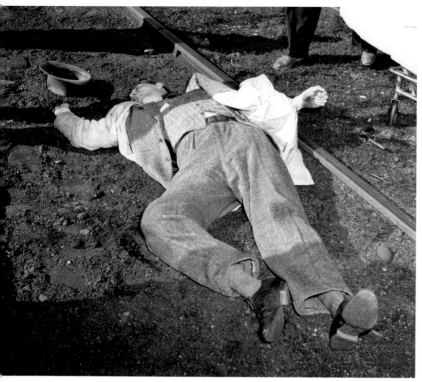

his end in a Skid Row hotel washroom in 1951; in the same year a fifty-four-year-old Finn who had been a champion cyclist in his homeland, Albert Backus, was beaten to death "by hoodlums;" also in 1951, Stephen Jacob Yuskow, the forty-six-year-old owner of the Morgan Hotel at 244 East Hastings, died from an inflicted head injury; Hilda May Dryborough, forty-three, was strangled in another low-rent hotel in 1953.[395] The 1954-5 "drug war" slaying of Danny Brant (aka Danny Brent), whose body was memorably dumped on the University Golf Course, was never solved. Around the same time a local newspaper printer, Robert D. Hopkins, was found in his 4010 Fleming Street home off Kingsway, bound and strangled with his own tie. Three years later, Horske Fenske, a forty-three-year-old former German soldier who had served time as a POW in the United States, got his skull fractured downtown in the 1000 block of Seymour and subsequently died from his injuries.[396]

Throughout these years there was always a fresh body turning up dead on Skid Row. What's more, they were invariably on the list of unsolved homicides. Horrific those these killings might have been, and however stunning the failure of the police to arrest a suspect, these cases pale in comparison to the two great unsolved murder cases of the *Noir* era.

The Babes in the Woods

The press, perhaps weaned on Sherlock Holmes and pulp novels, liked their murders dressed as mysteries with flashy titles. None came so close to this standard as the infamous 1953 "Babes in the Woods" case. On January 15th the skeletons of two children were found in Stanley Park, covered thinly by forest debris and a woman's fur coat. There were two

pairs of Oxford-style shoes and a blue, tin lunch bucket nearby. One of the skulls was covered by a leather aviator's helmet, "such as a small boy would wear"; the other skeleton had another, similar helmet in its hand.[397] The murder weapon—a shingler's hatchet—was found nearby, as was a single woman's shoe. The VPD wheeled in its forensic detection arsenal, focussing on the clothing worn by the children, and on the coat. It was reckoned that the bodies had been deposited in the Park as early as 1948. The Police also employed Erna von Engel-Baiersdorf, a physical anthropologist who had emigrated from Vienna after the war, to produce plaster copies of the skulls (two of which are still on display at

The Boyes and Ledingham funeral procession, 1947.
VANCOUVER POLICE MUSEUM, 589

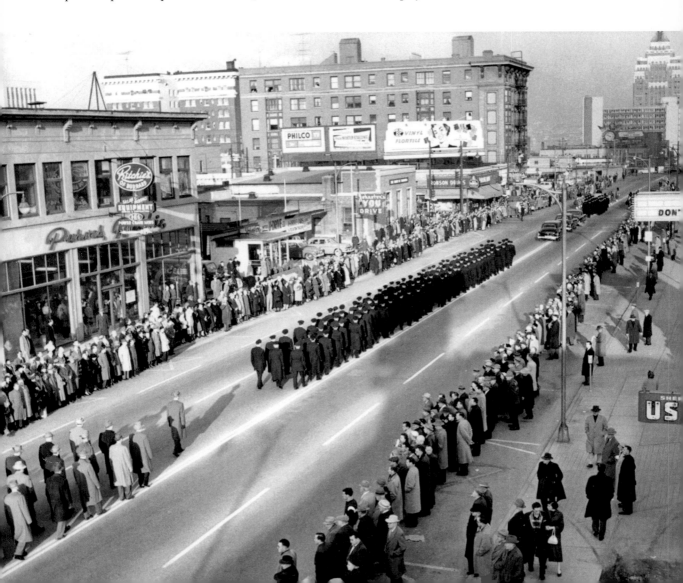

the Vancouver Police Museum). These efforts and the publicity around them were part of a strategy to raise awareness and flush out witnesses. Remarkably, there were few leads on a missing pair of children who wore good quality shoes and had dental cavities that suggested they "had been pampered with too much candy."[398] No one came forward to report missing children or to offer significant evidence. The case was not helped by the fact that the older of the children was originally misidentified as girl; although there were suspicions at the time that the victims were both boys, that fact would not be confirmed until 1998, when DNA tests were applied. After four months of investigation, the dominant theory was that the children were murdered by their mother (hypothesized to be a "chunky" 5'2"-5'4" "deranged" woman of modest means), who threw herself from the Lion's Gate Bridge after killing the children.[399] This remains a particularly chilling cold case in the VPD's files.[400]

The Pauls Mystery

Vancouver recorded two truly shocking murder cases in 1958. The April 3rd killing of Evelyn Roche was a brutal, late-night attack in the 2600 block of East 7th. The thirty-nine-year-old woman was returning from the post office, where she had sent off a package to her husband, who was working in a logging camp on the central coast. She picked up a bottle of liquor on the way back—as this was sometime around 10 p.m., presumably it was from a bootlegger—thirty minutes or so later, neighbours heard her screams as she was stabbed repeatedly. Although Roche was not sexually assaulted, the police decided they were looking for a rapist and interviewed "every known sex offender in the City."[401]

While Roche's murderer was being fruitlessly pursued, Vancouverites took extra precautions to keep themselves safe, which set the stage for a grisly multiple killing at 1014 East 53rd Avenue. The Pauls family, stunned as many Vancouverites were by the Roche murder, had taken additional care around late-night travel to and from work so as to avoid Roche's fate; even so disaster awaited them, but at their home and not in the city's streets.

This was a particularly ghastly killing, one that took the lives of David and Helen Pauls and their daughter, eleven-year-old Dorothy. There was no sign of theft, no ransacking or vandalism, no sexual assault took place … just three systematic killings. The police believed that it was a targeted hit, most likely on David Pauls, who was shot in the back

of the head three times. Dorothy was shot to death in her bedroom minutes later. But the killer or killers then waited, perhaps for hours, for Helen Pauls to return home and ambushed her as she came through the door, shooting her at close range in the head as she faced her assassin. Was Helen the real target? Was it the whole family? No witnesses ever came forward with anything of consequence. The mystery was never resolved and a motive was never established, though not for want of trying.[402] *The Sun* posted $4000 in rewards (which was trebled by other donations), lambasted the VPD's investigation efforts, and offered up the grisly scenario that the killer was a "necrophile" who was interrupted in his assault on the little girl.[403] A

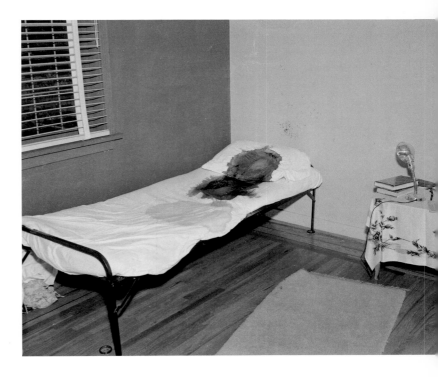

half-footprint in the garden outside Dorothy's bedroom window lent substance to the "peeping Tom" theory. Building a picture of the family proved a challenge: Helen and David were variously described as from Norway, Poland, and Russia. They were members of an Abbotsford-area Mennonite church and had lived in the Valley for eight years before coming to Vancouver a year and a half before their deaths. Helen may have had some connection with organized labour; perhaps some grudge had followed them to the Pacific coast from the Central European theatre of war. Not only is this one of the most grisly and mysterious of the *Noir* era murders in Vancouver, it is the coldest of the cold cases: while the Babes in the Woods and other mysteries are regularly reviewed in the press, it has been more than twenty years since the Pauls case received similar attention.

The bed in which Dorothy Pauls was murdered, 1958.

Vancouver Police Museum, N00644F

There are a couple of patterns to homicide in this era worth noting. First, 2 a.m. was a very dangerous time to be on the streets of Vancouver. Certainly time-of-death was often hazarded by the Coroner's Office after the fact, so perhaps one cannot be very precise about this pattern,

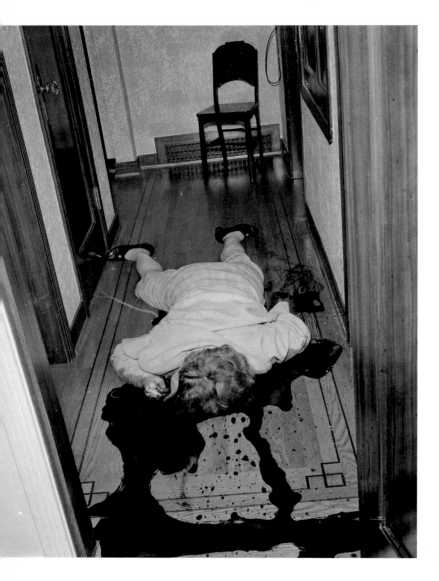

Helen Pauls, 1958.
VANCOUVER POLICE MUSEUM, N00644A

but it is remarkable how often murders seem to have taken place soon after the last bars closed. Second, although homicides (unlike moral deficiencies or allegations of being on the take) typically involve a few pieces of evidence—like a body, for starters—that didn't stop the press and the politicians from exaggerating fatal dangers as part of the ongoing rebuke of the East End.

To take one example, Hogan's Alley had a reputation in these years as the sort of place where one could get wine, women, song, and a decent steak, any time of the day. But it was also regarded as a place of physical calamity. Local historian Eric Nicol recalled from the vantage point of 1970 the ways in which Vancouver youth in particular saw the Afro-Canadian blocks: "the name that iced the spine with dread was Hogan's Alley, a cobbled lane east of Main so infamous that it did not have a signpost, in whose shadows huddled shacks whose inhabitants, as every schoolboy knew, combined the more disturbed attributes of Jack the Ripper, Count Dracula and Dr. Fu Manchu."[404] Peter Battistoni, a Strathconan, contributed to this mythologizing. His bread route took him through Hogan's Alley on Monday mornings: "…and almost every Monday you'd find a body. I seen two women dead one day under a barn. One in a garbage can with her feet sticking out. And you'd always find somebody. Now that was a big thing for anybody that lives out of the district. They thought they would drive through there fast with a car, like rich people so scared to go through Hogan's Alley. And I used to wonder,

'What's wrong with them? There's nothing wrong with this alley?' Sure, you find people who are dead, but that's an everyday thing. "[405] Other locals, however, recalled the situation differently. Angelo Branca, a long time resident of the Eastside who became a prominent criminal lawyer in these years and, eventually, a Justice of the Supreme and Appeals Courts of British Columbia, grew up at 343 Prior Street: Hogan's Alley was literally out his backdoor.[406] He recalled that there were few murders in the neighbourhood during the *Noir* era. By his reckoning, Hogan's Alley saw only one or two murders in all the time it was associated with bootlegging, prostitution, and street entertainment.[407] Another long-time resident could remember only one violent death in Hogan's Alley from the 1930s to the 1970s: a local who was clubbed with a wrench by another resident in an argument about the mistreatment of a dog.[408] It has to be said, in our analysis of VPD Annual Reports and our survey of newspaper coverage of murder cases, we did not encounter one instance of a murder case in the laneway between Main and Princess. And that may well be the greatest murder mystery of all.

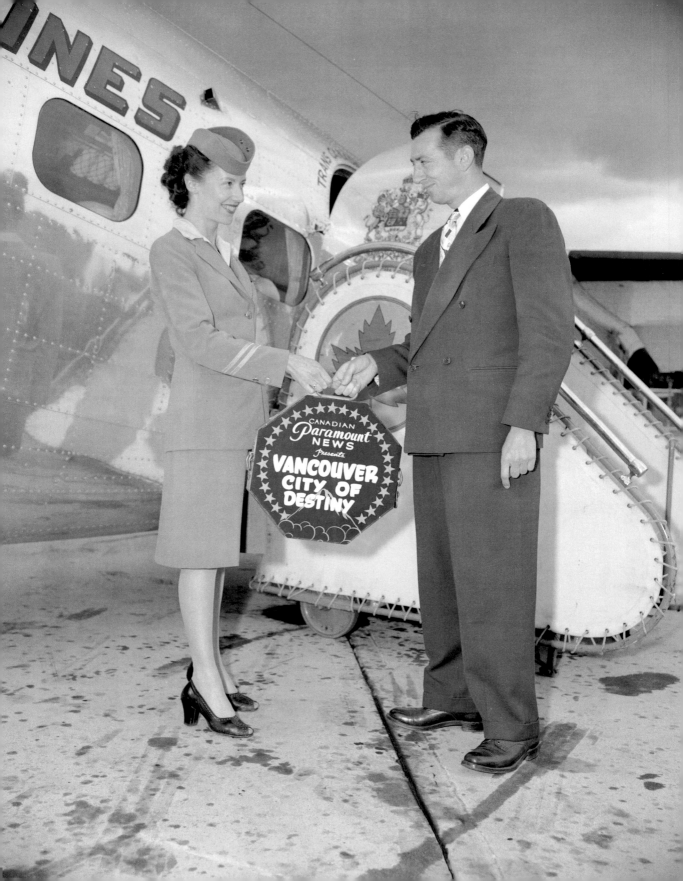

CITY OF GLASS: THE AGE OF NOIR

"There's no dough left in bootlegging; all the bawdy houses are closed down and now they stop a man from taking a few honest bets."
—Joe Celona, ca. 1956.

THE *Noir* ERA CLOSED with a spectacular headline. Errol Flynn, the Hollywood actor whose career spanned the family-friendly swashbuckling films of the 1930s to years of elegant wastage in the '40s and '50s, died in a physician's Vancouver penthouse apartment on 14 October 1959. He had come to Vancouver to sell his yacht and spent his evenings conspicuously at the Cave and the Penthouse nightclubs, a seventeen-year-old girlfriend (and lover) on his arm.

Flynn's death was one marker of a dying era. So were the beginnings of the West End apartment boom, the decline of downtown movie cinemas, and the relocation of the many ethnic groups of the Eastside to the further reaches of Grandview, Renfrew, and the suburbs. Just as the Marine Building—that unsurpassable expression of west coast Art Deco and modernism—ushered in the age of *Noir*, new towers and housing tracts in the late 1950s signalled its end. The battle for the city was over. The city lost.

There were other terminations that mark the end of *Noir*. Hogan's Alley—the largely black neighbourhood between Union and Prior that was home to bootleggers, prostitutes, criminals, gamblers, and good, reasonably priced steak dinners—succumbed to "urban renewal pogroms" and the Georgia Viaduct project.[409] Black and white film gave way to Kodachrome colour, even in the work of the VPD Coroner.[410] Planner and politician Bob Williams recalls the physical polarization of the city along Cambie Street, a "sea of greenery" on the west side, and "this bloody rooftop empty landscape to the east." This stark difference—a historical artefact to be sure, but inevitably mistaken by some as evidence of a lack of civic spirit in East Van—had matured in the very fibre of the

Halfway between the Wall Street Crash and the Mulligan Scandal, hope for the city's future springs eternal, 1946.
CITY OF VANCOUVER ARCHIVES 1184-2349, JACK LINDSAY

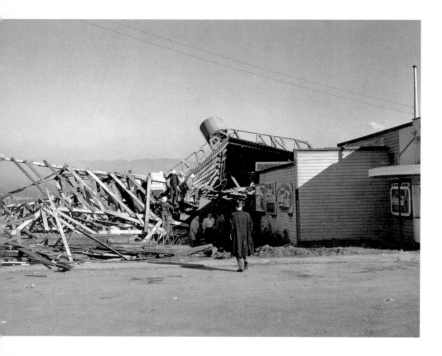

trees. An up and coming lefty could make political hay with that, change it, use Vancouver *Noir* against itself. Which is what Williams did.[411]

In some respects the city hadn't changed much by 1960. It was still the "engagingly seedy" place Williams had found in 1953 and which, for that matter, he would have found twenty or thirty years earlier. The architectural profile of the downtown was still, in 1960, dominated by two buildings: the Hotel Vancouver and the Marine Building.[412] Only four buildings of note had been added, two of them in the West End and south of Georgia: the BC Electric Company's headquarters—subsequently renamed the BC Hydro Building and now a bijou condo complex called The Electra Building—and the Vancouver Public Library, which moved from the Four Corners in 1958 to a new home Uptown at Burrard and Robson. The other important structures, the Canada Post Building on West Georgia and its neighbour, the Queen Elizabeth Theatre, were both squat modernist interventions that occupy whole city blocks, both of which sit atop the memory of Central School neighbourhood. All four projects were built around the same time—1955 through 1959—and they pulled the city's cultural and economic centre of gravity into what Bartholomew had decreed, three decades earlier, would be the Central Business District, further imperilling and impoverishing the old Downtown for another generation.

Other changes in the fabric of the city could be seen in the skyline. Zoning bylaws written in 1927 had limited building height in the West End to six storeys; in 1956 the City relented and a year later the eighteen-storey Ocean Towers was built, a harbinger of things to come.[413] Living in the downtown peninsula had been vilified for years, a process that fed the growth of light and happy suburban dreams. Even Vancouver's trademark neon signage was under attack. Although old examples were permitted to stay, new ones were discouraged as the 1960s got underway.

The cost of materials, it's true, had increased. But they were increasingly regarded as "vulgar," a word larded with class connotations.[414]

We have attempted to chart the contempt and fear of the old eastside Downtown held by Vancouverites from the west side. This did not end with the start of the 1960s. The middle-class Anglo-Saxon view of the city continued to find a voice. In a 1962 urban journey book about Vancouver, its West End author noted contemptuously that "Here and there the ranks of offices are broken by a series of old wooden houses, still resolutely inhabited despite the decay that marks them as slum dwellings without a slum to

New uniforms, same old VPD, ca.1960.
VANCOUVER POLICE MUSEUM, 885

rot in." Poverty was an embarrassment, and the people who lived in poverty no less so. And they were possibly irredeemable: "There is a great deal of the philistine in Vancouver's make-up. The spell of Vancouver's hard-muscled hard-drinking days is strong."[415] But it is in this sanctimonious caricature of the Downtown Eastside that we hear the fear and loathing that gave the era of *Noir* its divisive, judgemental, and exclusive flavour:

> *"Just inland from these docks lies skid road. It is a region of cheap hotels and crowded beer parlours, and Hastings Street is the main stem. Whenever the woods are closed, loggers roar into town to blow their stakes as they've always done, and when they're broke, they sign on again at nearby loggers' employment agencies. Here, less than a dozen blocks from where it forms the heart of financial Vancouver, Hastings is a street of bargain stores, drunks, dope addicts, wandering sailors, and the misfits who in every city seek some outdoor gathering place."* [416]

This view positions the neighbourhood as never being anything more than a sump for human degradation, as though it could never have a claim on dignity or pride. We argue that how the Downtown got to be perceived this way matters in the past and in the future of Vancouver.

The *Noir* era had a purpose and a meaning. *Noir* was a style, a sensibility, a vocabulary of trouble and edginess. Crimes and deviant behaviours that dated from before the Depression were reinvested with meaning; but some old crimes became suddenly more threatening than before, some old deviant qualities were identified as less tolerable. In addition, new kinds of crime and deviance appeared—or, more correctly, were identified—and new campaigns to root them out arose.

The louche life, seediness, glamour without beauty, entertainment without art, an incomprehensible teen culture, civic corruption … these were all targets in an increasingly bourgeois city. *Noir* acts as a dark mirror to define what the growing middle-class wanted from its city. As the power of the old ruling families declined relative to middle-class numbers and ideological hegemony, what came to be seen as the bad habits of both the upper and the lower classes came into question.

First and foremost, the middle class embraced individualism and the nuclear family. The symbols changed but private transportation, single-family housing, and a safe suburban lifestyle are certainly powerful examples. A Downtown dependent on clunky streetcars and populated by large numbers of single men whose work-lives and entertainments were rough and tumble was antithetical to this vision. Likewise political ideologies—in particular, Socialism of any variety—that endorsed collective identities rather than individual or family identities were threats. Sexual and physical deviance acted as another source of fear. Homosexuality, "freak shows," visible racial differences, prostitution, and even sex outside of the procreational paradigm of marriage challenged middle class norms.

Individual strength and rights often played out in confusing and complex ways. The individual might use the collective strength of the civic authority—particularly the VPD—as a means of protecting his assets and reining in his challengers. At the same time, the bourgeoisie lionized the individual crusader—like McGeer or Roddan—and was likely to believe in the moral fallibility of the police and other faceless civic employees.

The *Noir* era begins with a crisis. Historian Robert McDonald wrote of the pre-World War I elite in the city that its "upper class… had the advantage of ideological consensus and ethnic coherence."[417] That is to say, they were pro-Empire, pro-capitalism, white, and mostly Anglo-Saxon Protestants. In the midst of the global economic crisis of

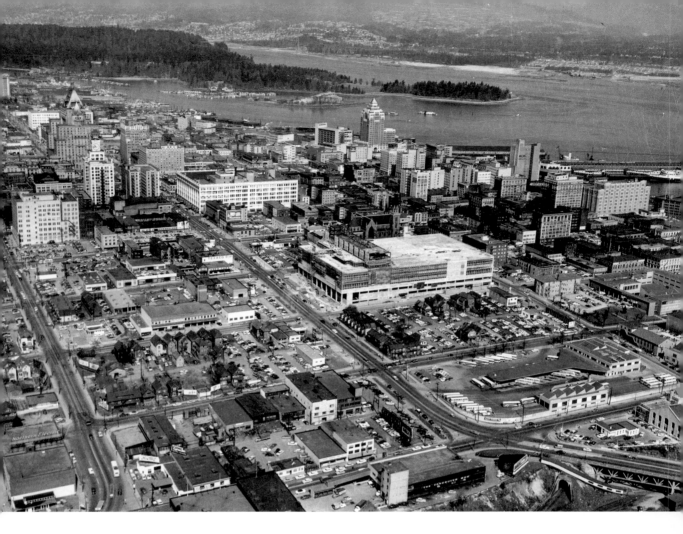

Only a small number of houses remain in Central School at the end of the 1950s, and their number is shrinking. Cambie Street Grounds has been converted into a bus depot, the new Post Office takes over a whole block, as will the Queen Elizabeth Theatre in the block in between.

CITY OF VANCOUVER ARCHIVES 296-33

the 1930s, their authority—and their understanding of the world—was being challenged in every way. With the collapse of the economy, the security of the entire middle-class population—that part of the American and Canadian population that sustained the vision of liberal democracy and into whose hands authority had fallen after the disaster of the Great War—was completely uncertain. We need to keep in mind that democracy was in retreat around the world in these years. Middle-class anxieties for the liberal order had a basis in fact. No surprise, then, that we find a cascade of moral panics, characterizations of marginally deviant behaviour as potentially catastrophic, and a renewed interest in justice *seen to be done*. No surprise, either, that these themes are not unique to Raymond Chandler novels, Hollywood movies, or even American cities of the mid-twentieth century. It was the bright light of bourgeois reform that created the shadows in which *Noir* lurked and evolved.

To continue with that metaphor, the *Noir* era ended as middle-class conservatism lost its power. The city centres of North America had been gutted of what made them most liveable and exciting, bringing on a rush to the suburbs and leaving little over which the establishment could legitimately moralize. Cold War campaigns against real and imagined fifth columnists had brushed up too close to anti-democratic fascistic impulses. Fears of excess—in the form of anti-communist "witch-hunts"—started to worry the intelligentsia and liberals alike. Television proved a more potent tool in the crusade to change behaviour than reform, if only by keeping kids off the street. The 1950s saw a renewal of immigration that further challenged the goal of a homogeneous, white-bread, Imperial British Columbia. An enlarged sense of Canadian democracy itself demanded that a culture of civil rights take root and in the midst of buoyant economic times by the early 1960s the disenfranchised minorities—the First Nations, the Chinese, the Japanese, and the Indo-Canadians—had been granted full citizenship.

Some of these themes are common across North America. But in Vancouver and British Columbia there were unique developments. In 1952 the provincial political leadership provided by generations of Liberal and Conservative Parties collapsed. The populist Social Credit Party—a recent arrival from Alberta—galvanized the rural, petit bourgeois, and better-off working-class vote. The role of Official Opposition remained in the hands of the social democratic Cooperative Commonwealth Federation (and its 1960s successor, the New Democratic Party). Shorn of a vehicle that would articulate a metropolitan bourgeois vision, the Vancouver middle-class shuffled obligingly into the wings of the Socred movement because, at the very least, they could keep the socialists out of power. This meant keeping political company with some very strange and unfamiliar bedfellows.

To be sure, the business of pathologizing the poor, the non-white, the "other" continued beyond the age of *Noir*. In 1958 City Hall reached back to the 1920s for a planning strategy that was meant to grind the life out of Strathcona. Building permits for renovations and home improvements were not to be issued and the kind of public works maintenance that was common in the rest of the city was denied the East End.[418] The effect was to pitch the neighbourhood—already the city's poorest—into a spiral of decline. The long-term goal was to worsen conditions to such an extent that razing most or all of it would come to be viewed as a mercy.

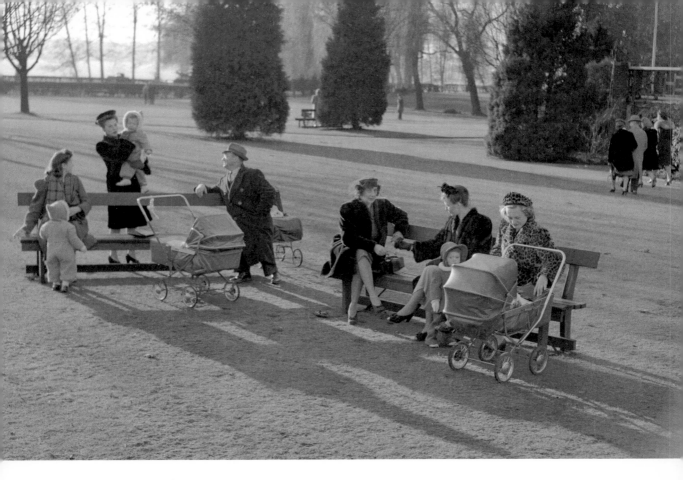

Throughout the *Noir* period, the fight against crime, social deviance, sexual non-conformity, and particular ways of being was confident, gritty, and filled with resolve. One has only to look at the photos of Colonel Foster astride his horse, quirt at the ready to slap around strikers, to know that the middle-class leadership of the city in the 1930s would brook no opposition. Likewise one could look to Andrew Roddan's barrel-chested pose amid the hobo jungles, or the bare-knuckled writing style of Walter Mulligan in the annual police reports. In the early 1950s, narcotics traffic was on the rise but not a worry; the police could beat it back. The same could be said of misbehaviours of any variety. But in his 1959 report, Chief Commissioner Archer blinked. He wrote, "One is led to the inescapable conclusion that we must accept the high incidences of certain types of offences as revealed by our statistical report herein as being the pattern for the foreseeable future inasmuch as all cities of comparable size on this continent report a similar increase, and this particularly in respect to breaking and enterings. Molesting of women and girls on city streets occasioned us considerable trouble as did the activities of sexual

Ideal images of motherhood and happy families in Stanley Park, scene of several gruesome murders, 1944.

The Hotels Vancouver, ca. 1947. The older building was, by this time, slated for demolition.

deviates. The problem of the drug pedlar and addicts continues to be a heavy one despite our efforts to control it." In one paragraph, Archer moves the VPD from the crime-fighting corps of its past and into an age of managing what cannot be quashed. The "drug pedlar and addicts" are, in this account, introduced as characters in the urban criminal landscape. To act on this changing situation, Archer introduced mobile units known as "Commandos," a squad of police dogs, and a City Health Plan that might address the "overly high incidence of heart disease which has robbed the Force of too many Officers and men during this year."[419] The old beat cop generation, raised on waterfront warfare and easy gunplay was literally dying off. In its place would emerge a leaner but qualitatively different force, one that was managed in part by the "Staff Counsellor" ("increasingly of value in the maintenance of morale") and the City's Personnel Department.

If the work of the police had changed, so too had the business of being a crook. The drug trade had overtaken the illegal supply of alcohol by the mid-1950s and the number of arrests on narcotics charges vastly outnumbered those of bootleggers by 1959. Even Vancouver's own special niche as a soft town for safecrackers was changing. A bank robbery on January 10, 1960, was accomplished by accessing the building next door, breaching a wall of laminated 2X4s by "boring 20 holes with an inch and a quarter brace and bit." This gave the yeggs access to the outer wall of the vault, which was made of half-inch steel plate surrounded by eighteen-inch concrete blocks. This is where the new technology of better organized safecrackers comes in. The bandits set up a tripod with a modified 30-06 calibre 1917 Eddystone American Army rifle, adding a cleverly fashioned silencer. The 30-06 ammunition was itself modified by drilling a hole into the bullet into which the thieves slid a half-inch steel tip. Using at least fifty-seven rounds of this tailor-made ordinance, the yeggs smashed through the concrete skin and then used a cutting torch to penetrate the steel vault wall. Having cleaned out a large number of safety deposit boxes, the yeggs made a quick getaway, leaving behind a huge inventory of equipment: the rifle and cartridges, an air hose, extension cords, gas masks, an electric fan, cutting torches and welding goggles, oxygen and acetylene tanks, and—to muffle their noise—a dozen large comforters.[420] This sort of operation is a far cry from the lone hold-up artists or the old-time safe jobs involving one or two men and a few vials of nitro.

Taking our lead from these yeggs, let us close this exciting chapter in the city's chequered history with a silencer of our own. In writing *Vancouver Noir*, we have purposely kept muffled the sound of theory, avoiding the use of academic phrases like 'cultural hegemony,' 'otherizing,' and 'orientalism.' These are explanatory categories used by scholars but bereft of meaning on the street. *Noir*—our term, but also that of a generation—captures better the contradictions of a sense of superiority coupled to a queasy feeling of vulnerability among the most powerful, contempt for the lower classes and non-white races married to a fascination with the earthy and the exotic, the piety of moralizers and crusaders in a city where the lawkeepers are corrupt, and the sense of style found in something as everyday as a slouch hat perched atop a coatrack at the White Lunch Café.

THE END

ENDNOTES

INTRODUCTION

1 Walter G. Hardwick, *Vancouver* (Don Mills: Collier-Macmillan, 1974), 26.

2 Michaela Freund, "The Politics of Naming: Constructing Prostitutes and Regulating Women in Vancouver, 1934-1945," unpublished M.A. thesis, Simon Fraser University, 1995, 31.

3 Will Straw, "Montréal Confidential: Notes on an Imagined City," *CinéAction*, 28 (Spring, 1992), 58-64.

4 See, for example, William Weintraub's *City Unique: Montréal Days and Nights in the 1940s and '50s* (Toronto: McClelland & Stewart, 1996).

5 Carolyn Strange and Tina Loo, *True Crime, True North: The Golden Age of Canadian Pulp Magazines* (Vancouver: Raincoast Books, 2004), 9.

6 Lee Server, "Introduction," Peggy Thompson and Saeko Usukawa, *Hard-Boiled: Great Lines from Classic Noir Films* (San Francisco: Chronicle Books, 1995), 1.

7 Bryan D. Palmer, *Cultures of Darkness: Night Travels in the Histories of Transgression* (New York: Monthly Review Press, 2000), 390.

8 The looks might have been coincidental but there's every likelihood that Angelo Branca—notorious for his theatrics in court—purposely drew on Tracy's style. Vincent Moore, *Angelo Branca: Gladiator of the Courts* (Vancouver: Douglas & McIntyre, 1981), 126.

9 Vancouver, *Police Commission Report, 1932*, 2.

10 Fred Herzog, "Exploring Vancouver in the Fifties and Sixties," *Unfinished Business: Photographing Vancouver Streets, 1955 to 1985*, Bill Jeffries, Glen Lowry, and Jerry Zaslove, eds. (Burnaby: West Coast Line, 2005), 160.

11 Photographic historians of Vancouver have privileged the colour era that begins in 1955. While it is true that the Beat artistic sensibility of the generation of photographers that includes Fred Herzog and Jeff Wall was more developed and nuanced, it would be wrong to think that street photography did not exist before 1955. Too, it would be a mistake to generalize, as Rob Brownie and Annabel Vaughan do, that "the photographs taken of early Vancouver celebrated industry, commerce, and construction," and that the individual and the "behaviour of the masses" was only documented after the mid-50s. Brownie and Vaughan, "Transient Vancouver: A Difficult Typology," *Unfinished Business*, 38.

12 Between the filming of *Timberjack* in 1954 and *That Cold Day in the Park* in 1969, no major commercial films were made in Vancouver. Mike Gasher, *Hollywood North: The Feature Film Industry in British Columbia* (Vancouver: UBC Press, 2002), 30-31.

13 David Spaner, *Dreaming in the Rain: How Vancouver Became Hollywood North by Northwest* (Vancouver: Arsenal Pulp Press, 2003), 21.

14 Jean Barman, "Neighbourhood and Commmunity in Interwar Vancouver: Residential Differentiation and Civic Voting Behaviour," *Vancouver Past: Essays in Social History*, Robert A.J. McDonald and Jean Barman, eds. (Vancouver: UBC Press, 1986),115.

15 In one case, a trial was rigged by Supreme Court Judge Alex Manson and Crown Prosecutor Frank Cunliffe. In 1948 Mirko Vitovich circulated a letter among the Croatian community of BC to be on the lookout for another local Croat whom he accused of being heavily involved during the war with the fascist Ustaše. Cunliffe and Manson reckoned Vitovich was a communist and conspired to secure a conviction under a rarely used 'criminal libel' charge. Patrick Murphy, "Reds Under Beds," *Sunday Reader, Victoria Times-Colonist*, 15 December 1996.

16 A victory that was later confirmed with the imposition of the at-large system of voting.

17 Hardwick, *Vancouver*, 28.

18 Jill Wade, *Houses for All: The Struggle for Social Housing in Vancouver, 1919-50* (Vancouver: UBC Press, 1994), 13.

19 Derek Simons, "Impressive and Interstitial Space in Vancouver's False Creek," *Unfinished Business*, 156.

20 Stan Douglas, *Every Building on 100 West Hastings* (Vancouver: Contemporary Art Gallery, 2002).

Endnotes

21 Daniel Francis, *L.D.: Mayor Louis Taylor and the Rise of Vancouver* (Vancouver: Arsenal Press, 2004), 150.

22 *Ibid*, 149-50, 166.

23 Patricia E. Roy, "A Half-Century of Writing on Vancouver's History," *BC Studies*, 69-70 (Spring/Summer 1986), 313.

24 George Kuthan and Donald Stainsby, *Vancouver: Sights & Insights* (Toronto: MacMillan, 1962), 1.

25 This has not been entirely and universally the case. For evidence of the survival of an excessively positive viewpoint, see Jim Wolf, *Royal City: A Photographic History of New Westminster, 1858-1960* (Surrey: Heritage House, 2005).

26 An excellent example of this is Daphne Marlatt and Carole Itter, *Opening Doors: Vancouver's East End* (Victoria: Sound Heritage, volume VIII, numbers 1 and 2: 1979). See also, Working Lives Collective, *Working Lives. Vancouver 1886-1986* (Vancouver: New Star Books, 1985).

27 Eric Nicol, *Vancouver* (Garden City, NY: Doubleday, 1970).

28 Roy, "A Half Century," *Vancouver Past,* 311-25.

29 See Tina Loo, *Making Law, Order, and Authority in British Columbia, 1821-1871* (Toronto: University of Toronto Press, 1994), 135.

30 Robert Menzies, "Governing Mentalities: The Deportation of 'Insane' and 'Feebleminded' Immigrants out of British Columbia from Confederation to World War II," *Crime and Deviance in Canada: Historical Perspectives*, Chris McCormick and Len Green, eds. (Toronto: Canadian Scholars Press, 2005), 162.

31 Clint Burnham, "Fourteen Reasons for Photoconceptualism," *Unfinished Business,* 103.

CHAPTER I
THE VANCOUVER WORLD: THE NOIR ERA

32 Allen Seager, "Organizing Labour in Vancouver, 1914-1945," *Working Lives: Vancouver 1886-1986* (Vancouver: New Star Books, 1985), 73.

33 The crowd is inherently distrusted by authority, as any number of histories have shown. See, for example, the classic work by George Rudé, *The Crowd in History* (London: Wiley, 1965).

34 Jamie Reid, "Curt Lang," *Unfinished Business: Photographing Vancouver Streets, 1955 to 1985,* Bill Jeffries, Glen Lowry, and Jerry Zaslove, eds. (Burnaby: West Coast Line, 2005), 80.

35 David Spaner, *Dreaming in the Rain: How Vancouver Became Hollywood North by Northwest* (Vancouver: Arsenal Pulp Press, 2003), 30.

36 See, for example, Derek Hayes, *Historical Atlas of Vancouver & the Lower Fraser Valley* (Vancouver: Douglas & McIntyre, 2006), 64-7.

37 Hayes, *Historical Atlas of Vancouver,* 64.

38 Rob Brownie and Annabel Vaughan, "Transient Vancouver: A Difficult Typology," Unfinished Business, 34.

39 Vancouver, *Police Commission Report, 1933,* 2.

40 *Ibid,,*39. An 'anti-blight' campaign in the 1960s saw the end of many declining neon signs.

41 Keith McKellar, *Neon Eulogy: Vancouver Cafe and Street* (Victoria: Ekstasis Editions, 2001), 11.

42 Daniel Francis, *L.D.: Mayor Louis Taylor and the Rise of Vancouver* (Vancouver: Arsenal Pulp Press, 2004), 149.

43 Bob Williams interviewed by Jerry Zaslove and Annabel Vaughan, "Bob Williams on the History of Planning in Vancouver," *Unfinished Business,* 271.

44 Marlatt and Itter, *Opening Doors,* 168, 172. See also Michael Kluckner and John Atkin, *Heritage Walks Around Vancouver* (Vancouver: Whitecap Books, 1992), 29-57.

45 *Vancouver Sun,* 8 March 1930, 2.

46 E.G. Perrault, *Tong: The Story of Tong Louie, Vancouver's Quiet Titan* (Madeira Park: Harbour, 2002), 102.

47 Eric Jamieson, *Tragedy at Second Narrows: The Story of the Ironworkers Memorial Bridge* (Madeira Park: Harbour, 2008), 29-30.

48 Jill Wade, *Houses for All: The Struggle for Social Housing in Vancouver, 1919-50* (Vancouver: UBC Press, 1994), 13.

49 Harold Kalman, *Exploring Vancouver* (Vancouver: University of British Columbia, 1974), 161.

50 Donald Luxton, "Townley & Matheson Partnership, 1919-1974," *Building the West: Early Architects of British Columbia*, 2nd edition, Donald Luxton, ed. (Vancouver: Talonbooks, 2007), 326.

51 David Monteyne, "McCarter & Nairne Partnership, 1921-1982," *Building the West*, 275-6.

52 John Mackie and Sarah Reeder, *Vancouver: The Unknown City* (Vancouver: Arsenal Pulp Press, 2003), 34-5.

53 John Mackie, personal correspondence, 20 July 2004.

54 Andrew Parnaby, *Citizen Docker: Making a New Deal on the Vancouver Waterfront, 1919-1939* (Toronto: University of Toronto Press, 2008), 13.

55 Jean Barman, "Neighbourhood and Commmunity in Interwar Vancouver: Residential Differentiation and Civic Voting Behaviour," *Vancouver Past: Essays in Social History*, Robert A.J. McDonald and Jean Barman, eds. (Vancouver: UBC Press, 1986), 107.

56 Joan Cupit Proctor, *Growing Up in Grandview* (Vancouver: 2005), 59-61.

57 Eve Lazarus, *At Home With History: The Untold Secrets of Greater Vancouver's Heritage Homes* (Vancouver: Anvil Press, 2007), 24-5; Vincent Moore, *Angelo Branca: 'Gladiator of the Courts'* (Vancouver: Douglas & McIntyre, 1981), 42.

58 Francis, *L.D.*, 151; Lazarus, *At Home With History*, 23.

59 Marlatt and Itter, *Opening Doors*, 52-3, 140, 143.

60 Hogan's Alley was also the site of an important human rights protest in 1952, following on the death of Clarence Clemons, a local black longshoreman, who was severely—fatally—beaten by Vancouver police. The Fountain Chapel—the centre of Afro-Canadian spirituality in Hogan's Alley— played a critical role in calling the VPD to task (albeit with limited success). See Ross Lambertson, "The Black, Brown, White, and Red Blues: The Beating of Clarence Clemons," *Canadian Historical Review*, 85, 4 (2004), 755-76.

61 Peter Trower, "Remember the Forties," *Vancouver Magazine*, 11 (November 1978), 100.

62 Marlatt and Itter, *Opening Doors*, 75.

63 *Vancouver Sun*, 2 December 1932, 1.

64 For purposes of consistency and constructive imprecision, we use the term 'Skid Row.' We believe it indicates an area that involves more than one street.

65 Vancouver, *Police Commission Report, 1944*, 9.

66 Quoted in Bill Jeffries, "The Shock of the Old—the Street Photograph in Vancouver," *Unfinished Business*, 22-3.

67 Greg Marquis, "Vancouver Vice: The Police and the Negotiation of Morality, 1904-1935," *Essays in the History of Canadian Law, v.6: British Columbia and the Yukon*, Hamar Foster and John McLaren, eds. (Toronto: Osgoode Society, 1995), 267.

68 Becki Ross, "Bumping and Grinding On the Line: Making Nudity Pay," *Labour/Le Travail*, 46 (Fall/Automne 2000), 238-9.

69 Eric Nicol, *Vancouver* (Garden City, NY: Doubleday, 1970), 219.

70 Rachel Adams, *Sideshow USA.: Freaks and the American Cultural Imagination* (Chicago: University of Chicago Press, 2001), 6.

71 Hayes, *Historical Atlas of Vancouver*, 125.

72 John Mackie and Sarah Reeder. *Vancouver: The Unknown City* (Vancouver: Arsenal Pulp Press, 2003), 68.

73 Jill Wade, *Houses for All,* 50.

74 Despite these conditions, "most of the occupants interviewed by civic officials seemed quite contented and happy…. There was no indication of sickness, and many stated that their health was considerably improved after living close to salt water." Vancouver *Daily Province*, 25 September 1937.

ENDNOTES

75 Jean Barman, *Stanley Park's Secret: The Forgotten Families of Whoi Whoi, Kanaka Ranch and Brockton Point* (Madeira Park: Harbour Publishing, 2005), 227.

76 *Ibid*, 231.

77 Norbert MacDonald, "Population Growth and Change in Seattle and Vancouver, 1880-1960," *Pacific Historical Review*, XXXIX, 3 (1970), 297-321, reprinted in *Historical Essays on British Columbia*, J. Friesen and H.K. Ralston, eds. (Ottawa: McClelland and Stewart, 1976), 212-14. See also Patricia E. Roy, "British Columbia's Fear of Asians 1900-1950," *Histoire Sociale/Social History*, XIII, 25 (May 1980), 161-72.

78 *The Sun* and *The Province* partnered under the mantle of Pacific Press in 1957, which bought and closed its lone remaining real competitor, *The News-Herald*, that same year. See Maxine Ruvinsky, review of Marc Edge, *Pacific Press: The Unauthorized Story of Vancouver's Newspaper Monopoly*, in *Textual Studies in Canada*, 16 (2002), 61-7.

79 Perrault, *Tong*, 74.

80 Ian MacDonald and Betty O'Keefe. *The Mulligan Affair: Top Cop on the Take* (Surrey: Heritage House, 1997), 50.

81 Kay Anderson, *Vancouver's Chinatown: Racial Discourse in Canada, 1875-1980* (Montréal & Kingston: McGill-Queen's University Press, 1991), 141.

82 Perrault, *Tong*, 92.

83 Anderson, *Vancouver's Chinatown*, 166.

84 *Ibid*, 168.

85 *Ibid*, 143.

86 Wade, *Houses for All*, 111.

87 Anderson, *Vancouver's Chinatown*, 147.

88 *Ibid*, 177.

89 *Ibid*, 157-8. If anything, fear of Chinese sexual predators with young white women in their sights became even sharper in these very years. Chinese arrest rates were 154 in 1953, down from more than 2,300 in 1948. Vancouver, *Police Commission Report, 1954*, 12.

90 Perrault, *Tong*, 65.

91 Michael Barnholden, *Reading the Riot Act: A Brief History of Rioting in Vancouver*, (Vancouver: Anvil Press, 2005), 41-4.

92 Anderson, *Vancouver's Chinatown*, 188-9.

93 Hanna Teicher, "Freeway," *Vancouver Matters*, James Eidse et al, eds. (Vancouver: Blueimprint Books 2008), 34.

94 Trower, "Remember the Forties," *Vancouver Magazine*, 42.

95 Wayde Compton, "Hogan's Alley and Retro-speculative Verse," *Unfinished Business*, 111.

96 Marlatt and Itter, *Opening Doors*, 165.

97 Jeffries, "The Shock of the Old—the Street Photograph in Vancouver," *Unfinished Business*, 23.

98 Luxton, "Towards the new Spirit," *Building the West*, 436.

99 Wade, *Houses for All*, 39.

100 *Ibid*, 144-6.

101 David Spaner, *Dreaming in the Rain: How Vancouver Became Hollywood North by Northwest* (Vancouver: Arsenal Pulp Press, 2003), 27.

102 Fred Herzog, "Exploring Vancouver in the Fifties and Sixties," *Unfinished Business*, 160.

103 Hayes, *Historical Atlas of Vancouver*, 128-31.

104 Paul S. Moore, "Movie Palaces on Canadian Downtown Main Streets: Montréal, Toronto, and Vancouver," *Urban History Review*, 32, 2 (Spring 2004), 3-20.

CHAPTER 2

THE LEFT COAST: PROTEST AND UNREST

105 *B.C. Catholic*, 23 October 1937, 2.

106 Michael Barnholden, *Reading the Riot Act: A Brief History of Rioting in Vancouver* (Vancouver: Anvil Press, 2005), 55.

107 Andrew Parnaby, *Citizen Docker: Making a New Deal on the Vancouver Waterfront, 1919–1939* (Toronto: University of Toronto Press, 2008), 100-101.

108 Todd McCallum, "The Reverend and the Tramp: Andrew Roddan's God in the Jungles," *BC Studies*, 147 (Autumn 2005), 55.

109 Jill Wade, *Houses for All: The Struggle for Social Housing in Vancouver, 1919–50* (Vancouver: UBC Press, 1994), 44.

110 Quoted in *The Province*, 4 September 1931, 3.

111 Rev. Andrew Roddan, *Canada's Untouchables: The Story of the Man Without A Home* (Vancouver: Clarke and Stewart, 1936), 20.

112 McCallum, "The Reverend and the Tramp," *BC Studies*, 51-88.

113 *The Province*, 5 January 1935, p.5; Rev. Andrew Roddan, *For Doubters Only: How I Was Changed* (Oxford Group Pamphlet, c.1936), 2.

114 John Douglas Belshaw, "Two Christian Denominations and the Relief of the Unemployed in Vancouver During the 1930s," *British Journal of Canadian Studies*, II (1987), 289-303.

115 Patricia Roy, "Vancouver: 'The Mecca of the Unemployed,' 1907-1929," *Town and City: Aspects of Western Canadian Urban Development*, Alan F. J. Artibise, ed. (Regina: Canadian Plains Research Center, 1981), 410.

116 Chuck Davis and Shirley Mooney, *Vancouver: An Illustrated Chronology* (Burlington, Ontario: Windsor Publishing, 1986), 93.

117 Parnaby, *Citizen Docker,* 107.

118 Davis and Mooney, *Vancouver*, 95.

119 John Douglas Belshaw, "The Administration of Relief to the Unemployed in Vancouver During the Great Depression," unpublished Master's thesis, Simon Fraser University, 1982.

120 Barnholden, *Reading the Riot Act*, 61.

121 Quoted in R.C. McCandless, "Vancouver's 'Red Menace' of 1935: The Waterfront Situation," *BC Studies*, 22 (Summer 1974), 63.

122 Parnaby, *Citizen Docker*, 146-7.

123 Barnholden, *Reading the Riot Act*, 63.

124 Willis Sharpala, quoted in *Hastings and Main: Stories from an Inner City Neighbourhood*, Jo-Ann Canning-Dew, ed. (Vancouver: New Star Books, 1987), 66.

125 Quoted in McCandless, "Vancouver's 'Red Menace' of 1935," 62.

126 Daphne Marlatt and Carole Itter, *Opening Doors: Vancouver's East End* (Victoria: Sound Heritage, volume VIII, numbers 1 and 2: 1979), 79-80.

127 Eve Lazarus, *At Home With History: The Untold Secrets of Greater Vancouver's Heritage Homes* (Vancouver: Anvil Press, 2007), 43.

128 Jim Wolf, *Royal City: A Photographic History of New Westminster, 1858-1960* (Surrey: Heritage House, 2005), 148-9.

129 Vincent Moore, *Angelo Branca: 'Gladiator of the Courts'* (Vancouver: Douglas & McIntyre, 1981), 55.

130 Keith McKellar, *Neon Eulogy: Vancouver Cafe and Street* (Victoria: Ekstasis Editions, 2001), 14.

131 Patricia Wejr and Howie Smith, eds. "The 'Bloody Sunday' of 1938," *Fighting for Labour: Four Decades of Work in British Columbia, 1910-1950* (Victoria: Sound Heritage, 1978), 212-3.

132 Marlatt and Itter, *Opening Doors*, 135.

133 Quoted in Parnaby, *Citizen Docker*, 112, 135.

134 Michael Kluckner and John Atkin, *Heritage Walks Around Vancouver* (Vancouver: Whitecap Books, 1992), 51.

Endnotes

135 Marlatt and Itter, *Opening Doors*, 84.

136 *Ibid*, 44-5; Moore, *Angelo Branca*, 71-4.

137 Marlatt and Itter, *Opening Doors*, 134.

138 Cited in Bill Jeffries, "The Shock of the Old—the Street Photograph in Vancouver," *Unfinished Business*, 22.

139 Vancouver, *Police Commission Report, 1940*, 20.

140 Jack Webster, *Webster! An Autobiography* (Toronto: Seal Books, 1991), 32-3.

141 Vancouver, *Police Commission Report, 1949*, 2.

142 John Mackie and Sarah Reeder. *Vancouver: The Unknown City* (Vancouver: Arsenal Pulp Press, 2003), 65.

CHAPTER 3
LOTUS LAND: GLAMOUR AND VICE

143 David Spaner, *Dreaming in the Rain: How Vancouver Became Hollywood North by Northwest* (Vancouver: Arsenal Pulp Press, 2003), 28.

144 Silver Donald Cameron, "Grasping the Point," *Canadian Geographic*, 119, (July/August 1999), 86.

145 Becki L. Ross, *Burlesque West: Showgirls, Sex, and Sin in Postwar Vancouver* (Toronto: University of Toronto Press, 2009), 9-10.

146 *Ibid*, 10-11.

147 Recollections of this landmark event in Vancouver theatre history were recently published in *The Vancouver Sun*, 18 June 2011, A8.

148 Ross, *Burlesque West*, 11-12. Bandmaster Dal Richards remembers this somewhat differently: the State morphed into the Avon Theatre in 1946—presumably after the raid—and became a live theatre featuring stage plays and "names from Hollywood's 'B' list". Dal Richards with Jim Taylor, *One More Time! The Dal Richards Story* (Madeira Park: Harbour Publishing, 2009), 78-9.

149 John Mackie and Sarah Reeder, *Vancouver: The Unknown City* (Vancouver: Arsenal Pulp Press, 2003), 40-41; Harold Kalman, *Exploring Vancouver* (Vancouver: University of British Columbia, 1974), 170.

150 Eric Nicol, *Vancouver* (Garden City, NY: Doubleday, 1970), 164; Ross, *Burlesque West*, 8.

151 Stuart Stark and Donald Luxton, "Opera Houses, Vaudville Theatres and Movie Palaces," *Building the West: Early Architects of British Columbia*, 2nd edition, Donald Luxton, ed. (Vancouver: Talonbooks, 2007), 265-7.

152 Nicol, *Vancouver*, 178.

153 *Ibid, 182*.

154 Richards, *One More Time!*, 86; Ross, *Burlesque West,* 32.

155 Ross, *Burlesque West*, 88-9.

156 Richards, *One More Time!*, 47.

157 Mackie and Reeder, *Vancouver*, 181.

158 Richards, *One More Time!*, 95-6.

159 *Ibid*, 134.

160 Spaner, *Dreaming in the Rain*, 19-20; Richards, *One More Time!*, 54.

161 Mackie and Reeder, *Vancouver*, 188.

162 *Ibid*, 187.

163 Richards, *One More Time!*, 92.

164 *Ibid*, 43-4.

165 Ross, *Burlesque West,* 30-31. The "show business railway" comes from Patrick Nagle, a Vancouver Sun journalist. See also, William Weintraub, *City Unique: Montréal Days and Nights in the 1940s and '50s* (Toronto: McClelland & Stewart, 1996).

166 Ross, *Burlesque West,* 122; Richards, *One More Time!,* 105.

167 Mackie and Reeder, *Vancouver,* 200.

168 Robert A. Campbell, *Sit Down and Drink Your Beer: Regulating Vancouver's Beer Parlours, 1925-1954* (Toronto: University of Toronto Press, 2001), 12-13.

169 Gary Kinsman, "'Character Weaknesses' and 'Fruit Machines': Towards an Analysis of the Anti-Homosexual Security Campaign in the Canadian Civil Service, 1959-1964," *Crime and Deviance in Canada: Historical Perspectives,* Chris McCormick and Len Green, eds. (Toronto: Canadian Scholars' Press, 2005), 323.

170 Vancouver, *Police Commission Report, 1961,* 11-13.

171 Vancouver, *Police Commission Report, 1961,* 12.

172 Daphne Marlatt and Carole Itter, *Opening Doors: Vancouver's East End* (Victoria: Sound Heritage, volume VIII, numbers 1 and 2: 1979), 6-7.

173 Eve Lazarus, *At Home With History: The Untold Secrets of Greater Vancouver's Heritage Homes* (Vancouver: Anvil Press, 2007), 17-21; Andrew Parnaby, *Citizen Docker: Making a New Deal on the Vancouver Waterfront, 1919-1939* (Toronto: University of Toronto Press, 2008), 148.

174 Marlatt and Itter, *Opening Doors,* 6.

175 During Malkin's turn as mayor, Taylor railed against the 'wave' of violent crime and the persistence of vice crimes. Daniel Francis, *L.D.: Mayor Louis Taylor and the Rise of Vancouver* (Vancouver: Arsenal Press, 2004), 166.

176 *Vancouver Sun,* 20 March 1947, 3.

177 *Ibid.*

178 *Ibid.*

179 Marlatt and Itter, *Opening Doors,* 17.

180 *Ibid,* 18.

181 *Ibid,* 17.

182 *Vancouver Sun,* 20 March 1947, 3.

183 Marlatt and Itter, *Opening Doors,* 80.

184 *Ibid,* 105.

185 Saeko Usukawa, ed., *Sound Heritage: Voices from British Columbia* (Vancouver: Douglas & McIntyre, 1984), 156-8.

186 Vancouver, *Police Commission Report, 1961,* 19.

187 Campbell, *Sit Down and Drink Your Beer,* 24. The formal designation of drinking spaces for 'Ladies and Escorts,' as opposed to 'Men' appear in the 1940s. Some smaller beer parlours were obliged to have distinct 'Ladies' and 'Men' entrances and, of course, signage on the street.

188 Vincent Moore, *Angelo Branca: 'Gladiator of the Courts'* (Vancouver: Douglas & McIntyre, 1981), 46.

189 Robert Campbell, *Demon Rum or Easy Money: Government Control of Liquor in British Columbia from Prohibition to Privatization* (Ottawa: Carleton University Press, 1991), 117.

190 Usukawa, *Sound Heritage,* 156.

191 Marlatt and Itter, *Opening Doors,* 70, 75.

192 *Ibid,* 136.

193 *Vancouver Sun,* 26 June 1937, 1.

194 Vancouver, *Police Commission Report, 1938,* 5.

195 Campbell, *Demon Rum,* 81.

196 *Vancouver Sun,* 20 March 1947, 3.

197 Lazarus, *At Home With History,* 45.

198 Vancouver, *Police Commission Report, 1944,* 9

199 *The Daily Province,* 30 October 1946, 1.

200 *The Daily Province,* 10 June 1955, 1.

201 *The Daily Province,* 10 August 1959, 14.

202 *The Vancouver Sun,* 19 December 1959, 1-2.

203 David Ricardo Williams, *Mayor Gerry: The Remarkable Gerald Grattan McGeer* (Douglas & McIntyre, 1986), 138.

Endnotes

204 Campbell, *Demon Rum*, 85.

205 *Ibid*, 97-9.

206 Usukawa, *Sound Heritage*, 158.

207 *Vancouver Sun*, 4 April 1930, 1.

208 *Vancouver Sun*, 8 March 1930, 2

209 Robert R. Solomon and Melvyn Green, "The First Century: The History of Non-medical Opiate Use and Control Policies in Canada, 1870-1970," *Crime and Deviance in Canada* McCormick and Green, eds., 358-9.

210 Ian MacDonald and Betty O'Keefe. *The Mulligan Affair: Top Cop on the Take* (Surrey: Heritage House, 1997), 44-5.

211 Vancouver, *Police Commission Report, 1955*, 6.

212 Vancouver, *Police Commission Report, 1956*, 2.

213 Vancouver, *Police Commission Report, 1957*, 14.

214 Vancouver, *Police Commission Report, 1961*, 19.

215 Marlatt and Itter, *Opening Doors*, 32.

216 *Ibid*, 81.

217 "Rev. Roddan's Crusade Caused Fireworks," *The Vancouver Sun*, 24 July 1965, 9.

218 Marlatt and Itter, *Opening Doors*, 104-5.

219 Vancouver, *Police Commission Report, 1930*, 17.

220 Kay Anderson, *Vancouver's Chinatown: Racial Discourse in Canada, 1875-1980* (Montréal & Kingston: McGill-Queen's University Press, 1991), 159; Vancouver, *Police Commission Report, 1931*, 2.

221 Quoted in Anderson, *Vancouver's Chinatown*, 169.

222 *Ibid*, 92.

223 *Ibid*, 159-62.

224 Vancouver, *Police Commission Report, 1937*, 2.

225 Michaela Freund, "The Politics of Naming: Constructing Prostitutes and Regulating Women in Vancouver, 1934-1945," unpublished M.A. thesis, Simon Fraser University, 1995, 14.

226 Anderson, *Vancouver's Chinatown*, 163.

227 Freund, "The Politics of Naming," 19-20.

228 University of British Columbia Special Collections, "Mayor McGeer's Fight Against Crime in Vancouver," Radio Speech over CKWX, Sunday, September 15, 1935, 11.

229 *Vancouver Sun*, 22 March 1947, 1.

230 Vancouver, *Police Commission Report, 1938*, 5.

231 *Freund,* "The Politics of Naming," 61.

232 , *Ibid.*

233 *Daily Province*, 10 February 1939, cited in Freund, 65.

234 City of Vancouver Archives, Health Department Fonds, Series 101, Vancouver (B.C.). Medical Health Officer Subject Files, Loc. 103-A-3, Minutes, October 1936-November 1949.

235 Marlatt and Itter, *Opening Doors*, 75, 82.

236 Campbell, *Sit Down and Drink Your Beer*, 60, 66.

237 Vancouver, *Police Commission Report, 1961*, 18.

CHAPTER 4

BY SEA AND LAND WE PROSPER: CRIME

238 Vancouver, *Police Commission Report, 1950*, 8.

239 H.A. Weir, "Unemployed Youth," *Canada's Unemployment Problem*, L.Richter, ed. (Toronto: The MacMillan Company, 1939), 145.

240 Vancouver Sun, 31 January 1932, 1-2.

241 *Vancouver Sun*, 7 January 1930, 1-2.

242 Rev. Andrew Roddan, quoted in *The [Vancouver] Star*, 7 September 1931, 5.

243 Vancouver, *Police Commission Report, 1944*, 4.

244 *Vancouver Police Annual Report 1930*, quoted in James P. Huzel, "The Incidence of Crime in Vancouver During the Great Depression," *Vancouver Past: Essays in Social History*, Robert A.J. McDonald and Jean Barman, eds. (Vancouver: UBC Press, 1986), 234.

245 Vancouver, *Police Commission Report, 1944*, 4.

246 *Vancouver Sun*, 28 February 1947, 1.

247 The height of VPD members in 1930 was recorded as an even six feet. Vancouver, *Police Commission Report, 1930*, 42.

248 *Ibid,*,3.

249 Andrew Parnaby, *Citizen Docker: Making a New Deal on the Vancouver Waterfront, 1919–1939* (Toronto: University of Toronto Press, 2008), 149.

250 The term appears in quotation marks in the 1931 Police Report, suggesting it was still a novelty. Vancouver, *Police Commission Report, 1931*, 2.

251 Vancouver, *Police Commission Report, 1932*, 5.

252 Vancouver, *Police Commission Report, 1933*, 7.

253 Vancouver, *Police Commission Report, 1955*, 10.

254 Vancouver, *Police Commission Report, 1958*, n.p.

255 Vancouver, *Police Commission Report, 1959*, 14.

256 Vancouver, *Police Commission Report, 1956*, 2.

257 *Vancouver Sun*, 1 February 1930, 2.

258 Vancouver, *Police Commission Report, 1959*, 8.

259 Vancouver, *Police Commission Report, 1931*, 2.

260 *Vancouver Sun*, 1 February 1930, 2.

261 *Vancouver Sun*, 8 March1930, 1.

262 Joe Swan, "Chief W.W. Foster and the Blue Sedan Bandits," *The West Ender*, 28 July 1983, 5.

263 Vancouver, *Police Commission Report, 1944*, 11.

264 Vancouver, *Police Commission Report, 1940*, 7.

265 Vancouver, *Police Commission Report, 1946*, 5; *Vancouver Daily Province*, 13 December 1946, 1-2.

266 Vancouver, *Police Commission Report, 1948*, 6.

267 Vancouver, *Police Commission Report, 1953*, 1.

268 Ian MacDonald and Betty O'Keefe, *Born to Die: A Cop Killer's Final Message* (Surrey: Heritage House, 2003), 145.

269 Vincent Moore, *Angelo Branca: Gladiator of the Courts* (Vancouver: Douglas & McIntyre, 1981), 147-8.

270 Vancouver, *Police Commission Report, 1960*, 10-11.

271 *Vancouver News-Herald*, 17 February 1947, 1, 5.

272 *Vancouver News-Herald*, 17 April 1947, 1.

273 *Vancouver News-Herald*, 29 December 1947, 1.

274 *Vancouver News-Herald*, 5 February 1938.

275 *Vancouver Sun*, 8 March 1930, 1.

276 Vancouver, *Police Commission Report, 1937*, n.p.

277 Vancouver, *Police Commission Report, 1959*, 12.

278 Vancouver, *Police Commission Report, 1944*, 9.

279 *Ibid,* 8-13.

280 *The Daily Province*, 30 October 1946, 1.

281 *Vancouver Sun*, 19 February 1947, 1

282 *Vancouver Sun*, 4 March 1947, 1.

283 Vancouver, *Police Commission Report, 1940*, 8.

284 *Vancouver Sun*, 23August 1949, 1.

285 Vancouver, *Police Commission Report, 1946*, 6.

286 *Vancouver Sun*, 14 November 1947, 2.

Endnotes

287 *Vancouver Sun*, 1 April 1953, 1.

288 Vancouver, *Police Commission Report, 1955*, 6.

289 Vancouver, *Police Commission Report, 1930*, 3.

290 Vancouver, *Police Commission Report, 1940*, 19.

291 Vancouver, *Police Commission Report, 1946*, 7.

292 Vancouver, *Police Commission Report, 1947*, 10.

293 Winifred Denny, *The Story of a House: Ceperley Mansion to Burnaby Art Gallery* (Burnaby Art Gallery Association, 1974).

294 Vancouver, *Police Commission Report, 1950*, 1.

295 Vancouver, *Police Commission Report, 1940*, 19.

296 *Ibid.*

297 Vancouver, *Police Commission Report, 1938*, 13.

298 Vancouver, *Police Commission Report, 1940*, 20.

299 Vancouver, *Police Commission Report, 1946*, 7.

300 *Ibid*, 11.

301 More ominous in name, if not in reputation, was the Bull Gang, also from East Van. Daphne Marlatt and Carole Itter, *Opening Doors: Vancouver's East End* (Victoria: Sound Heritage, volume VIII, numbers 1 and 2: 1979), 9.

302 Michael G. Young, "The History of Vancouver Youth Gangs: 1900-1985," unpublished M.A. thesis, Simon Fraser University, 1993, 42-43.

303 Marlatt and Itter, *Opening Doors*, 136-7.

304 *Past Tense: Fragments of Vancouver's History and Reflections Thereon*, 'Zoot Suit Riots,' http://pasttensevancouver.wordpress.com/2008/03/03/zoot-suit-riots-2/

305 Young, "The History of Vancouver Youth Gangs: 1900-1985," 49-59.

306 Vancouver, *Police Commission Report, 1951*, 2.

307 *Vancouver Sun*, 22 March 1950, 1.

308 Peter Trower, "Remember the Forties," *Vancouver Magazine*, 11 (November 1978), 100-3.

309 Vancouver, *Police Commission Report, 1953*, 20.

310 *Ibid.*

311 Vancouver, *Police Commission Report, 1955*, 9.

312 Vancouver, *Police Commission Report, 1956*, 2.

313 Vancouver, *Police Commission Report, 1953*, 22.

314 David Hadju, *The Ten-Cent Plague: The Great Comic-Book Scare and How It Changed America* (New York: Farrar, Straus and Giroux, 2008), 112, 152-3.

315 This was believed to be the first comic book burning in Canada. *The Vancouver Herald*, 13 December 1954, 1.

316 Huzel, "The Incidence of Crime in Vancouver During the Great Depression," 240.

CHAPTER 5
THE BIG SMOKE: CORRUPTION

317 University of British Columbia Special Collections, "Mayor McGeer's Fight Against Crime in Vancouver," Radio Speech over CKWX, 15 September 1935.

318 Vincent Moore, *Angelo Branca: 'Gladiator of the Courts'* (Vancouver: Douglas & McIntyre, 1981), 2-3. Josie Celona had a tough time keeping her name out of the papers. In October 1943 she was convicted on a charge of negligent driving, having mowed down an 18-year-old Edward Copich at Powell and Victoria. Angelo Branca, ever at the disposal of the bootlegger's family, defended Mrs. Celona, unsuccessfully. *Vancouver News-Herald*, 22 October 1943.

319 *Vancouver Sun*, 20 March 1947, 1.

320 Daphne Marlatt and Carole Itter. *Opening Doors: Vancouver's East End* (Victoria: Sound Heritage, volume VIII, numbers 1 and 2: 1979), 143.

321 Eric Nicol, *Vancouver* (Garden City, NY: Doubleday, 1970), 165-6.

322 Marlatt and Itter, *Opening Doors*, 142.

323 Nicol, *Vancouver*, 173.

324 Andrew Parnaby, *Citizen Docker: Making a New Deal on the Vancouver Waterfront, 1919-1939* (Toronto: University of Toronto Press, 2008), 149.

325 G.G. McGeer, Speech at Hotel Vancouver, 21 November 1934, PABC, McGeer Papers, Vol.7, cited in Patricia E. Roy, *Vancouver: An Illustrated History* (Toronto: James Lorimer & Company, 1980), 123.

326 Greg Marquis, "Vancouver Vice: The Police and the Negotiation of Morality, 1904-1935," *Essays in the History of Canadian Law, v.6: British Columbia and the Yukon*, Hamar Foster and John McLaren, eds. (Toronto: Osgoode Society, 1995), 245.

327 Alan Morley, *Vancouver: From Milltown to Metropolis* (Vancouver: Mitchell Press, 1961), 177.

328 *Ibid*, 186.

329 Vancouver, W.J. Barrett-Leonard, "Report on the Reorganization of the Civic Administration of the City of Vancouver," 9 December 1936, 5, City of Vancouver Archives.

330 *The Vancouver Sun*, 17 December 1936, 1.

331 "Full Text of Hill Report," *Vancouver Province*, 28 February 1947, 15.

332 *The Vancouver Daily Province*, 28 February 1947, 1.

333 Daniel Francis, *L.D.: Mayor Louis Taylor and the Rise of Vancouver* (Vancouver: Arsenal Press, 2004), 154.

334 *Past Tense: Fragments of Vancouver History and Reflections Thereon*, 'Public Enemy No.1,' http://pasttensevancouver.wordpress.com/2009/08/07/public-enemy-no-1/.

335 Michaela Freund, "The Politics of Naming: Constructing Prostitutes and Regulating Women in Vancouver, 1934-1945," unpublished M.A. thesis, Simon Fraser University, 1995, 40.

336 Saeko Usukawa, ed., *Sound Heritage: Voices from British Columbia* (Vancouver: Douglas & McIntyre, 1984), 159.

337 *Vancouver Sun*, 25 March 1935, 1.

338 *Vancouver Sun*, 26 March 1935, 1-2; *Daily Province*, 2 April 1935, 2.

339 *Daily Province*, 2 April 1935, 2.

340 *Daily Province*, 12 April 1935, 2.

341 *Vancouver Sun*, 25 March 1935, 1.

342 *Daily Province*, 1 April 1935, 2.

343 *Vancouver Sun*, 26 March 1935, 1-2.

344 *Daily Province*, 12 April 1935, 2.

345 *Past Tense*, 'Public Enemy No.1,' http://pasttensevancouver.wordpress.com/2009/08/07/public-enemy-no-1/.

346 *Daily Province*, 24 April 1935, 1-2.

347 In fact, Cameron resigned on the 31st of December 1934, before McGeer could sack him. David Ricardo Williams, *Mayor Gerry: The Remarkable Gerald Grattan McGeer* (Douglas & McIntyre, 1986), 172.

348 Morley, *Vancouver*, 197.

349 Ian Macdonald and Betty O'Keefe, *Born to Die: a Cop Killer's Final Message* (Surrey: Heritage House, 2003), 26.

350 *Vancouver Sun*, 20 March 1947, 1.

351 *Ibid*.

352 Jack Webster, *Webster! An Autobiography* (Toronto: Seal Books, 1991), 40-1.

353 Ian MacDonald and Betty O'Keefe. *The Mulligan Affair: Top Cop on the Take* (Surrey: Heritage House, 1997), 53-5.

354 *The Daily Province*, 11 August 1955, 3.

355 MacDonald and O'Keefe, *The Mulligan Affair*.

356 Eve Lazarus, *At Home With History: The Untold Secrets of Greater Vancouver's Heritage Homes* (Vancouver: Anvil Press, 2007), 48-51.

Endnotes

357 Vancouver, *Police Commission Report, 1947*, 10.

358 MacDonald and O'Keefe, *The Mulligan Affair*, 64.

359 *Ibid*, 71-3, 89-91.

360 "Police Scandal," *The History of Metropolitan Vancouver*, http://www.vancouverhistory.ca/archives_mulligan.htm

CHAPTER 6
TERMINAL CITY: MURDER

361 Vancouver Public Library, Board of Police Commissioners, Vancouver B.C., *Annual Report of the Vancouver City Police Department, 1939*, 9.

362 Remarkably, in the midst of the *Noir* era, homicides per capita in Los Angeles fell almost steadily from 1933 to 1955. See Eric H. Monkkonon, "Homicide in Los Angeles, 1927-2002," *Journal of Interdisciplinary History*, 36, 2 (Autumn 2005), 174.

363 Canada, Bureau of Statistics, *Vital Statistics of Canada, 1929-1939* (Ottawa: King's Printer).

364 BC, *The Nineteen Eighties: A Statistical Resource for a Decade of Vital Events in British Columbia* (Victoria: Ministry of Health and Ministry Responsible for Seniors, 1994), 31.

365 *The Daily Province*, 23 January 1936, 1.

366 Vincent Moore, *Angelo Branca: Gladiator of the Courts* (Vancouver: Douglas & McIntyre, 1981), 103-6.

367 Vancouver, *Police Commission Report, 1946*, 4.

368 *Vancouver Sun*, 15 February 1930, 1.

369 *Vancouver Sun, 17 February 1930, 1; 18 February 1930*, 1.

370 Diane B. Purvey, "Perceptions of Wife-Beating in Post-World War II English-Speaking Canada: Blaming Women for Violence Against Wives," unpublished Ph.D. dissertation, University of British Columbia, 2000, 192-6.

371 *Vancouver Sun*, 13 July 1958, 2.

372 Vancouver, *Police Commission Report, 1961*, 14.

373 Vancouver, *Police Commission Report, 1942*, 8.

374 Moore, *Angelo Branca*, 140.

375 Vancouver, *Police Commission Report, 1942*, 8.

376 Quoted in Moore, *Angelo Branca*, 98-9.

377 Carolyn Strange and Tina Loo, *True Crime, True North: The Golden Age of Canadian Pulp Magazines* (Vancouver: Raincoast Books, 2004), 65-6.

378 Moore, *Angelo Branca*, 101.

379 Vancouver, *Police Commission Report, 1944*, 8.

380 Vancouver, *Police Commission Report, 1942*, 8.

381 Vancouver, *Police Commission Report, 1947*, 8.

382 *Vancouver Sun*, 23 March 1950, 2.

383 *Vancouver Sun*, 9 March 1950, 1.

384 *Vancouver Sun*, 11 January 1950, 2.

385 *Vancouver Sun*, 13 March 1950, 1-2.

386 *Vancouver Sun*, 17 March 1950, 1; 21 March 1950, 1.

387 *Vancouver Sun*, 17 March 1950, 1.

388 Jack Webster, *Webster! An Autobiography* (Toronto: Seal Books, 1991), 37-8.

389 Ian MacDonald and Betty O'Keefe, *Born to Die: A Cop Killer's Final Message* (Surrey: Heritage House, 2003), 118.

390 Michael G. Young, "The History of Vancouver Youth Gangs: 1900-1985," unpublished M.A. thesis, Simon Fraser University, 1993, 44. The tipster involved is now believed to have been William Foulder "Fats" Robertson, a gang member who was bitter about not being invited along on the heist. Vancouver Police Museum:, Memorial: Saluting the Heroes (http://www.vancouverpolicemuseum.ca/FallenOfficers/oliver_ledingham.html). Robertson would be a persistent

thorn in the side of the law in Vancouver for decades to come. After years in the drug trade he became, in 1962, the key man in a ring trying to establish a high-end but clandestine gambling casino at the Wigwam Inn at the top of Indian Arm. That case involved artworks stolen from the Victoria Art Gallery, counterfeiting plates, and attempted bribery of a police officer. Ten years later he was involved with suspicious practices on the Vancouver Stock Exchange. In 1979 he was sent to prison (not for the first time) for his involvement in a cocaine smuggling ring. He resurfaced in the press in 2003 during the trial of hitman Mickie Phillip Smith, who claimed that Robertson was his "mentor in the world of crime."

391 Vancouver, *Police Commission Report, 1947*, 7.

392 *Vancouver News-Herald*, 2 October, 1947, 3, and 16 October 1947, 4.

393 Joe Swan, "Shoot-out at high noon," *The West Ender*, 9 June 1983, 5.

394 Vancouver, *Police Commission Report, 1939*, 9.

395 *Vancouver Sun*, 13 July 1958, 2.

396 *Ibid.*

397 *Vancouver Sun*, 15 January 1953, 1.

398 *Vancouver Province*, 15 April 1953, 1.

399 *Ibid.*

400 Vancouver, *Police Commission Report, 1954*, 23.

401 Vancouver, *Police Commission Report, 1959*, 9.

402 *Ibid*, 10.

403 *Vancouver Sun*, 14 July 1958, 2.

404 Eric Nicol, *Vancouver* (Garden City, NY: Doubleday, 1970), 178.

405 Daphne Marlatt and Carole Itter, *Opening Doors: Vancouver's East End* (Victoria: Sound Heritage, volume VIII, numbers 1 and 2: 1979), 51.

406 Eve Lazarus, *At Home With History: The Untold Secrets of Greater Vancouver's Heritage Homes* (Vancouver: Anvil Press, 2007), 21.

407 Marlatt and Itter, *Opening Doors*, 31-2; Saeko Usukawa, ed., *Sound Heritage: Voices from British Columbia* (Vancouver: Douglas & McIntyre, 1984), 157.

408 Marlatt and Itter, *Opening Doors*, 142.

CHAPTER 7
CITY OF GLASS: THE AGE OF NOIR

409 Wayde Compton, "Hogan's Alley and Retro-speculative Verse," *Unfinished Business: Photographing Vancouver Streets, 1955 to 1985*, Bill Jeffries, Glen Lowry, and Jerry Zaslove, eds. (Burnaby: West Coast Line, 2005), 109.

410 Vancouver, *Police Commission Report, 1960*, 2.

411 Bob Williams interviewed by Jerry Zaslove and Annabel Vaughan, "Bob Williams on the History of Planning in Vancouver," *Unfinished Business*, 266.

412 *Ibid*, 277.

413 John Mackie and Sarah Reeder. *Vancouver: The Unknown City* (Vancouver: Arsenal Pulp Press, 2003), 38.

414 Keith McKellar, *Neon Eulogy: Vancouver Cafe and Street* (Victoria: Ekstasis Editions, 2001), 15.

415 George Kuthan and Donald Stainsby, *Vancouver: Sights & Insights* (Toronto: MacMillan, 1962), 2, 12-13.

416 *Ibid*, 44.

417 Robert A.J. McDonald, *Making Vancouver, 1863-1913* (Vancouver: UBC Press, 1996), 233.

418 Daphne Marlatt and Carole Itter, *Opening Doors: Vancouver's East End* (Victoria: Sound Heritage, volume VIII, numbers 1 and 2: 1979), 182, fn.1.

419 Vancouver, *Police Commission Report, 1959*, 2.

420 Vancouver, *Police Commission Report, 1961*, 12-14.

Adams, Rachel. *Sideshow USA: Freaks and the American Cultural Imagination.* Chicago: University of Chicago Press, 2001.

Anderson, Kay. *Vancouver's Chinatown: Racial Discourse in Canada, 1875-1980.* Montréal & Kingston: McGill-Queen's University Press, 1991.

Barman, Jean. *Stanley Park's Secret: The Forgotten Families of Whoi Whoi, Kanaka Ranch and Brockton Point.* Madeira Park: Harbour, 2005.

Barnholden, Michael. *Reading the Riot Act: A Brief History of Rioting in Vancouver.* Vancouver: Anvil Press, 2005.

B.C. Catholic.

British Columbia. *The Nineteen Eighties: A Statistical Resource for a Decade of Vital Events in British Columbia.* Victoria: Ministry of Health and Ministry Responsible for Seniors, 1994.

Belshaw, John with David J. Mitchell. "The Economy of British Columbia since the Great War." *The Pacific Province: A History of British Columbia.* Hugh Johnston, ed. Vancouver: Douglas & McIntyre, 1996.

Belshaw, John. "Two Christian Denominations and the Relief of the Unemployed in Vancouver During the 1930s," *British Journal of Canadian Studies*, II (1987): 289-303

Belshaw, John. "The Administration of Relief to the Unemployed in Vancouver During The Great Depression." Unpublished M.A. thesis, Simon Fraser University, 1982.

Cameron, Silver Donald. "Grasping the Point." *Canadian Geographic*, 119 (July/August 1999): 86.

Campbell, Robert. *Demon Rum or Easy Money: Government Control of Liquor in British Columbia from Prohibition to Privatization.* Ottawa: Carleton University Press, 1991.

Campbell, Robert. *Sit Down and Drink your Beer: Regulating Vancouver's Beer Parlours, 1925-1954.* Toronto: University of Toronto Press, 2001.

Canada, Bureau of Statistics. *Vital Statistics of Canada, 1929-1939.* Ottawa: King's Printer.

Canning-Dew, Jo-Ann, ed. *Hastings and Main: Stories from an Inner City Neighbourhood.* Vancouver: New Star Books, 1987.

Davis, Chuck. *The History of Metropolitan Vancouver.* Madeira Park: Harbour, forthcoming, http://www.vancouverhistory.ca/archives_mulligan.htm

Davis, Chuck and Shirley Mooney. *Vancouver: An Illustrated Chronology.* Burlington, Ontario: Windsor Publishing, 1986.

Davis, Chuck. *Vancouver, Then & Now.* Ottawa: Magic Light, 2001.

Denny, Winifred. *The Story of a House: Ceperley Mansion to Burnaby Art Gallery.* Burnaby Art Gallery Association, 1974.

Douglas, Stan. *Every Building on 100 West Hastings.* Vancouver: Contemporary Art Gallery, 2002.

Eidse, James et al, eds. *Vancouver Matters.* Vancouver: Blueimprint Books, 2008.

Foster, Hamar and John McLaren, eds. *Essays in the History of Canadian Law, Volume 6: British Columbia and the Yukon.* Toronto: Osgoode Society, 1995.

Francis, Daniel. *L.D.: Mayor Louis Taylor and the Rise of Vancouver.* Vancouver: Arsenal Press, 2004.

Freund, Michaela. "The Politics of Naming: Constructing Prostitutes and Regulating Women in Vancouver, 1934-1945." Unpublished M.A. thesis, Simon Fraser University, 1995.

Gasher, Mike. *Hollywood North: The Feature Film Industry in British Columbia.* Vancouver: UBC Press, 2002.

Hadju, David. *The Ten-Cent Plague: The Great Comic-Book Scare and How It Changed America.* New York: Farrar, Straus and Giroux, 2008.

Hardwick, Walter G. *Vancouver.* Don Mills: Collier-Macmillan, 1974.

Harris, Cole. "The Lower Mainland, 1820-81." *Vancouver and Its Region.* Graeme Wynn and Timothy Oke, eds. Vancouver: UBC Press, 1992.

Hayes, Derek. *Historical Atlas of Vancouver & the Lower Fraser Valley.* Vancouver: Douglas & McIntyre, 2006.

Huzel, James. "The Incidence of Crime in Vancouver During the Great Depression." *BC Studies,* 69-70 (Spring/Summer 1986): 211-48.

Jamieson, Eric. *Tragedy at Second Narrows: The Story of the Ironworkers Memorial Bridge.* Madeira Park: Harbour, 2008.

Jeffries, Bill, Glen Lowry and Jerry Zaslove, eds. *Unfinished Business: Photographing Vancouver Streets 1955-1985.* Burnaby: West Coast Line, 2005.

Kalman, Harold. *Exploring Vancouver.* Vancouver: University of British Columbia, 1974.

Kluckner, Michael and John Atkin. *Heritage Walks Around Vancouver.* Vancouver: Whitecap Books, 1992.

Knight, Rolf. *Along The No. 20 Line: Reminiscences of the Vancouver Waterfront.* Vancouver: New Star Books, 1980.

Kuthan, George and Donald Stainsby. *Vancouver: Sights & Insights.* Toronto: MacMillan, 1962.

Lambertson, Ross. "The Black, Brown, White, and Red Blues: The Beating of Clarence Clemons." *Canadian Historical Review,* 85, 4 (2004): 755-76.

Lazarus, Eve. *At Home With History: The Untold Secrets of Greater Vancouver's Heritage Homes.* Vancouver: Anvil Press, 2007.

Leier, Mark. *Red Flags and Red Tape: The Making of a Labour Bureaucracy.* Toronto: University of Toronto Press, 1995.

Loo, Tina. *Making Law, Order, and Authority in British Columbia, 1821–1871.* Toronto: University of Toronto Press, 1994.

Luxton, Donald, ed. *Building the West: Early Architects of British Columbia.* 2nd edition. Vancouver: Talonbooks, 2007.

Macdonald, Ian and Betty O'Keefe. *Born to Die: A Cop Killer's Final Message.* Surrey: Heritage House, 2003.

Macdonald, Ian, and Betty O'Keefe. *The Mulligan Affair: Top Cop on the Take.* Surrey: Heritage House, 1997.

MacDonald, Norbert. "A Critical growth cycle for Vancouver, 1900-1914," *BC Studies,* 17 (Spring 1973): 26-42.

MacDonald, Norbert. *Distant Neighbors: A Comparative History of Seattle and Vancouver.* Lincoln: University of Nebraska Press, 1987.

MacDonald, Norbert. "Population Growth and Change in Seattle and Vancouver, 1880-1960." *Pacific Historical Review,* XXXIX, 3 (1970): 297-321.

Mackie, John and Sarah Reeder. *Vancouver: The Unknown City.* Vancouver: Arsenal Pulp Press, 2003.

Marlatt, Daphne and Carole Itter. *Opening Doors: Vancouver's East End.* Victoria: Sound Heritage, Volume VIII, Numbers 1 and 2, 1979.

McCallum, Todd. "The Reverend and the Tramp: Andrew Roddan's God in the Jungles." *BC Studies,* 147 (Autumn 2005): 51-88.

McCandless, Richard C. "Vancouver's 'Red Menace' of 1935: The Waterfront Situation." *BC Studies,* 22 (Summer 1974): 56-74.

McCormick, Chris and Len Green, eds. *Crime and Deviance in Canada: Historical Perspectives.* Toronto: Canadian Scholars Press, 2005.

McDonald, Robert A.J. *Making Vancouver: Class, Status, and Social Boundaries, 1863-1913*. Vancouver: UBC Press, 1996.

McDonald, Robert A.J. and Jean Barman, eds. *Vancouver Past: Essays in Social History*. Vancouver: UBC Press, 1986.

McKellar, Keith. *Neon Eulogy: Vancouver Cafe and Street*. Victoria: Ekstasis Editions, 2001.

Monkkonon, Eric H. "Homicide in Los Angeles, 1927-2002." *Journal of Interdisciplinary History*, 36, 2 (Autumn 2005): 167-183.

Moore, Paul S. "Movie Palaces on Canadian Downtown Main Streets: Montreal, Toronto, and Vancouver." *Urban History Review*, 32, 2 (Spring 2004): 3-20.

Moore, Vincent. *Angelo Branca: Gladiator of the Courts*. Vancouver: Douglas & McIntyre, 1981.

Morley, Alan. *Vancouver: From Milltown to Metropolis*. Vancouver: Mitchell Press, 1961.

Nicol, Eric. *Vancouver*. Garden City, NY: Doubleday, 1970.

Palmer, Bryan D. *Cultures of Darkness: Night Travels in the Histories of Transgression*. New York: Monthly Review Press, 2000.

Parnaby, Andrew. *Citizen Docker: Making a New Deal on the Vancouver Waterfront, 1919-1939*. Toronto: University of Toronto Press, 2008.

Past Tense: Fragments of Vancouver's History and Reflections Thereon. "Zoot Suit Riots." http://pasttensevancouver.wordpress.com

Perrault, E.G. *Tong: The Story of Tong Louie, Vancouver's Quiet Titan*. Madeira Park: Harbour, 2002.

Proctor, Joan Cupit. *Growing Up in Grandview*. Vancouver: 2005.

Purvey, Diane. "'Must a Wife do all the Adjusting?' Attitudes and Practices of Social Workers toward Wife Abuse in Vancouver, 1945-1960." *Child and Family Welfare in British Columbia: A History*. Ed. Diane Purvey and Christopher Walmsley, Calgary: Detselig, 2005.

Purvey, Diane. "Perceptions of Wife-Beating in Post-World War II English Speaking Canada: Blaming Women for Violence Against Wives." Unpublished Ph.D. dissertation, University of British Columbia, 2000.

Richards, Dal with Jim Taylor. *One More Time! The Dal Richards Story*. Madeira Park: Harbour, 2009.

Richter, L. ed. *Canada's Unemployment Problem*. Toronto: The MacMillan Company, 1939.

Roddan, Rev. Andrew. *Canada's Untouchables: The Story of the Man Without A Home.* Vancouver: Clarke and Stewart, 1936.

Roddan, Rev, Andrew. *For Doubters Only: How I Was Changed.* Oxford Group Pamphlet, c.1936.

Ross, Becki L. *Burlesque West: Showgirls, Sex, and Sin in Postwar Vancouver.* Toronto: University of Toronto Press, 2009.

Ross, Becki L. "Bumping and Grinding On the Line: Making Nudity Pay." *Labour/Le Travail*, 46 (Fall/Automne 2000): 221-250.

Ross, Becki and Kim Greenwall. "Spectacular Striptease: Performing the Sexual and Racial Other in Vancouver, B.C., 1945-1975." *Journal of Women's History* 17,1 (Spring 2005): 137-164.

Roy, Patricia E. "A Half-Century of Writing on Vancouver's History." *BC Studies*, 69-70 (Spring/Summer 1986): 311-25.

Roy, Patricia E. "British Columbia's Fear of Asians 1900-1950." *Histoire Sociale/Social History,* XIII, 25 (May 1980): 161-72.

Roy, Patricia E. *Vancouver: An Illustrated History.* Toronto: James Lorimer & Company, 1980.

Roy, Patricia E. "Vancouver: 'The Mecca of the Unemployed,' 1907-1929." *Town and City: Aspects of Western Canadian Urban Development,* Alan F. J. Artibise, ed. Regina: Canadian Plains Research Center, 1981: 393-413.

Rude, George. *The Crowd in History.* London: Wiley, 1965.

Ruvinsky, Maxine. Review of Marc Edge, *Pacific Press: The Unauthorized Story of Vancouver's Newspaper Monopoly* in *Textual Studies in Canada,* 16 (2002): 61-7.

Spaner, David. *Dreaming in the Rain: How Vancouver Became Hollywood North by Northwest.* Vancouver: Arsenal Pulp Press, 2003.

Strange, Carolyn and Tina Loo. *True Crime, True North: The Golden Age of Canadian Pulp Magazines.* Vancouver: Raincoast Books, 2004.

Straw, Will. "Montreal Confidential: Notes on an Imagined City." *CinéAction,* 28 (Spring, 1992): 58-64.

Thompson, Peggy and Saeko Usukawa. *Hard-Boiled: Great Lines from Classic Noir Films.* San Francisco: Chronicle Books, 1995.

Trower, Peter. "Remember the Forties." *Vancouver Magazine,* 11 (November 1978): 100.

Usakawa, Saeko, ed. *Sound Heritage: Voices from British Columbia.* Vancouver: Douglas & McIntyre, 1984.

Vancouver. *Police Commission Report*. 1930-1961.

Vancouver News-Herald.

Vancouver Province.

Vancouver Sun.

Victoria Times-Colonist.

Wade, Jill. *Houses for All: The Struggle for Social Housing in Vancouver, 1919-50*. Vancouver: UBC Press, 1994.

Webster, Jack. *Webster! An Autobiography*. Toronto: Seal Books, 1991.

Weintraub, William. *City Unique: Montreal Days and Nights in the 1940s and '50s*. Toronto: McClelland & Stewart, 1996.

Wejr, Patricia, and Howie Smith, eds. *Fighting for Labour: Four Decades of Work in British Columbia, 1910-1950*. Victoria: Sound Heritage, 1978.

The West Ender.

Wickberg, Edgar *et al. From China to Canada: A History of the Chinese Communities in* Canada. Toronto: McClelland and Stewart, 1982.

Williams, David Ricardo. *Mayor Gerry: The Remarkable Gerald Grattan McGeer*. Douglas & McIntyre, 1986.

Wolf, Jim. *Royal City: A Photographic History of New Westminster, 1858-1960*. Surrey: Heritage House, 2005.

Working Lives Collective. *Working Lives: Vancouver 1886-1986*. Vancouver: New Star Books, 1985.

Yee, Paul. *Saltwater City: The Chinese in Vancouver*. Vancouver: Douglas & McIntyre, 1988.

Young, Michael G. "The History of Vancouver Youth Gangs: 1900-1985." Unpublished M.A. thesis. Simon Fraser University, 1993.

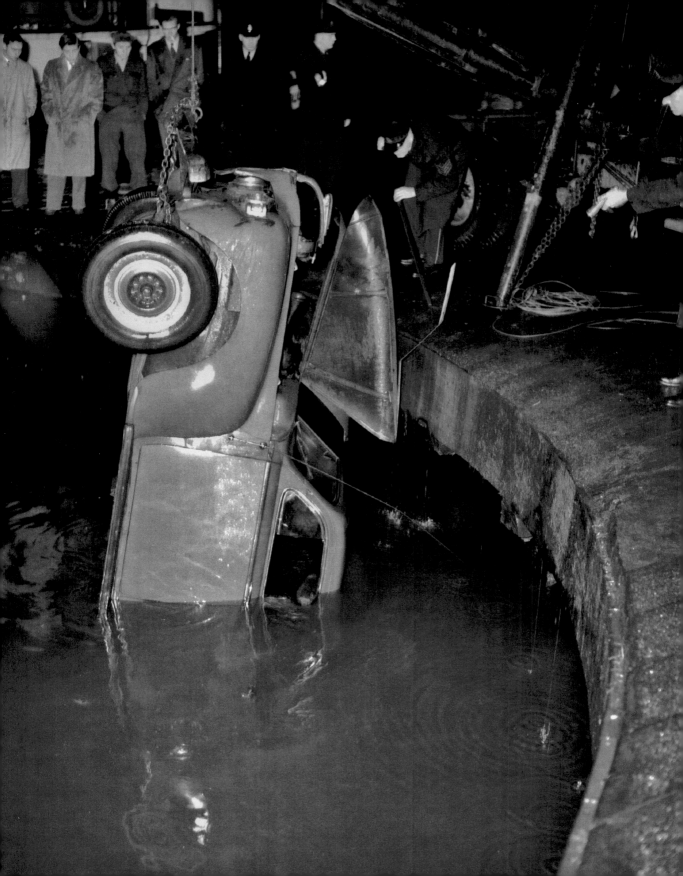

DIANE PURVEY is Dean of Arts at Kwantlen Polytechnic University. She was, formerly, an Associate. Her research interests include the history of deinstitutionalization in BC, and educational leadership and student diversity. She co-edited *Child and Family Welfare in British Columbia: A History* (Detselig Press, 2005).

JOHN BELSHAW is the author of *Colonization and Community: The Vancouver Island Coalfield and the Making of the British Columbian Working Class, 1848-1900* (McGill-Queen's University Press, 2002) and *Becoming British Columbia: A Population History*. Formerly a university and college professor and administrator he is now a consultant and writer.

Purvey and Belshaw co-authored *Private Grief, Public Mourning: The Rise of the Roadside Shrine in BC* (Anvil Press, 2009).

PHOTOGRAPH BY DEREK VON ESSEN.